THE STORY OF
POPULAR PHOTOGRAPHY

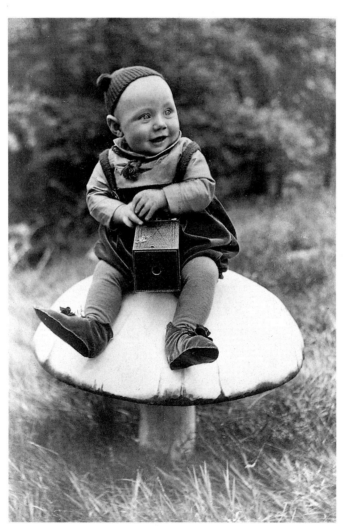

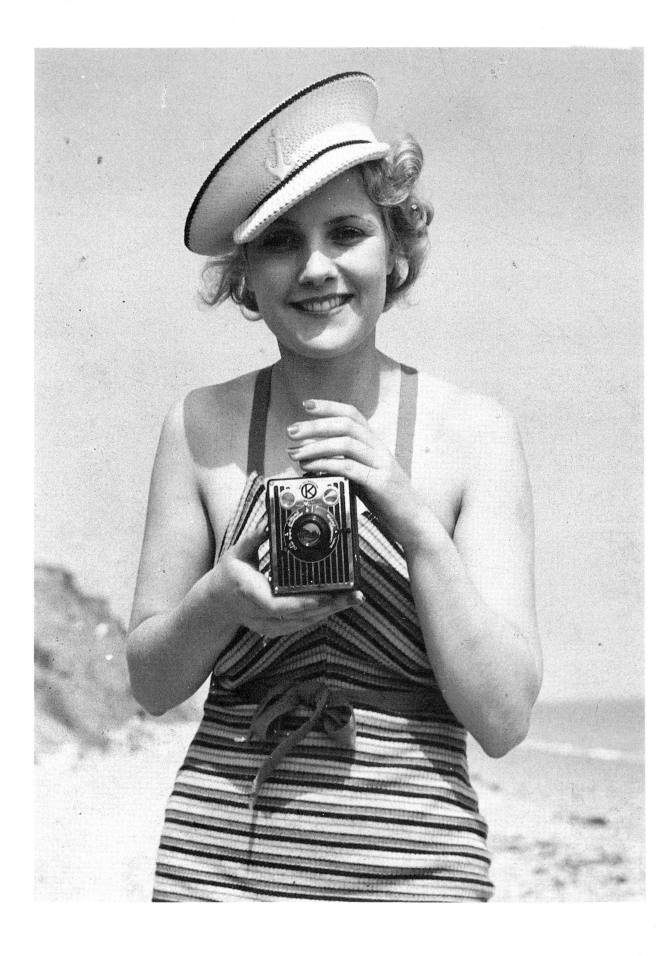

THE STORY OF
POPULAR PHOTOGRAPHY

Edited by COLIN FORD

Trafalgar Square Publishing
North Pomfret, Vermont

First published in the United States of America in 1989 by
Trafalgar Square Publishing, North Pomfret, Vermont 05053.

ISBN 0 943955 15 7

Designed by Behram Kapadia

Typeset in Monophoto Apollo by
Vision Typesetting, Manchester

Printed and bound in Germany

Contents

Foreword

Though the idea of a museum of photography is almost as old as photography itself, the impetus for Britain's National Museum of Photography, Film and Television can perhaps be most directly traced back to a letter in *The Times* of 3 March 1952. Its clutch of distinguished signatories included the art critic Clive Bell, the Editor of *Picture Post* Sir Tom Hopkinson, the President of the Royal Academy Sir Gerald Kelly, the architectural historian Nikolaus Pevsner, and the novelist and playwright J.B. Priestley. Its subject was Britain's need for a public collection of photographic art 'containing the best work of the nineteenth and twentieth centuries with the finest of today'.

A long and lively correspondence ensued, and on 31 May 1952 the group wrote again to summarize the main activities envisaged for their national collection of photography:

1. Permanent display. The evolution of photography as a science and as an art. Photographs and apparatus of all periods.
2. Special exhibitions of the work of famous photographers of all periods, or particular aspects of photography, such as social or general historical subjects.
3. The library . . . available to students . . . Information and documentation services.
4. The photographic department would supply prints of any photograph, &c., in the collection.
5. Lectures. During the period of each special exhibition, lantern lectures would be given on the subject.
6. Publications. Film strips . . . a journal promoting appreciation of nineteenth-century as well as contemporary photography.

Though the signatories to that 1952 letter might well have found the NMPFT—which finally opened its doors twenty-one years later—surprisingly popular (and populist), I believe they would have approved its unique mix of aesthetics and technology, its dedication to photographs as records of social history, and its wide range of activities. If we have not yet achieved every one of their aspirations, it is because we have not yet had time to do so, rather than because there was anything remotely wrong with their vision. We have added film and television to their brief, believing that these visual media form part of a continuum: within fifty years of the first photographs, ways were found of making them move; fifty years later still, moving photographs began to be seen regularly on television screens.

J.B. Priestley, in particular, would surely have approved of the fact that we are sited in his home town, Bradford. That city has made a spectacular city centre building available to us at a nominal rent, and spent a large sum of money making it ready for our occupation. A man of the people able to communicate with a very wide audience, Priestley could be expected to share our view that photography has always played its most important role as a popular medium. The Museum now in Bradford, and especially its Kodak Museum (to which this book is a companion), is devoted to the story of how photography has been perceived by the person in the street during the last 150 years.

A century and a half ago, the honour of inventing photography could legitimately be claimed on both sides of the English Channel. Though there undoubtedly were experimenters in several countries working on the permanent chemical retention of the two-dimensional images seen by the *camera obscura* (and *camera lucida*), the two processes described in John Ward's chapter on 'The Beginnings of Photography' were cumbersome, difficult to manipulate, expensive and slow. Only those with time and money to spare could become experienced practitioners.

In the 1850s, a new British process replaced both calotype and daguerrotype, though it still demanded a lot of time and care. This 'wet collodion' led to the very widespread dissemination of the medium, as David Allison explains in 'Photography and the Mass Market',

and it attracted many to take up photography as a hobby. But such amateurs still had to be comparatively well-off.

As early as 1860, the eminent Victorian astronomer and scientist, Sir John Herschel, wrote: 'What I have to propose may appear a dream. It is . . . the possibility of taking a photograph, as it were, by a snapshot—of securing a picture in a tenth of a second of time.' Herschel's dream of the snapshot almost became reality in the 1870s with the invention of the dry plate, soon widely available. The famous 'Ilford' plate, introduced in 1879, became in the 1880s the best-selling photographic plate in the world.

Dry plates enabled Eadweard Muybridge, an Englishman at the University of Pennsylvania, and Etienne Marey, a Frenchman, to make many studies of the movements of animals and human beings. When the dry plate was replaced by lighter and more flexible film, Marey could speed up still further, recording the wing movements of birds in flight. His new apparatus, the Chronophotographe, was virtually the world's first 'moving picture camera and, had he been a businessman or an entertainer rather than a scientist, he might now be recognized as the inventor of cinema, and John Chittock's chapter, 'From Home Movie to Home Video', might have started differently. As it is, moving pictures had to wait for ten years and the most significant photographic invention of the 1880s, chronicled in Brian Coe's 'The Rollfilm Revolution', was the American George Eastman's Kodak camera. Easy to carry and operate, freed of the hitherto inhibiting tripod, it at last enabled photographers to capture moments of unposed reality. From now on, the world had to be ready to be photographed unawares.

From the 1888 invention of the first Kodak, photography had also to abandon its status as an art form. From the very beginning, when the French painter Eugene Delacroix had looked at a daguerreotype and exclaimed: 'From today, painting is dead', artists, critics and connoisseurs had willingly accepted photographs as works of art. After the Kodak, however, this changed. If all one had to do was, literally, 'press the button', and photographs could be taken by any man,

woman or child, the results could hardly be works of art. Nor, usually, were they. Whatever the fascination of snapshots and the social lessons to be learned from them, they were rarely 'art'. Hereafter, amateur photographers were no more likely to advance the art of photography than Sunday painters. As Margaret Harker records in 'The Inter-War Years', it was a group of dedicated professionals, and an even smaller number of very serious amateurs, who kept the cause of art photography alive, particularly in Europe, which in many ways had lost its leadership to America.

In the first fifty years of its history, photography had run the gamut from scientific wonder to lucrative profession, from respected art form to widespread hobby. From the 1880s on, it was to be of as much interest to the social historian as to the historian of science, technology or art. In the last fifty years, it has become even more widespread: nowadays, almost everybody, it seems, owns a camera, and can take and collect photographs for themselves. The spread of this phenomenon, and the dramatic change from black-and-white to colour, is told by Geoffrey Crawley in 'Colour Comes to All', bringing the story up to date.

Ever since the invention of the snapshot, photography has played an increasing role in people's lives, recording their work and leisure, showing them what the world is like, and expanding their vision. It is this exploration of the place where photography touches every human being's existence which has made the National Museum of Photography, Film and Television so immensely popular, with an audience that comes to be amused, excited, entertained and educated by a medium they see daily—from newspapers at breakfast time to television in the evening. Winner of the 1988 Museum of the Year Award, we are, we like to think, a mecca for everybody who has taken a photograph, been photographed, been to a cinema, or watched television. This book explains why.

COLIN FORD
Keeper
National Museum of Photography, Film and Television
Bradford
1988

Introduction

The beginnings of the Kodak Museum can be traced back to 1927 and the influence of one person, John Pledge. It was his interest in scientific photography, and his love of photographic history, that led to the creation of what was then known as the Works Museum.

Many large companies find they have gathered together, unintentionally, sufficient material over the years to create a company archive or museum. Kodak, exceptionally, took the view that a history of the company and its products, though valuable, would be too narrow and inward-looking for visitors. Instead, they encouraged Pledge to collect widely across the range of photographic history and thus establish a pattern for future development. From the very outset, the museum was used by the company as part of its public relations exercise. Visitors to the Harrow factory, having toured the manufacturing plant, ended with an inspection of the museum. Here, the contrast between the earliest equipment and the latest products served to emphasize Kodak's innovative role.

By 1939, the museum had expanded to such an extent that it was removed to larger premises in the factory. This coincided with the centenary of the invention of photography, and the role of the museum was further consolidated by a newly awakened popular interest in the history of the medium. Penguin Books published a paperback, *A Hundred Years of Photography* by Lucia Moholy, which cost just a few pence, and employees at the Harrow factory were encouraged by the Works Bulletin to visit the museum during their lunch hour to study 'the vast number of interesting and instructive subjects' on display.

These encouraging signs of general interest were quickly obscured by the declaration of war later that year. Very soon, the factory was given special status by the Government as its manufacturing role was diverted towards the war effort. Everyone was affected. The design and mass production of special equipment transformed the camera department. Film and paper production was stepped up to meet the new demands. Factory tours were stopped for security reasons and employees became the museum's only visitors.

The museum's growth and direction up to 1941 was fastened on a part-time voluntary basis by the enthusiastic Pledge. On his retirement in that year, he was retained by the company as a full-time curator. By 1945, when he handed over to his successor, C.L. Manlove, the collection had grown to over 2,000 items, giving a comprehensive overview of the history of photography. It was a major achievement to have formed such a collection and the company recognized its significance by publishing in 1947 a handsome catalogue. This described the permanent displays in some detail and illustrated many items. On its front cover it boldly stated the museum's philosophy: to illustrate 'the history of photography and some of its applications in science, art and history'. The concept remains to this day.

The next major period of expansion came under the curatorship of the company's research librarian, Dr Rolf Schutze, who succeeded Manlove in 1953. Under his skilful direction many important items were added to the collections, notably a group of photographs which had belonged to the eminent nineteenth-century scientist and photographic pioneer, Sir John Herschel.

In 1956, the museum was packed up again, to be returned to its former premises in the oldest building on the Kodak site, the original home of the developing and printing departments in 1891. Here it remained until 1985.

The final phase of development at Harrow was heralded by the appointment in 1969 of Brian Coe as full-time curator. Working closely with the public relations department, he was able to promote the museum through radio, television and exhibitions. Coe's books reached a wide audience and helped to popularize the subject. His approach drew attention to the museum and reflected well on Kodak. One result was an increase in the rate of acquisitions, as the public

realized that the museum was a natural place to donate treasured cameras or photographs.

Just prior to the celebration of the museum's Diamond Jubilee in 1977, there was a lengthy debate within the company as to how best to secure its future and present the collections. The press release announcing the fiftieth birthday also gave the news that a new museum was planned on the ground floor of its existing building. This new facility and exhibition centre would be freely available to members of the public.

The new museum was opened in May 1980 by the then Director of the Science Museum, Dame Margaret Weston. The future seemed bright, with an extensive new building, an active education department and a staff of twelve. But by 1982 the company was facing a major world-wide reorganization and the future of the museum was called into question.

Negotiations with the Science Museum and other interested parties began. The Science Museum seemed the natural choice as it had almost completed its new National Museum of Photography, Film & Television in Bradford. Early in 1984, it was decided to close the museum at Harrow and to donate its collection to the NMPFT.

During the latter part of 1984 and early 1985, a team of curators worked with Coe on the difficult task of packing and listing the collection. The last boxes arrived in Bradford during the summer of 1985. Coe himself became the curator of another nationally important collection, at the Royal Photographic Society, Bath.

I took up my appointment in September 1985. On that day I was shown, with some pride, the ordered ranks of boxes from Harrow. Row upon row, shelf upon shelf, store upon store: over 50,000 items. It has taken more than a year to unpack them all, and two further years to develop, design and construct a new Kodak Museum, one that for the first time tells the story of 'popular photography' from 1839 to 1989.

The possibility of making such a display owes a great deal to the collecting zeal and wisdom of my four predecessors as Curators of this internationally important collection. I salute them.

ROGER TAYLOR
Curator
Kodak Museum
Bradford, 1988

The Beginnings of Photography

Throughout 6 January 1839, England was reeling under the effects of a gale of extraordinary violence. In London, vessels on the Thames broke from their moorings, trees were uprooted and chimney pots blown down. Further north there were reports of streets strewn with fragments of stones, slates and bricks which had been hurled from buildings. The most grave consequences of the gale occurred on the seas around Britain. Many vessels were lost, including two packet ships bound for New York. Over a hundred souls perished in the stormy waters. The inevitable disruption of the mails delayed the regular delivery of newspapers from across the channel in France.

When Britons were finally able to read the latest dispatches from Paris they learned of astonishing and exciting news. A French artist had made a discovery which was described as 'a prodigy'. 'It confounds all the theories of science in light and optics.' The journalist was heralding one of the nineteenth century's most important inventions, later to be described as one of the most wonderful discoveries of the age. The report was the first public announcement to the world of the invention of photography.

The bald details of the discovery took longer to reach the United States, and it was not until 18 May that a fuller description appeared there. On that day the *New York Observer* published a letter from Samuel Morse to his brothers, who were its publishers.

. . . the exquisite minuteness of the delineation cannot be conceived. No painting or engraving ever approached it. For example: In a view up the street, a distant sign would be perceived, and the eye could just discern that there were lines of letters upon it, but so minute as not to be read with the naked eye. By the assistance of a powerful lens, which magnifies 50 times . . . every letter was clearly and distinctly legible.

Original inventions are rarely conceived by a single person in a moment of inspiration and photography was no exception.

Its origins can be traced back down the centuries by two distinct paths. One path leads to those who first observed that an image of the outside scene was formed by sunlight shining through a small hole into a darkened room. This phenomenon was later used to construct a miniature form of the darkened room, the camera obscura, which by the eighteenth century was a popular artist's aid to drawing. The other path leads back to those who first discovered that certain substances were physically changed by the action of light. Again, by the eighteenth century it was known that salts of silver were particularly sensitive to light and detailed descriptions of this action were published. It was the bringing together of these optical and chemical phenomena that made the invention of photography possible.

At the end of the eighteenth century Thomas Wedgwood made the first recorded attempts to produce photographic images. Wedgwood made outline pictures by placing objects on materials sensitized with silver salts and exposing them to sunlight. He also made the important

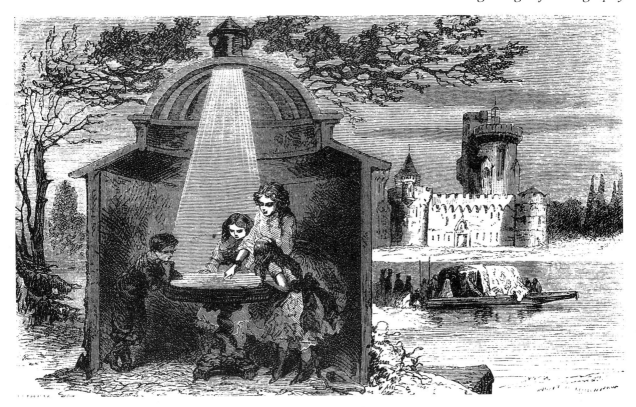

conceptual step of placing his sensitized materials in a camera obscura but was unable to record the image formed, even after a long exposure. Wedgwood could not preserve or 'fix' his outline images; he could only view them by candlelight and they soon faded away. Wedgwood was a sick man and did not pursue his experiments. The details were published by his friend Humphry Davy in 1802 and then quietly forgotten for over thirty years.

Others tried experiments, sometimes with more success. According to one report, James M. Wattles, a student from Indiana, managed to make landscape photographs on sensitized paper in 1828, but like Wedgwood, he was unable to fix them:

I first dipped a quarter sheet of thin writing paper in a weak solution of caustic (as I then called it) and dried it in an empty box, to keep it in the dark . . . I then soaked the same piece of paper in a solution of common potash, and then again in caustic water, a little stronger than the first, and when dry, placed it in the camera. In about forty-five minutes I plainly perceived the effect, in the gradual darkening of various parts of the view, which was the old stone fort in the rear of the old school garden, with the trees, fence &c. I then became convinced of the practicality of producing beautiful solar pictures in this way . . .

Ironically, Wattles' parents laughed at his efforts, dismissing them as 'moonshine'.

A French inventor, Joseph Nicéphore Niépce, had tried the same experiment with silver salts as early as 1816, but he eventually despaired of producing images using a substance which changed colour when exposed to light. Instead he turned to materials which hardened. During the 1820s he produced a series of images made using bitumen of Judea on pewter plates. Although this technique has more in common with what we would today call photomechanical printing rather than photography, a bitumen of Judea picture made in the camera obscura and taken from Niépce's window in 1827 can be regarded as the world's earliest surviving camera photograph.

Niépce's camera pictures were indistinct and only produced after an exposure

The direct forerunner of the camera was the camera obscura, shown here in its most highly developed form. A lens on a rotating turret projected an image of the scene outside, via a mirror, down on to a white-topped table where the picture could be viewed. Early experimenters realized that if the table was covered by a sheet of light-sensitive material, it could capture a permanent record of the scene. Few camera obscuras were this grand; most were very much smaller, and many folded up, to be carried around as sketching aids for artists.

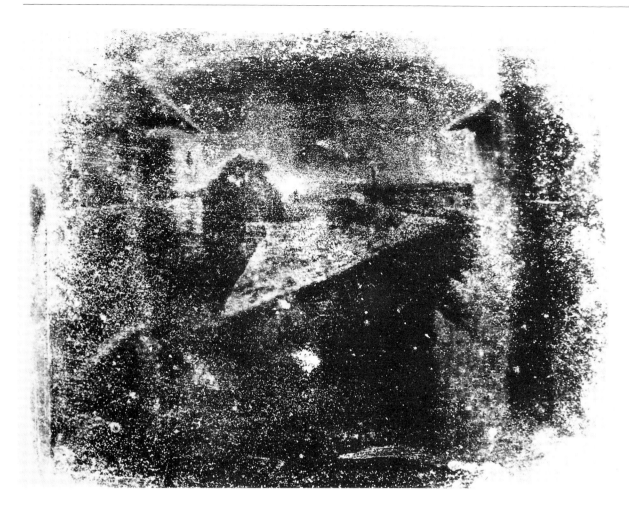

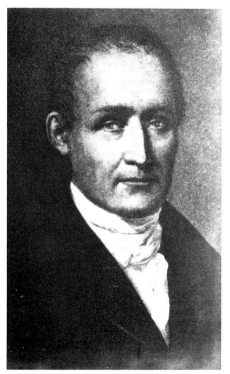

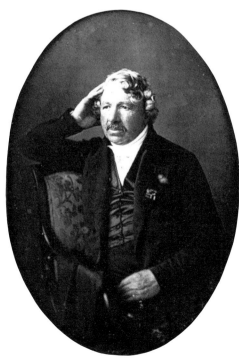

ABOVE The world's first surviving camera photograph, taken by Niépce from the family home at Châlons-sur-Sâone, shows a courtyard, with a pigeon loft on the left and the roofs of outbuildings visible in the middle.

RIGHT Nicéphore Niépce, a Frenchman who was born in 1765, could be regarded as the very first photographer in the sense that we use the word today.

FAR RIGHT Louis Daguerre became fascinated by the idea of fixing the images of the camera obscura in the late 1820s and realized his dream in 1837.

of several hours. His process could not therefore be regarded as a satisfactory system of photography. However, his work came to the notice of a French artist and scene painter, Louis Jacques Mandé Daguerre, who for some years had been fascinated by the possibility of fixing the images formed by the camera obscura. Daguerre contacted Niépce and, although relations were initially cool, they collaborated until Niépce's sudden death in 1833. Daguerre continued working alone, but it was after pursuing many false trails that he eventually devised a process which was only indirectly related to Niépce's. Using silver iodide as his light-sensitive compound, Daguerre produced direct positive pictures on silver-coated copper plates. The minimum exposure time in the camera was several minutes, but the mirror-like daguerreotypes, as they were called, were minutely detailed. Towards the end of 1838, Daguerre showed his plates privately to several distinguished artists and scientists who immediately recognized the importance of the invention. At a meeting of the Académie des Sciences on Monday 7 January 1839, the physicist Arago announced the

discovery of the world's first practicable photographic process.

By one Englishman at least, the news was received with dismay. William Henry Fox Talbot, a gentleman of Lacock Abbey in Wiltshire, had been working for several years on what then appeared to be a similar process. Talbot's interest in the subject began on his honeymoon in Italy in 1833. He had attempted to sketch using a popular artist's aid of the time, the camera lucida. His efforts in his own words were 'melancholy to behold'. Later his thoughts turned to another artist's aid he had used, the camera obscura. It was while he was reflecting on the nature of the images formed—'fairy pictures, creations of a moment and destined as rapidly to fade away'—that the idea occurred to him. Why not capture the image chemically? Like the earlier experimenters, Talbot thought of using silver salts but, unlike them, he was a competent scientist, well grounded in optics and chemistry. In the spring of 1834, using a series of weak silver chloride solutions on paper, Talbot obtained outline pictures of leaves and lace in the same way that Wedgwood had done many

Talbot's interest in photography was fired by his use of the camera lucida, a sketching aid which he used to make this drawing. Like the camera obscura, the camera lucida formed an image which the artist could copy on to paper. However, the camera lucida created an image that could not be thrown on to a sheet of paper or screen. The camera obscura, which formed images directly on a screen, was thus a more suitable choice for Talbot's experiments on photography.

Villa Melzi

5th Oct.r 1833

By pressing objects between glass and sensitized paper and exposing the 'sandwich' to daylight, early photographic experimenters were able to make elegant silhouettes and shadow pictures, such as this 1839 print by Talbot from a piece of lace. Such images were made without the use of lens or camera by directly placing the object in contact with sensitized paper. Some experiments such as those made by Thomas Wedgwood, predate the first true photographs by many years.

BELOW The earliest cameras were made according to the state of knowledge of the time, without the benefit of existing designs to work from, and Talbot's first cameras (shown here in replica) were possibly constructed by a local carpenter or cabinet maker. One camera was even created from a cigar box sawn into two, with a hole drilled for the lens. Prompted by the appearance of the tiny boxes, some of which had a small round hole at the front, Talbot's wife Constance dubbed them 'mousetraps', as some Victorian traps were wooden boxes with an aperture for the mouse to enter.

years earlier. But he went further than Wedgwood, for Talbot was able to preserve his pictures using a strong salt solution. After further experiments, Talbot found that he could record the images formed by a solar microscope and, finally, the camera obscura.

The earliest surviving camera picture made by Talbot, a view of a lattice window in Lacock Abbey, was made in the summer of 1835. Talbot's camera pictures at this time were very small negative images and they appeared only after an exposure of at least half an hour in the camera. It was also in 1835 that Talbot made a momentous discovery. As he later explained, 'if the picture so obtained is first preserved so as to bear sunshine, it may afterwards be employed as an object to be copied and by means of this second process the lights and shadows are brought back to their original dispo-

sition.' Talbot had discovered the principle which was to form the basis of modern photography—the negative which could be used to make an unlimited number of positives. Having reached this point in 1835, Talbot did very little further work on what he called 'photogenic drawing' until he heard the startling news of Daguerre's discovery. Talbot then immediately made plans to publicize his own work. On 25 January 1839, Michael Faraday showed examples of Talbot's photogenic drawings at a Royal Institution meeting, and this was followed by a paper read to the Royal Society on 31 January, at which details of the workings of the photographic process were presented to the world.

In Paris there was a fever of expectation as people struggled to come to terms with the concept of a minutely detailed picture created not by the hand of an artist but

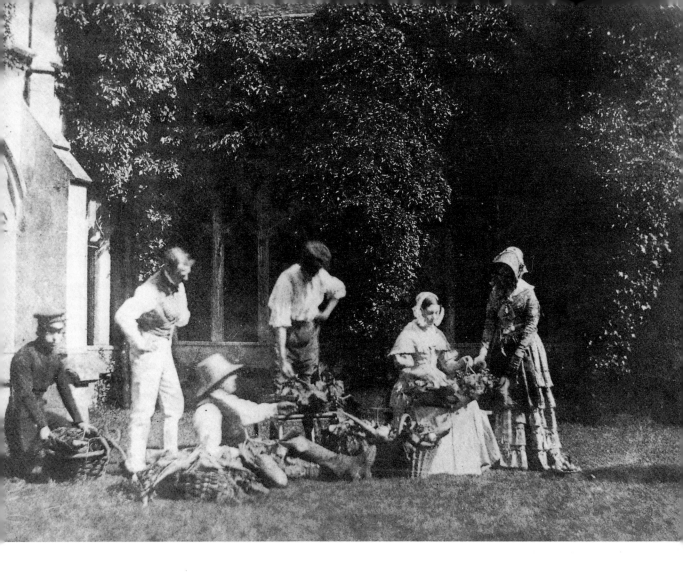

solely by the rays of the sun. During those early months of 1839, Daguerre showed his daguerreotypes only to a limited circle of influential and distinguished contemporaries but those who saw them were, without exception, astonished. The visiting English astronomer Sir John Herschel described the specimens as 'miraculous'. The American, Samuel Morse, who was in Paris to promote his electric telegraph, described the invention as 'one of the most beautiful discoveries of the age'.

In England the announcement of Daguerre's and Talbot's processes almost simultaneously aroused a similar interest and speculation. As in Paris, few of the early commentators could have actually seen a photograph, for there were very few to see, but this did not blunt their enthusiasm. Like Talbot before them, many assumed that the two processes were the same and it was clear that there

was much muddle and confusion. At least one journal published an account of Daguerre's invention in Paris but cited as examples Talbot's photogenic drawings shown in London. As winter turned into spring, an awareness gradually spread that there were two very different processes, and because the British saw no daguerreotypes during those early months of 1839, photography was photogenic drawing. In comparison with contemporary daguerreotypes, Talbot's pictures were crude and lacked detail, but they were undoubtedly a source of wonder and amazement, particularly the leaf and lace impressions. Examples of the latter were much admired by the young Queen Victoria when specimens were shown to her by her ladies-in-waiting.

Another reason for the interest in photogenic drawing in England was that while Daguerre had withheld operational

Talbot took many pictures in and around his home at Lacock. This picture, taken in the cloister, is a valiant attempt at posing the figures so as to suggest action and dynamism in what is necessarily a static scene.

Talbot optimistically described such tableaux:
. . . when a group of persons has been artistically arranged, and trained by a little practice to maintain an absolute immobility for a few seconds of time, very delightful pictures are easily obtained. I have observed that family groups are especial favourites: and the same five or six individuals may be combined in so many varying attitudes, so to give much interest and a great air of reality to a series of such pictures.'

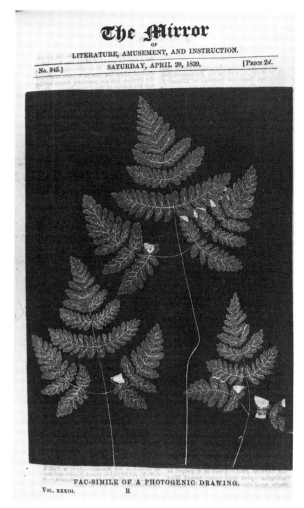

FAC-SIMILE OF A PHOTOGENIC DRAWING.

VOL. XXXIII. R

ABOVE Talbot's earliest surviving photograph, taken in 1835, shows a lattice window at his home, Lacock Abbey. The image is tiny, because Fox Talbot used miniature cameras just a few inches in size. This enabled him to concentrate as much light as possible on the surface of his paper, which had limited sensitivity to light.

ABOVE RIGHT The first printed reproduction of a photograph appeared in April 1839, less than three months after Talbot announced his process to the world. The picture was accompanied by 'A Treatise on Photogenic Drawing' which provided detailed instructions in the use of Talbot's process, together with a wildly inaccurate description of Daguerre's discovery.

details of his process, Talbot had given an outline of how to make his photographs in a Royal Society paper. This information was subsequently published and the details discussed in many of the popular journals of the day. In April 1839 Ackermann & Co of London offered for sale an outfit for making photogenic drawings which included chemicals, paper, a printing frame and an instruction booklet. Unfortunately, when the enthusiasts for the 'New Art' began to try it for themselves, it soon became apparent that there were many subtleties, and careful chemical manipulation was required before even the crudest image could be produced. Some found that they could produce nothing at all, others only imperfect images in muddy colours. A few careful practitioners worked diligently to produce satisfactory results and were then

mortified to find that their beautiful pictures faded away. It is also clear that Talbot's negative-positive technique had not been grasped. One journal reported the astonishment of a gentleman who, when attempting to copy an engraving of a man with a white face and black hair, found that by some 'ludicrous metamorphosis' his picture showed a black man with white hair. Ackermann's booklet did not even attempt to explain how to make camera pictures, for these proved especially difficult to produce and they did not wish to 'mislead our readers by inducing them to attempt to produce effects which can only be obtained by the greatest skill'.

By August the first enthusiasm for photography began to flag. It was revived on the 19th of the month when, in a blaze of publicity, the secret of Daguerre's

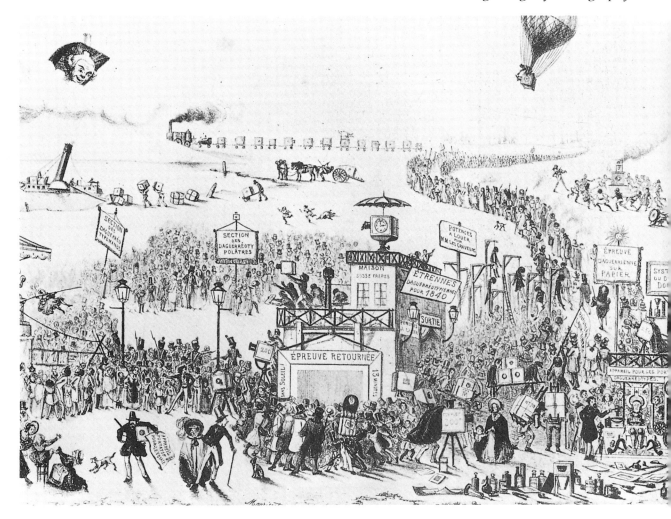

process was at last announced. A limited supply of apparatus was made available and a manual published on the history and practice of the daguerreotype. (What was not immediately made public was that Daguerre had recently made arrangements to patent his process in England.) The response in Paris was immediate. Within an hour of the announcement, opticians in the capital were besieged by would-be daguerreotypists. Soon it seemed to some commentators that all of Paris was occupied in polishing plates and siting cameras. It was reported that the shop windows where finished views were exhibited were so crowded that streets became completely impassable. Paris was gripped by 'daguerreotypemania'. London saw its first daguerreotypes in September when the process was demonstrated by a M. de St Croix and, soon

after, by Mr J. T. Cooper. Although London enthusiasm did not quite match that in Paris, the exquisite detail of the daguerreotype in comparison to Talbot's photogenic drawings certainly did not fail to impress. M. de St Croix took several daguerreotype views of London during this period. The few that survive are the earliest known photographs of the city.

New York, Boston and Philadelphia embraced the new art with the same vigour as the European capitals. Morse, whose imagination had been sparked by his visit to Daguerre in Paris, was in the vanguard of the new photographers. He was aided by reading the full details of the process in a daguerreotype manual brought to him in the autumn of 1839 by D. W. Seager. Seager had just arrived from Europe, where the manual had been thrown to him from the dockside after his

Daguerre's announcement of a practical photographic process created a storm of interest in his native France, and the subsequent publication of the details resulted in a rush for cameras and daguerreotype equipment, as depicted in this satirical 1840 lithograph by Maurisset.

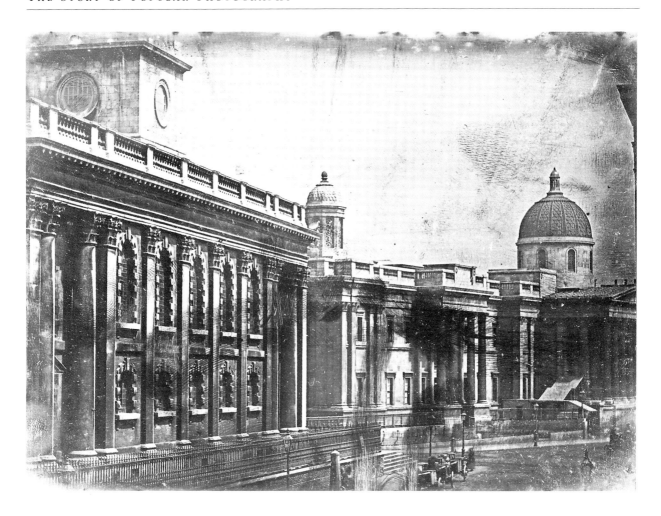

The first daguerreotypes taken in Britain date from September 1839, when a visiting Frenchman, M. de St Croix, demonstrated the process in Piccadilly, before an audience of eminent artists and scientists. They concluded that the plates resembled '. . . an exquisite mezzotint'. This picture of the National Gallery still bears out their assessment.

ship had already cast off. On reaching New York, he sought out Morse, and they co-operated, first in building a camera, then in making the first truly American photographs. It is unclear which of the two men had the first success: reminiscences written forty years on would seem to give this accolade to Morse, but the first picture to be exhibited was Seager's image of St Paul's Church, which still stands on Broadway and Fulton Street.

In America, interest centred principally on Daguerre's process, largely because of the foresight of the French government in purchasing the inventor's rights to the process and in broadcasting the details world-wide. The spread of the daguerreotype was accelerated when the inventor's agent, Francois Gouraud, lectured on the process in New York in November 1839 and exhibited plates there, before moving on to Boston. The examples he showed had been created by

Daguerre himself, and were far superior to those of the home-grown pioneers. Gouraud drew large crowds at his presentations, gave private tuition in the process, and sold the apparatus.

As 1839 drew to a close, the differences between the two processes at last began to be fully appreciated. Daguerre's process involved sensitizing with iodine vapour a highly polished metal plate coated with silver. After the plate was exposed in the camera, development with mercury vapour produced a single unique positive image; no negative was involved. The image was fixed with a strong salt solution. The mirror-like pictures contained exquisite detail but their soft surface required protection by glass. Talbot's images on paper were prepared by dipping writing paper into a weak solution of common salt and then applying a solution of silver nitrate. When exposed in a camera, the paper produced a negative

image which was fixed with a saturated solution of common salt. Positives were made by placing the negative in contact with a second sheet of sensitized paper and exposing this new sheet to light transmitted through the negative. It was this capacity to produce many positive pictures from a single negative which was the most important part of Talbot's process. It was recognized that both processes were in a very imperfect state and both were improved in less than a year.

Improvements to the daguerreotype process took place by a series of small steps. The most notable improvements to the chemistry were those made in England by John Goddard who used bromine vapour to increase the sensitivity of the plates in 1840, and Antoine Claudet (a Frenchman working in England) who later found that mixtures of chlorine and iodine vapours had the same effect. Hippolyte Fizeau's method of toning with gold, which toughened the fragile surface of the plate and increased the contrast of the image, was also important. In Vienna Joseph Petzval designed and manufactured a large-aperture lens which was twenty times faster than the lens on Daguerre's original camera.

From the outset Talbot was in little doubt that his photogenic drawing process was in a primitive state and that it compared unfavourably with the rival French process in several important respects. Throughout 1839 he had worked feverishly to improve his methods, and his efforts continued into 1840. By May he had made some progress and received gratifyingly good press reviews. Yet it was not until the late summer that he made the most momentous step forward. On 23 September he mixed gallic acid with silver nitrate to make what he called an 'exciting liquid' and used this mixture to sensitize photogenic drawing paper. Talbot found that, when the paper was exposed briefly in the camera, an invisible or latent image was produced which could be made visible by further applications of the gallic acid solution. The consequences were dramatic. Exposure times were reduced to a few minutes and this transformed the possibilities for Talbot's art.

Most importantly, he could now photograph living subjects. Talbot called his new process the calotype, which also became known as the talbotype. Like Daguerre before him, he patented the process in England. By the end of 1840 it became evident that commercial portrait photography, one of the most exciting

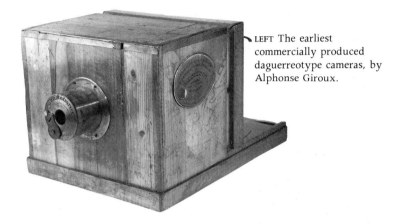

LEFT The earliest commercially produced daguerreotype cameras, by Alphonse Giroux.

BELOW Daguerreotypists required much equipment. A buffer (a) was used with progressively finer polishes to impart a mirror-like gleam to the silvered surface of the plate (b). Polishing was followed by sensitization, using iodine and bromine vapours contained in a sensitizing box (c). After exposure, the daguerreotype was 'developed' by fuming with the vapour of heated mercury in a developing box (d). The beveller (e) put a neat edge on the plate.

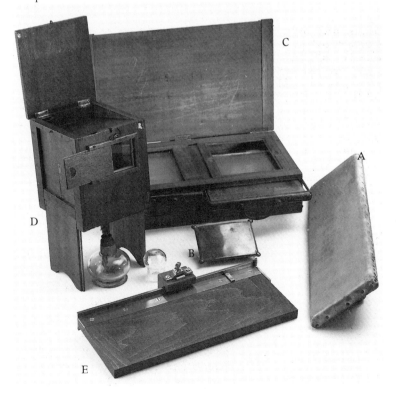

The first daguerrèotype portrait studio in Britain was opened at 309 Regent Street, London in 1841 by coal merchant Richard Beard. By using specially sensitized plates and a camera equipped with a concave mirror instead of a lens, Beard was able to make some of the earliest daguerreotype portraits such as the example on the right. The camera could, however, accommodate only very small plates, a drawback that even a highly elaborate frame could not disguise. A label pasted into the back of the frame (BELOW) made much of the innovative reflecting camera.

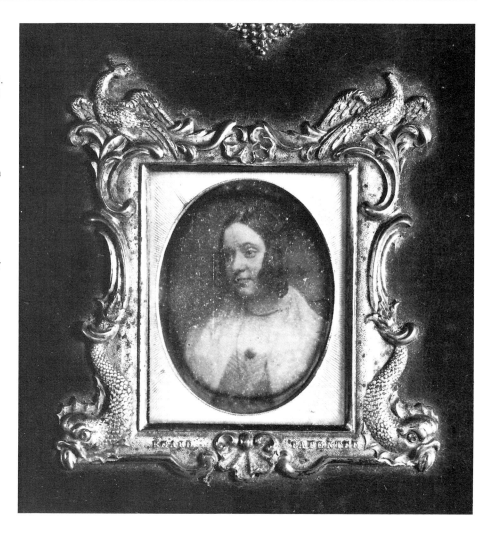

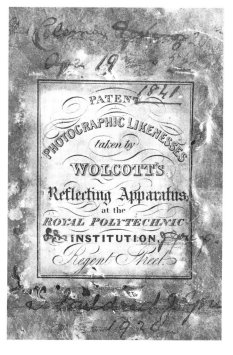

possibilities of the new art, could be achieved using either of the pioneer processes.

From the beginning, attempts had been made to take portraits, but even where a representation of the human figure was obtained the results were grotesque. A proposal by a daguerreotypist made in November 1839 illustrates the ordeal to which the unfortunate sitter was required to submit. 'Paint in dead white the face of the patient, powder his hair and fix the back of his head between two or three planks solidly attached to the back of an armchair and wound up with screws.' The minimum time the sitter would have been required to remain completely immobile in the circumstances described would have been twenty minutes. In America, Samuel Morse managed, with difficulty, to capture a daguerreotype representation

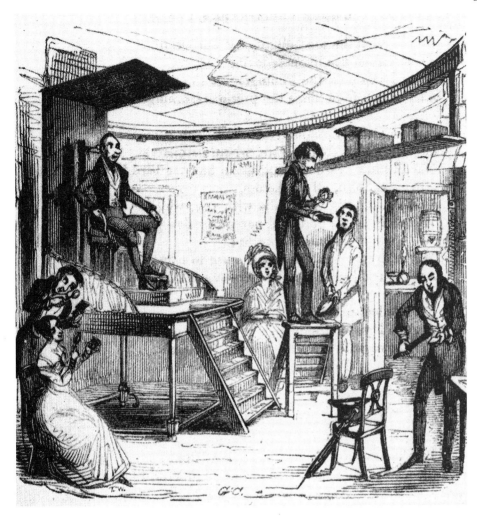

George Cruikshank packed his engraving of Beard's portrait studio with a wealth of carefully observed detail. Behind the sitter's head can be seen the clamps that ensured corpse-like immobility; Wolcott's cameras are visible on a shelf opposite. At the bottom right an assistant polishes a plate, and the two satisfied customers on the left hold magnifying glasses to emphasize the fact that detail on the plates truly was microscopic; provided the subject had not moved, a hand-lens would reveal the texture of the finest fabrics. The photographer himself times the exposure with a pocket-watch.

of his daughter, and limited success was enjoyed by his countryman Dr J. W. Draper during the winter of 1839–40. More successful still was a New York manufacturer of dental supplies, Alexander S. Wolcott, who opened the first US studio there in March 1840. He managed to reduce exposure times by using a camera of novel design which incorporated a concave mirror in place of the usual lens. By later standards, the quality of Wolcott's daguerreotypes was at best indifferent, but the *New York Sun* described them as 'astonishing'. Wolcott refined his technique further by the addition of an ingenious lighting system involving large mirrors and blue glass filters.

Wolcott's system was brought to London in February 1840 by his partner's father, W. S. Johnson, who entered into an arrangement with Richard Beard, a coal merchant and patent speculator. Johnson and Beard, with no scientific knowledge between them, in turn hired the services of John Goddard, a lecturer in optics and natural philosophy at the Adelaide Gallery. It appears to have been Goddard's work on the chemistry of the process during the winter of 1840–1 that reduced exposure times to the point where his associates were convinced that commercial portrait photography was ready for the most prosperous city in the world. In March 1841, Beard opened Europe's first public studio at the Royal Polytechnic Institute in London's Regent Street. One of the earliest reviews in *The Spectator* noted: 'If the charge be moderate . . . thousands will flock to the Polytechnic portrait room and the patentee, Mr Beard, will make a fortune.' The crowds did

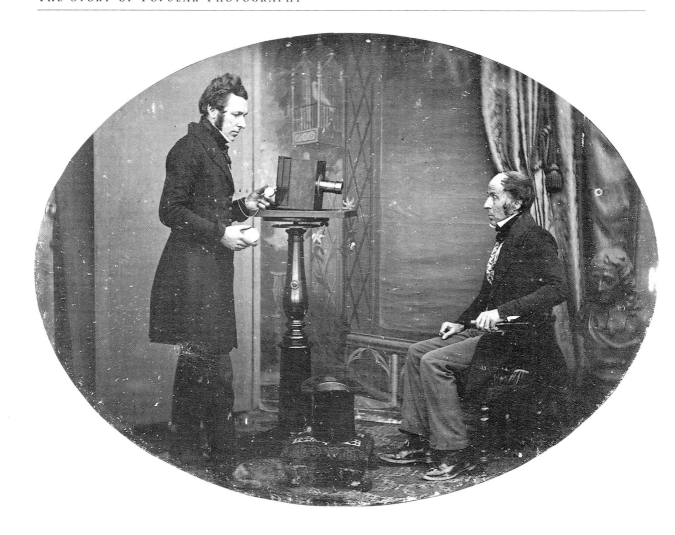

A photograph of Beard's London studio, taken in 1843, shows some remarkable similarities to Cruikshank's illustration (see p.21), and suggests that perhaps the magnificent podium was a touch of artist's licence. The differences, though, are perhaps as revealing as the resemblances: Cruikshank chose to omit many of the trappings of the professional daguerreotype studio— heavy curtains, *trompe-l'oeil* backdrops and statuary— that here surround William S. Johnson as he has his portrait taken.

indeed flock, amongst them, according to another commentator, 'the nobility and beauty of England . . .'. Mr Beard made a great deal of money—between £25,000 and £35,000 in the second year alone. Portrait photography was an immediate and outstanding success.

Only three months after Beard opened his studio, Antoine Claudet opened a rival portrait establishment on the roof of the Adelaide Gallery in London. Although he had been actively working on the daguerreotype process for almost a year, it was not until May 1841 that Claudet made the discovery that a combination of chlorine and iodine vapours greatly increased the sensitivity of the plates. Claudet's portraits were at first inferior to those produced by Beard's studio, but when technical advances in lens design made Beard's Wolcott camera obsolete, the major advantage was lost. Claudet was a

sensitive artist and a more than competent scientist. He later became the most influential and distinguished of the London daguerreotypists. The success of Beard and Claudet's studios was such that Beard opened two further London studios during 1842. Other professional daguerreotypists began to appear, in London and other towns, licensed by Beard.

Parallel developments were taking place throughout Europe and America. Attendance at a daguerreotype portrait studio soon became an essential social exercise for the fashion-conscious. An early visitor in London was Prince Albert who consented to inaugurate Beard's new studio in Parliament Street on 21 March 1842. According to *The Times*, six portraits were taken and 'by the skill of the patentee in the management of the apparatus, four of the miniature portraits were admirably taken, and came out

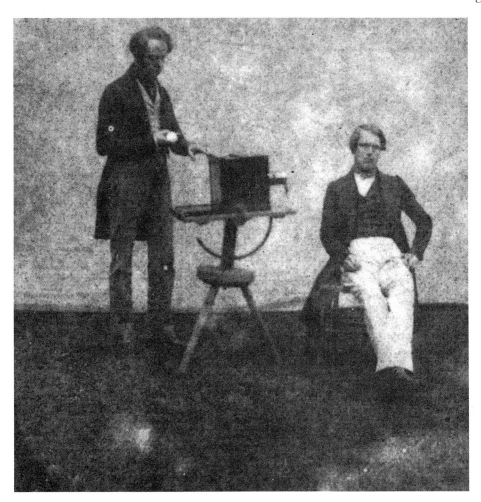

Sitters for calotype portraits had to remain as motionless as daguerreotype subjects—on a sunny day exposures were as brief as nine or ten minutes, but in duller weather, or in winter, the lens had to remain uncapped for several times as long.

perfect likenesses of His Royal Highness who expressed himself fully satisfied with the results'. Of course, not all daguerreotypes were taken in such fashionable surroundings and the sitters were often not so pleased with the results. John Werge, later to become a photographer himself, recalled an early visit to a provincial daguerreotypist, a certain Mr McGhee. He was taken into a back yard and 'against a brick wall with a piece of old grey cloth nailed over it, I was requested to sit down on an old chair; then he placed before me an instrument which looked like a very ugly theodolite . . . and after putting his head under a black cloth, told me to look at a mark on the other side of the garden, without winking or moving till he said "done" . . . Next day the portraits were delivered . . . but I confess I was somewhat disappointed at getting so little for

my money. It was a very small picture . . . and not particularly like myself, but a scowling looking individual with a limp collar, and rather dirty looking face.'

Talbot observed the popularity of the first daguerrotype studios with increasing interest, for he had high hopes that calotype portrait studios would prove equally successful. In August 1841 he licensed the first professional calotypist, Henry Collen, a miniature painter by training. Collen's calotype portraits were quite well received by the press but they failed to capture the imagination of the public. The enterprise, in Somerset Street, London, was not helped by the complete absence of any business flair on the part of either Talbot or Collen. Even when the fashionable Claudet was licensed to take calotypes alongside daguerreotypes the demand remained small. That the calotype process was a suitable medium for

Talbot's research on his photogenic drawing process bore fruit in 1840 when he discovered a way to cut exposure times down to just a few minutes, and as a result, he was at last able to take portraits. However, compared to the daguerreotype the images were unsharp, and bore traces of the fibres of the paper, as this experimental example illustrates.

RIGHT A calotype of John George Children, made by Henry Collen, using Talbot's process.

FAR RIGHT Scotland's most prominent practitioners of the Talbot process were David Octavius Hill and Robert Adamson, who took this likeness.

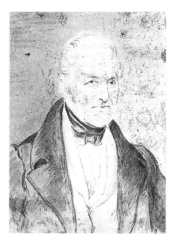

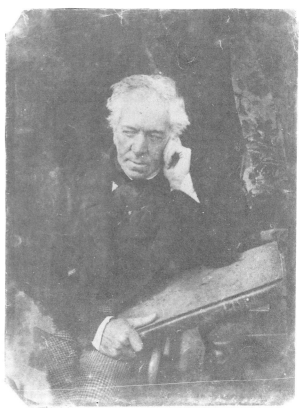

BELOW Talbot set up a photographic business in Reading, and arranged this panorama to illustrate the range of work carried out on the premises. From left to right, a photographer copies a work of art, timing the exposure with a clock, while another uncaps a lens to start a portrait exposure (note the hoop-shaped head-rest behind the subject). In the second picture an aproned assistant checks the racks of contact prints, each angled to face the sun, and another photographer copies a sculpture. At the extreme right is a gauge used to check the focal length of the camera lenses.

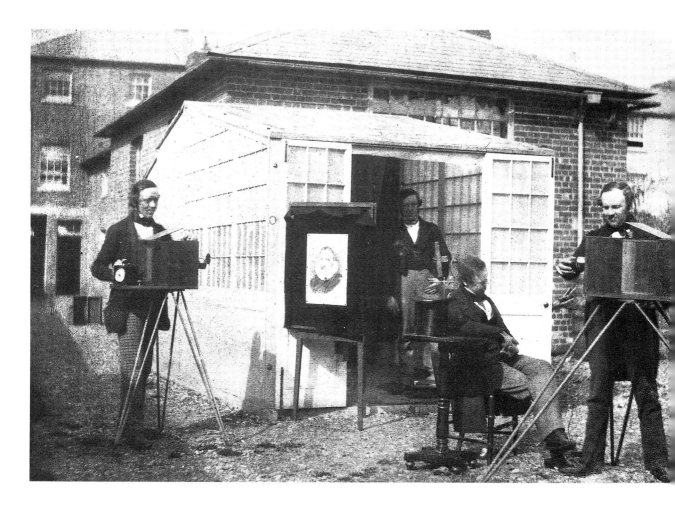

portrait photography was proved by Talbot himself, who made some charming private portraits of his friends and family, particularly the children, and notably by two calotypists in Scotland, Robert Adamson and David Octavius Hill. Adamson and Hill formed a partnership in 1843. Until Adamson's death in 1848 they produced around 1,500 calotype portraits which some commentators judged to be amongst the most masterly photographs of the period. Hill, a painter, considered the coarse texture of Talbot's process the only suitable photographic medium for an artist — the shiny detail of the daguerreotype was empty by comparison.

The American people disagreed. They were fascinated by the minute detail of the daguerreotype, and dismissed what they saw as fuzziness in Talbot's process. The daguerreotype caught public imagination in America to a greater extent than anywhere outside France, and American daguerreotypes came to be considered the finest in the world. The American rights to the calotype had been bought by Frederick and William Langenheim, who paid £600 for the privilege (they had actually offered the astonishing sum of £1,000). The Langenheims were optimistic about the prospects for the calotype in America, and wrote to Talbot in the summer of 1849 that 'the talbotypes have created a great sensation all over the United States'. However, sales did not follow sensation. Months later, despite their claims that the calotype was 'devoid of the metallic glare' that had marred the daguerreotype, licenses had been sold in only five states of the union, and the Langenheims asked Talbot if they could delay their monthly payments, which were spread over two years. The following year the Langenheims were bankrupt as a result of their venture.

Talbot, meanwhile, disappointed by the failure in England of commercial calotype portrait photography, was planning a new venture, a book of calotypes. Early in 1844, he set up a printing establishment in Reading under the direction of his one-time valet, Nicolaas Henneman.

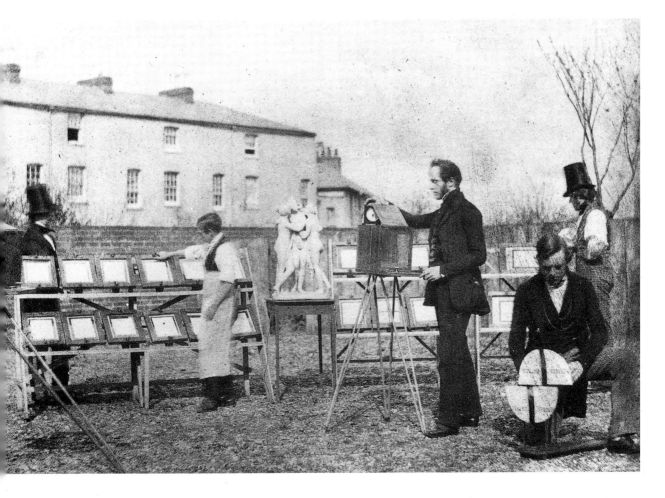

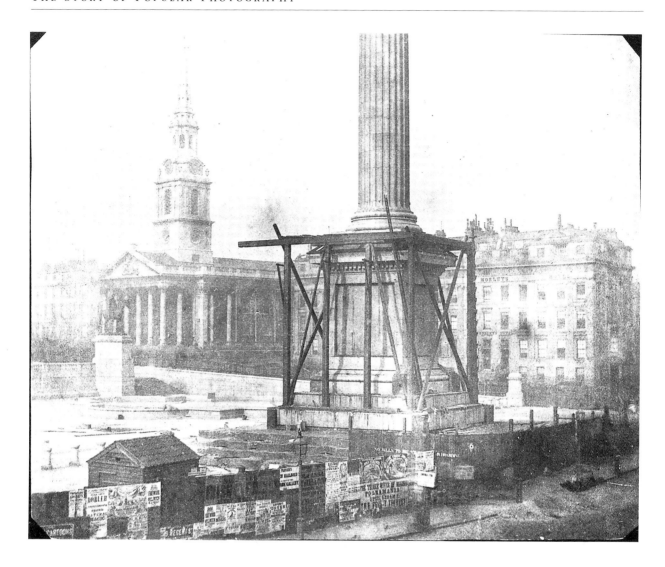

Talbot probably photographed London's Trafalgar Square in 1843, after Nelson's Column was complete, but two years before the fountains had been installed in basins visible in the background of the picture. The famous lions that now flank the Column did not appear until 1867. By the time Talbot took this picture, processes had much improved: the clarity of this picture is remarkable—you can even read the playbills on the hoarding—and makes a striking contrast with Talbot's early efforts shown on p.23.

It was here that the calotypes used in the world's first commercial photographically illustrated book, *The Pencil of Nature*, were made. The publication was issued in six parts between June 1844 and April 1846. When completed it contained a long introduction giving an historical account of Talbot's discoveries, and twenty-four calotypes with accompanying notes. Perhaps significantly, it contained views, still-life studies and one group, but no portraits. The text of *The Pencil of Nature* proved Talbot to be not only a brilliant inventor but also one of the most perceptive forecasters of the future of photography. Where so many of his contemporaries saw the art as painting in another medium, Talbot saw it as a working tool, a recording system, a means of multiplying and manipulating visual images, a means of providing a different view of the physical world around him. Talbot specifically mentions collecting family photographs and making photographic records of precious objects as an aid to crime detection; he clearly foresaw infra-red and ultra-violet photography. Almost alone, Talbot saw photography as it is practised today.

Until the Reading establishment closed in 1847, Talbot used it to produce an enormous number of prints, from his own negatives and from many supplied by associates and friends. The surviving calotypes show a great variety of subject, but amongst the more interesting are Talbot's London views which form the most important early photographic record of the city. Talbot was working at a time when massive construction works were taking

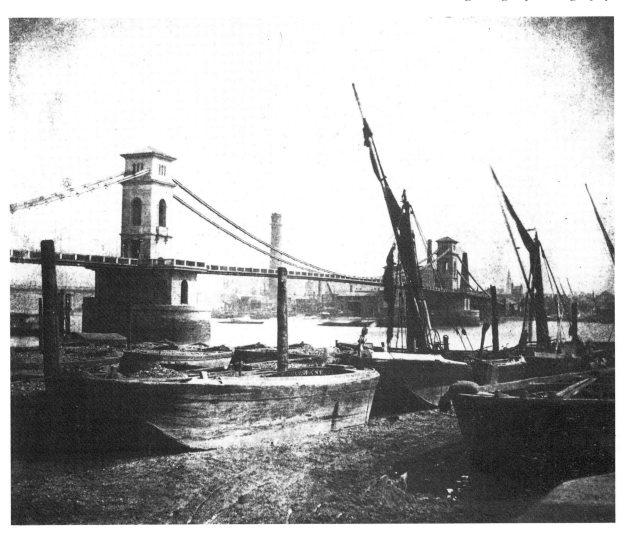

place in London. Between 1844 and 1846 he made calotypes of several of the building projects, including Brunel's Hungerford Bridge, the new Conservative Club, the Royal Exchange and Nelson's Column in Trafalgar Square. The last was particularly controversial: one press report described it as 'a monstrous blunder', a sentiment frequently expressed about new building schemes today. Talbot took at least five views of Trafalgar Square over a period of about three years. By recording such scenes of popular interest, Talbot comes close to the modern concept of a documentary photographer.

The pioneer photographers were quick to recognize that a public used to seeing strange and exotic lands only through the eyes of an artist would be fascinated by foreign photographic views. As early as

ABOVE The new and novel frequently formed subjects for Talbot's camera: he photographed Brunel's Hungerford suspension bridge, which spanned the Thames at Charing Cross, soon after it had been completed in 1845.

LEFT To publicize his process, Talbot published a book—The Pencil of Nature —illustrated with 24 calotypes and published in 6 parts.

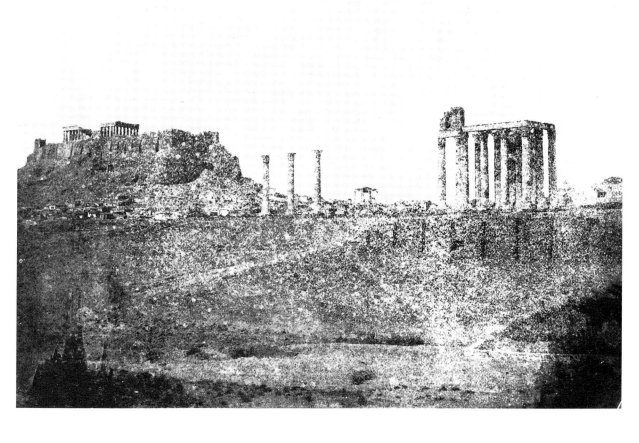

The Rev. George W. Bridges was an enthusiastic travel photographer who was instructed in the use of the calotype by Talbot's assistant, Henneman. Bridges' picture of the Acropolis was probably taken during a seven-year-long expedition that he started in 1846.

1839, French daguerreotypists were dispatched all over the world to take views. The Mediterranean lands were already a favourite haunt of the British, and it was to those regions that many English photographers took their cameras. The earliest comprehensive collection of Italian views was made by, or under the direction of, an Englishman, Dr A. J. Ellis, using Daguerre's original process. Talbot's photographic expeditions abroad were mainly confined to France, but his associates were the most prolific English photographers of the Mediterranean lands. The Rev. Calvert Jones and Talbot's cousin, C. R. M. (Kit) Talbot, took hundreds of calotypes in Malta and Italy. Between 1846 and 1853 the Rev. Bridges appears to have taken over 1,700 views in Mediterranean countries and the Holy Land, most of them calotypes.

The explorers of the New World favoured the daguerreotype. An early trip to the Yucatan was photographed almost certainly by the travel writer John Lloyd Stephens and Frederick Catherwood, an archaeologist and man of many parts. They were, however, hampered in taking pictures of the Mayan ruins by the high temperatures and the yellow atmosphere on the Mexican peninsula, and were reportedly disappointed by the photographs of the 1841 trip. Other explorers had more success. In the same year Edward Anthony travelled as a surveyor with a government expedition to the north-east boundary of the USA, the location of which was in dispute with Great Britain. He succeeded in making several views, which proved the existence of the 'highlands' at the centre of the disagreement. Very few of these early

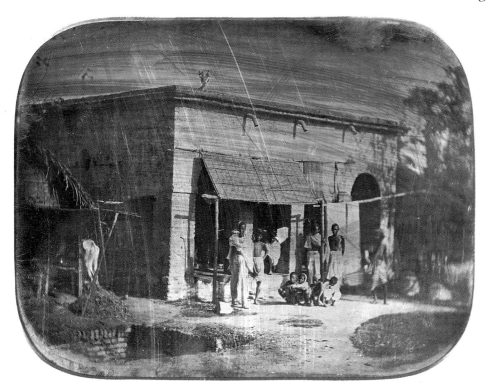

Despite the cumbersome preparations needed to take both calotypes and daguerreotypes, both processes were widely used by travellers, and this daguerreotype of an Indian street scene would have provided its viewers in the West with a first glimpse of Asia. The photographer took care to concentrate all important detail in the middle of the picture, because at the large apertures he was forced to use to permit an action-stopping short exposure, his simple lens was incapable of forming sharp images at the corners of the plate.

photographs survive. The few explorers apart, there does not seem to have been an American equivalent of the British gentleman amateur photographer in the 1840s. This is perhaps partly because the cal-otype process—much cheaper, more portable and less complex to practise—was almost unknown in the United States.

In March 1841 Talbot wrote to his friend Herschel, 'there appears to be no

Talbot's cousin, Kit Talbot introduced an old college friend to photography, and Rev. Calvert Jones soon became something of an expert with the camera, as this example of his work shows. He photographed widely in the Swansea area, and toured the Mediterranean taking pictures. Jones was an ardent advocate of the calotype, and could not understand why Talbot's process did not enjoy greater success.

RIGHT An early use for the infant art of photography was to make a permanent record of microscope specimens. The solar microscope could concentrate a powerful beam of light on the microscope slide, and prepared specimens presented the camera with the necessary static subject. Foucault used the daguerreotype process to photograph the blood-cells of a frog in 1843.

BELOW The first distinct photograph of the moon was this daguerreotype, which was almost certainly taken by John Adams Whipple of Boston in 1853. He used a 15 in (38 cm) reflecting telescope to form a 3 in (7.5 cm) wide image of the moon.

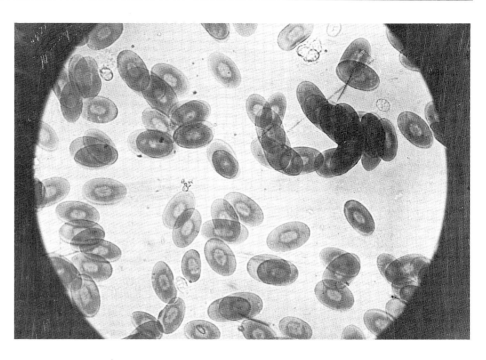

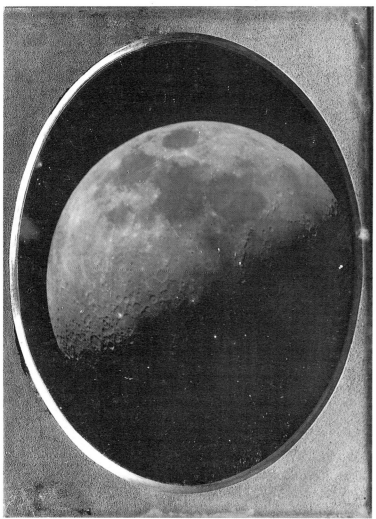

end to the prospect of scientific research which photography has opened out'. Talbot was as perceptive as ever but, in this area at least, he was not alone. Much of a scientist's work involves painstaking observation, and it was immediately recognized that photography had the potential to be an invaluable aid to the information-gathering, recording, storing and analysing process. The first serious application of photography to scientific publication was probably Anna Atkins' privately printed *British Algae: Cyanotype Impressions*, produced in parts between 1843 and 1853. The images were contact impressions, produced in what later became known as the 'blueprint' process which was invented by Sir John Herschel in 1842. Photography quickly revolutionized the study of the infinitely small and the infinitely far away. Talbot's first views through a microscope were done in the 1830s before he had made camera photographs. Several early daguerreotypists also made photomicrographs of surprisingly high quality. Particularly notable was the work of the French scientist Alfred Donne who was able to show detailed views of the eye of a fly in 1839. By 1844, in association with Leon Foucault, he was making daguerreotype plates of blood cells and similar structures

for use as the basis of illustrations for an atlas of microscopic anatomy. The first photographs of the moon through a telescope were made as early as 1840 by Professor Draper at New York University. In 1842 he made a daguerreotype of the spectrum of the sun, a plate that survives to the present day. Several photographers made daguerreotypes of both lunar and solar eclipses during the 1840s. The basis of much of modern scientific photography was established in photography's first decade. Microscopical and astronomical investigation in particular was transformed by the invention of the new art.

As the 1840s progressed, the public began to come to terms with photography, to appreciate that it was able to represent the world around them with a verisimilitude that previous generations had not enjoyed. Photography began to be widely used to copy works of art and was a major factor in the popularization of art in the nineteenth century. The great debate as to whether photography was itself an art had already begun and the battle lines were firmly drawn. By the end of the 1840s photography was becoming more organized. The first photographic clubs were already formed and there was a growing number of people, albeit from a restricted, privileged section of society, who were practising photography as a hobby. Professional photographic portrait studios were to be found in most major towns, and the seeds of a new industry were evident as certain instrument makers and chemists began to specialize as photographic equipment manufacturers and dealers. Apparatus generally was becoming more sophisticated: lenses were being designed specifically for photography, but the typical camera still bore a close physical resemblance to the pre-photographic camera obscura. After the rapid improvements of 1840, technical development was steady rather than spectacular. Several new processes were devised, but few offered any real advantages over the processes devised by Daguerre and Talbot. The typical photographs of the 1840s were therefore the finely detailed daguerreotype images on metal favoured by the professional portrait photographer, and the coarser calotype images on paper used by most amateurs or where many duplicates were required.

The invention of photography had taken place in a world of change and uncertainty. Although not fully appreciated at the time, the USA was fast becoming a serious industrial and technological rival to Europe in general and Britain in particular. Fine quality goods were still imported from Europe in large quantities, but there was a tremendous increase in the production and consumption of all manufactured goods as the population trebled between 1815 and 1850. It was during this period that America first became prominent in the production of labour-saving devices, and there was a widespread interest in new mechanical and technical 'gadgets'. The opening-up of the continent stimulated such a tremendous interest in communications that in the first decade of railways (1830s) more track was laid in America than in the whole of Europe. On the rivers it was calculated that a larger tonnage of steamers was employed than in the whole of the British Empire.

In England there was a genuine fear of revolution. If one set of symbols of the age was steam power and new factories, another was riots and the workhouse. Great wealth and raw energy existed alongside abject poverty and social unrest. Against this background photography survived and even thrived. Talbot was a great influence during the decade. In 1844 he wrote, 'the Art can hardly be said to have advanced beyond its infancy.' Six years later that was still the case, but Talbot had no doubt that the infant was healthy and had a secure future. By 1850 he had already begun the work which was to evolve into the first practicable system of photo-engraving, and within a year he was to make the first high-speed flash photograph. The new decade was to be a turning point for Britain and for photography. A rapidly growing economy was to spread a new confidence through society as the grey years of 'the hungry forties' were left behind. And technical innovation in England was to bring a new

RIGHT The delicate silver surface of the daguerreotype plate was easily damaged, so plates were mounted in protective frames. Some were highly elaborate and decorative, and many featured a hinged lid lined with dark velvet. This made the image much easier to view, because the plate could be angled so that the highly polished shadow areas reflected the dark lid lining; highlight areas then appeared paler by comparison. When the plate reflected a light surface, the tones appeared reversed, and the viewer saw a dim negative.

BELOW RIGHT Early calotype cameras were simple boxes —the familiar bellows did not appear until later. This 1850 example, fitted with a lens made by British optician Andrew Ross, is especially interesting in that the camera has a primitive 'rising front' movement. This enabled the photographer to raise the image on the plate, so as to include the tops of tall buildings without tilting the camera, and thus ensure that parallel lines in the subject did not converge on the print.

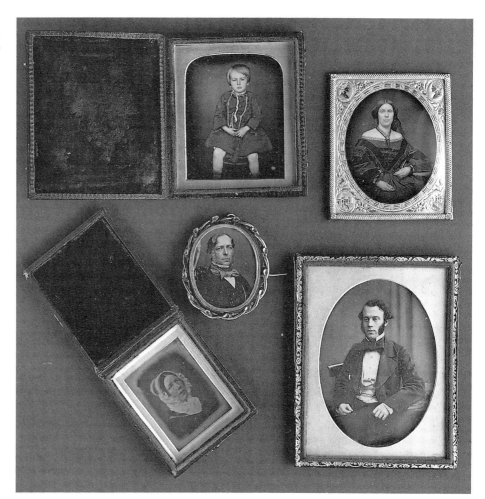

OPPOSITE The Victorian public thirsted for glimpses of the wealthy, the famous and the bizarre—and the producers of *cartes-de-visite* were happy to oblige.

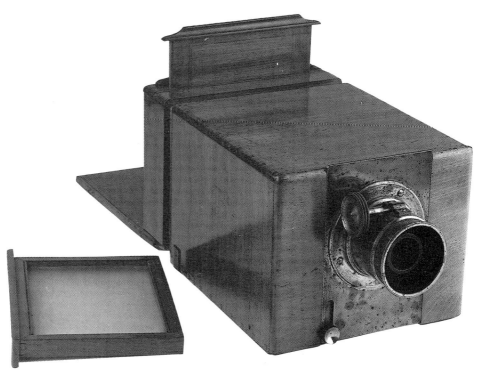

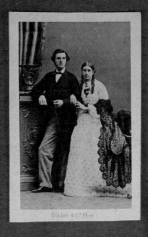

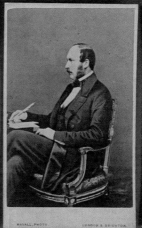

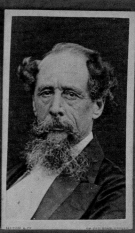

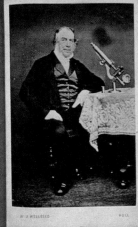

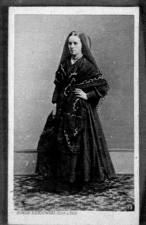

King Tom

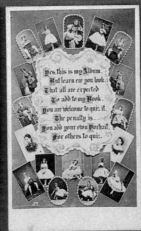

Yes, this is my Album.
But learn ere you look.
That all are expected
To add to my Book.
You are welcome to look it.
The penalty is.
You add your own Portrait.
For others to quiz.

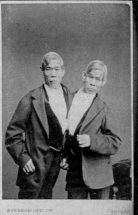

Dryburgh Abbey—From the Refectory.
G. W. Wilson, No. 846. Aberdeen

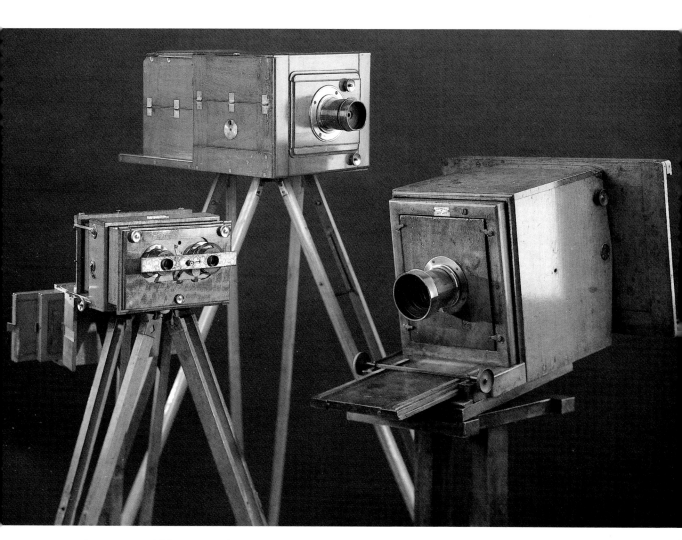

ABOVE (LEFT TO RIGHT) The Tourist Binocular camera of the 1860s, for use with albumen-on-glass dry plate negatives; a folding sliding-box camera of 1853, similar to that used by Lewis Carroll; and a typical studio camera of the mid-1860s, designed to take two images on a single plate. RIGHT Stereoscopes of the 1850s and '60s varied in their degree of elaboration and decoration. The large box-shaped model held up to 100 views on an endless belt.

OPPOSITE In an attempt to satisfy burgeoning demand for stereo cards, photographers turned their cameras on a tremendous range of subject matter. Landscapes and genre were enduring favourites but staged tableaux were also popular.

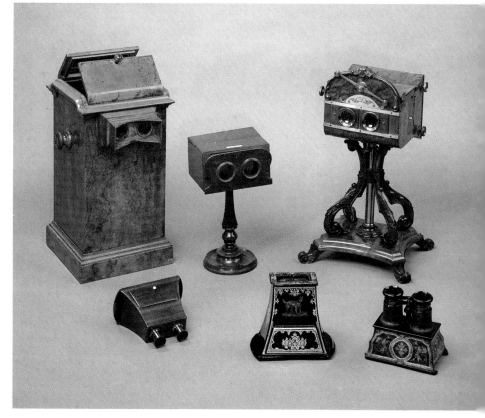

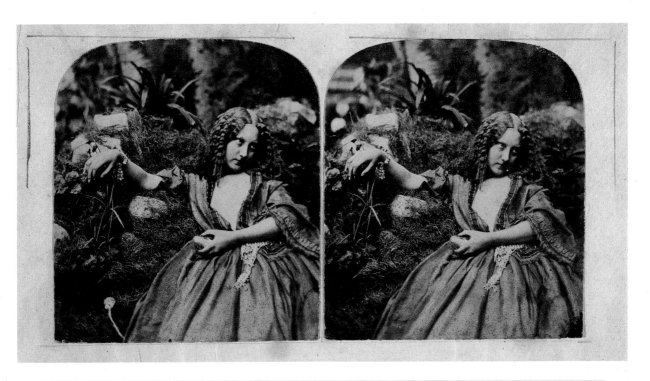

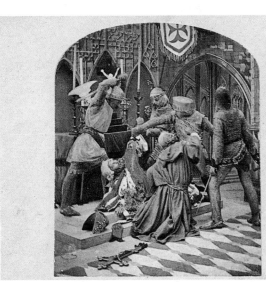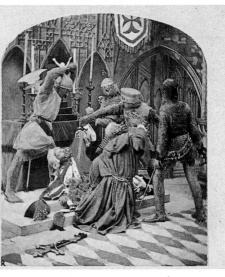

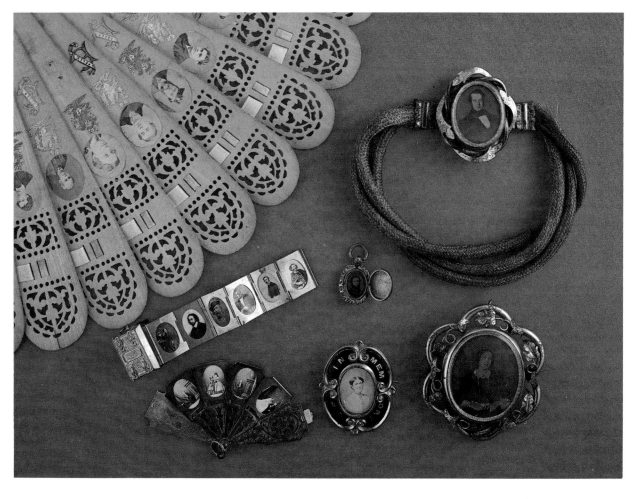

ABOVE Miniature photographs were incorporated as decoration in all manner of everyday objects—much as miniature paintings had been in earlier times.

BELOW LEFT The early Kodak cameras were so compact and easy to use that for the first time photography could simply be an integral and convenient part of a family day out—rather than the prime motive for an elaborate expedition.

BELOW RIGHT Brownie cameras were as foolproof as nineteenth-century technology could make them. Everything appeared sharp from about 1.5 m (5 ft) to the far distance, so the photographer could move close enough to frame quite small subjects such as this dog.

Save your happy
memories with a
Kodak

The Kodak girl advertised Kodak cameras in Britain over a period of three decades.

Advertisements for cameras, plates and papers were created by leading artists.

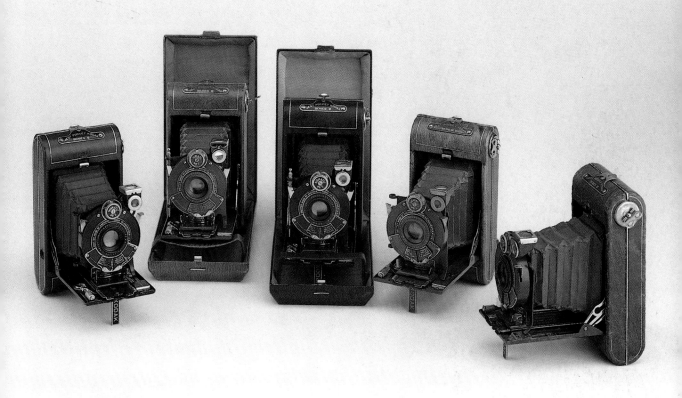

ABOVE In the late 1920s and early '30s, many cameras were manufactured in a choice of colours, in a direct move to attract the fashion-conscious female buyer to the camera as an accessory. The Vanity Kodak Ensemble consisted of a coloured Vest Pocket Kodak camera, with matching coloured case, and co-ordinated lipstick holder, compact, mirror and change pocket. The experiment was not entirely successful, because colours are so subject to fashion whims—dealers ended up with piles of unsaleable cameras in unpopular colours.

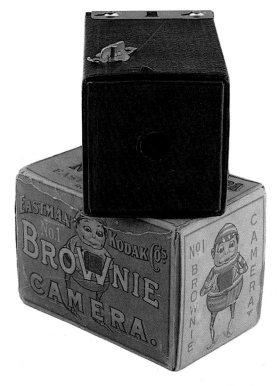

LEFT With the Brownie camera, Eastman produced a camera designed to a low price. The camera was literally a cardboard box with a wooden end, yet it took perfectly good photographs.

39

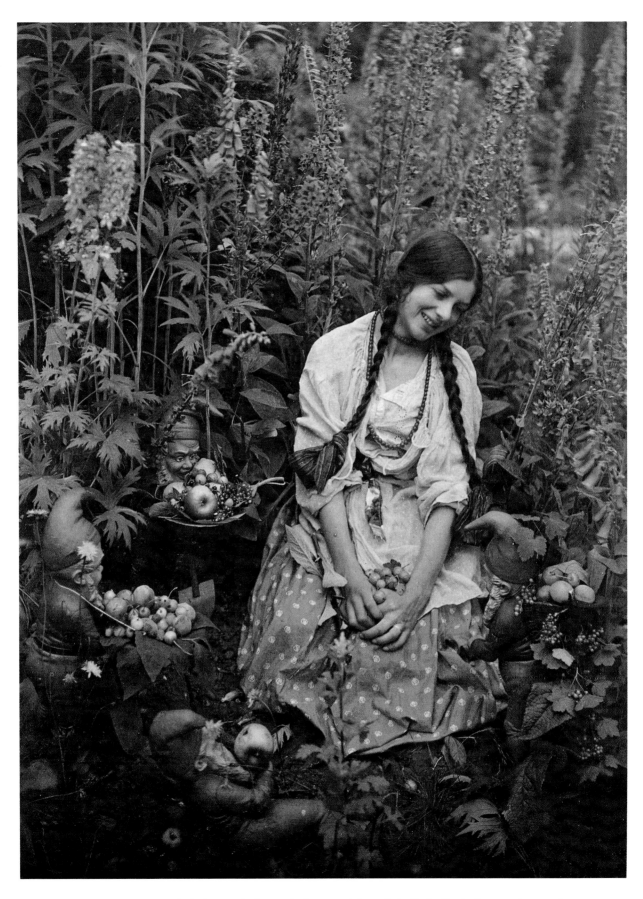

Autochromes had a particular appeal for artistically inclined photographers, and are reminiscent of French pointillist paintings. This beautiful portrait by the well-known amateur photographer, Mrs G.A. Barton, called *Old Familiar Flowers* (1919), has a typically painterly feel.

process to photography which combined the best qualities of the two major pioneering processes with a shorter exposure time than either. During the 1840s photography had been enthusiastically received by the informed and fashion-conscious, but for great masses of the population it remained a novelty, one of the many new wonders of an innovative age. All this was to change in the 1850s when photography would be brought before a wider public than ever before. Talbot's infant was to grow into one of the most powerful tools of civilized man.

This curiously-shaped camera for the daguerreotype process was introduced by Vöigtlander in 1841. The focusing screen was positioned at the fattest part of the camera, and there was a magnifier in the shorter of the two cones to aid focusing. Once the picture was sharp, the photographer had to go into the darkroom, and swap the focusing screen for a daguerreotype plate; to maintain sharpness, a special cradle ensured that the camera was replaced with the plate in precisely the same position.

Photography and the Mass Market

'Wherever in our fashionable streets we see a crowd congregated before a shop window there for certain a like number of notables are staring back at the crowd in the shape of *cartes-de-visite* . . .'

(*Once a Week*)

*I*n 1862, when Andrew Wynter wrote this comment on the public frenzy for tiny photographic portraits, photography was not yet a quarter of a century old. Yet it had already become big business. Many uses had been —or were about to be—discovered, among them news coverage, military campaigns, map-making, criminal records, even psychiatry. But it was the public's thirst for

pictures of themselves, their peers and their environment that was most ripe for exploitation. That demand was to be satisfied by a new industry, whose inventiveness, entrepreneurial skill and hard work introduced all sorts of photographic paraphernalia: the *carte-de-visite*, the stereograph, the travel view and, later, the photographic lantern slide were to be the most successful.

The confident Victorians of the third quarter of the nineteenth century luxuriated in their world supremacy. The landed gentry had lost some of its grip on the country when the protectionist Corn Laws were repealed in 1846, and the gradual shift of power to industrialists and city administrators strengthened Britain's industrial position.

Under Prince Albert's enthusiastic guidance, one exceptional event was to reflect the spirit of this new manufacturing age: The Great Exhibition of the Industry of All Nations opened in May 1851 at the Crystal Palace in Hyde Park, London. Queen Victoria wrote to her uncle, King Leopold of the Belgians:

. . . I wish you could have witnessed the 1st May 1851, the *greatest* day in our history, the most *beautiful* and *imposing* and *touching* spectacle ever seen, and the triumph of my beloved Albert. Truly it was astonishing, a fairy scene . . .

Both Queen Victoria and her husband Prince Albert were early and enthusiastic devotees of the new process of photography, and their approval must have contributed greatly to its growing popularity in the 1850s and '60s. In May 1860, they commissioned Yorkshire-born photographer J.E. Mayall to make a series of *cartes-de-visite* (miniature portraits) of them. They were assembled in a book, *Royal Album*; but the individual *cartes-de-visite* were the real success. These first pictures of royalty made available to the public sold in large numbers. Before long *cartes* of all kinds of celebrities, such as President Lincoln, General Grant, Sarah Bernhardt and Adelina Patti, were being published.

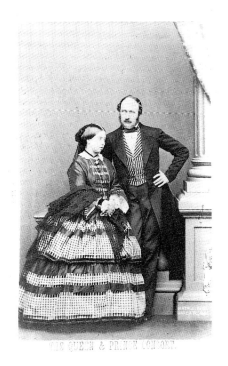

THE QUEEN & PRINCE CONSORT

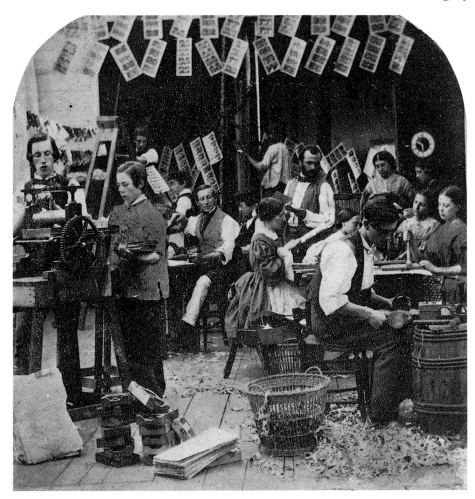

As photographs became ever more popular in the mid-nineteenth century, so operators were established all over Europe and North America. In Paris, the number of photographic establishments rose tenfold between 1850 and 1870; in Britain and the United States, the growth was, if anything, more rapid still. This is a studio photograph set up to illustrate the production of stereo cards.

BELOW The Great Exhibition in London of 1851 revealed just how far photography had advanced in its short life. On display in the Crystal Palace were many fine daguerreotypes, calotypes and stereo views. No better indication of the progress photography had made was the fact that it could be used to record the great event in the official reports.

The exhibition's four sections—Raw Material, Machinery, Manufacturers and Fine Arts—were intended to reflect every area of human endeavour, and contained 109,000 exhibits. Slightly less than half the exhibitors came from non-colonial countries, and the forecasts that British interests would be swamped proved to be unnecessarily pessimistic. Soon after the opening, the entry fee was lowered to one shilling (5p) and there were over six million visitors from all walks of life. Indeed, after the labour strife of the hungry forties, the press acknowledged the working classes as 'the men who made the Exhibition what it is and who, we hope, will derive the greatest advantage from it'.

The Great Exhibition was an incredible success, the father of scores of future international exhibitions and world's fairs and, incidentally, still one of the few

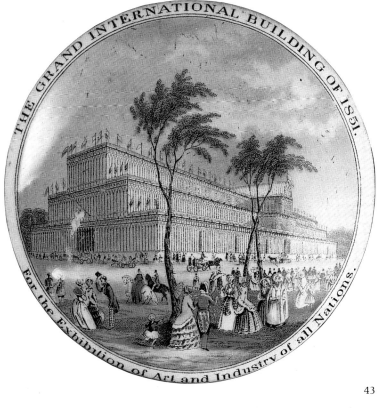

Shown here are two of the 155 pictures of the 1851 Exhibition published the following year in the four volumes of 'Reports by the Juries'. The picture of the large anchor is a print from a paper negative by Hugh Owen; the Glass Fountain is by Claude Marie Ferrier. For British photographers, however, the Exhibition had a deeper significance, for it showed just how far they had fallen behind the Americans in daguerreotyping and the French in calotyping. This spurred a group of British photographers into action and, little more than a year later, they formed the first British photographic society, the Photographic Society of London.

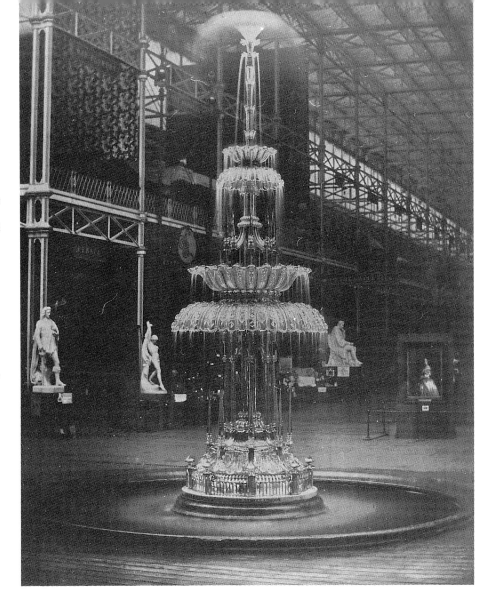

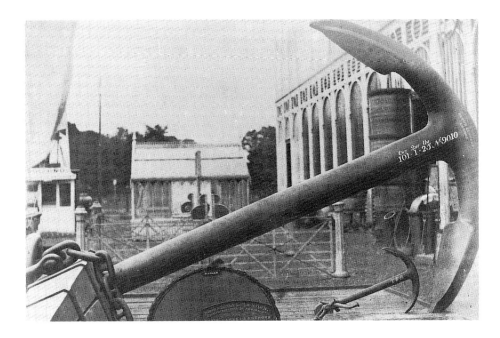

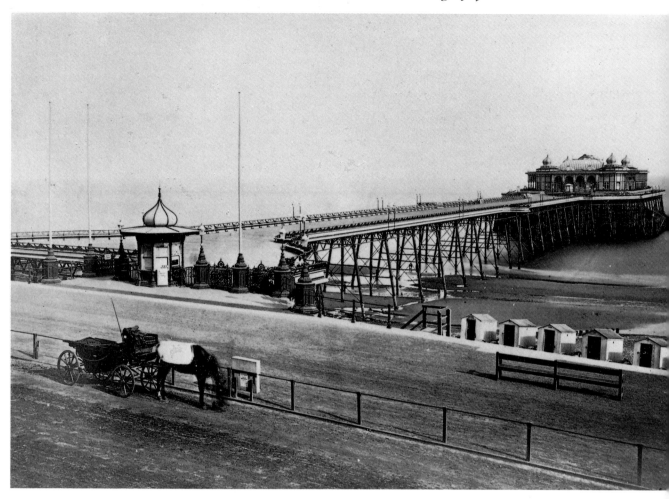

which has made a financial profit. Most importantly, it heralded the beginning of mass-production techniques, nowhere more clearly demonstrated than by Joseph Paxton's magnificent Crystal Palace itself, a marvellously organized 'kit-built' framework designed to accommodate 300,000 glass plates of uniform shape and size.

Photography's role in the Great Exhibition was twofold. First, it gave many the opportunity to see just how far equipment and pictures had progressed. Queen Victoria's fascination with Sir David Brewster's lenticular stereoscope, with its convincing illusion of three dimensions, and the Prince Consort's admiration of the daguerrotypes of the exhibition taken by J.E. Mayall, who lived in America, were to have profound effects. American influence in the photography exhibits was strong, and was indicative of the extent to

which the daguerreotype had become popularized in the US. American exhibitors took all three daguerreotype awards, with Mathew Brady receiving a prize medal for forty-eight uncoloured daguerreotypes. The jury also noted that two large portraits, each $12\frac{1}{2} \times 10\frac{1}{2}$ in (32×27 cm) were 'throughout, perfectly in focus'. It was machine-polishing of the American daguerreotype plates that contributed both to their mass production, and to their technical superiority: the English photographer John Werge commented on seeing the exhibit that the American plates lacked the buff-marks that marred the (hand-polished) British contributions. But few of those who saw the daguerreotypes and talbotypes in the Crystal Palace could have foreseen how their long exposures and labour-intensive methods would soon be streamlined into a profitable mass market product.

For almost forty years, the vast majority of photographic prints were made on albumen paper, invented in 1850 by Blanquart-Evrard, head of the photographic printing works in Lille. This print of Hastings Pier in southern England (*c.*1880) demonstrates the fine detail and good tonal range that was possible in this process.

The invention of the collodion process by Frederick Scott Archer in 1851 was a significant step forward in photography, for the use of a glass plate gave a crisp and clear image. Yet it was based on the negative/positive process like Fox Talbot's calotypes, so the negative could be used for repeat prints. One adaptation of the collodion process was the Ambrotype, a direct positive. The whole process was so quick that portraits could be taken and a finished print given to the sitter in a matter of minutes. To make a positive, the glass negative was slightly underexposed, then mounted in a frame on a black background of varnish, paper or cloth so that dark areas of the negative appeared light and vice versa. Here an ambrotype (a type of collodion positive briefly popular in America) has been separated to show how the two components, negative and background mount, combine to give the final positive image.

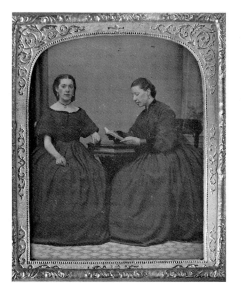

The second role of photography was to record the spectacular event for posterity. Hugh Owen and C. M. Ferrier were commissioned to take photographs for inclusion in the official catalogue, *Reports by the Jurors*. Both used the negative/positive process, the final contact prints from their negatives being made at Talbot's Reading establishment by Nikolaas Henneman. Owen took paper negatives by Talbot's process, whereas the Frenchman Ferrier used the new albumen-coated glass plates. Glass, being a far more transparent and durable base than paper, was to be crucial in improving photography, but the problem had always been how to make the light-sensitive chemicals adhere to its slippery surface. Albumen (egg white) solved the problem and was first used for glass negatives in France in 1847 by Abel Niépce de St Victor. In 1849, L. D. Blanquart-Evrard used it for positive paper prints.

A thin layer of sensitized albumen gave very high resolution, and albumen negatives and prints combined the fine detail of daguerreotypes with the multiple print-making ability of the talbotype. But there were drawbacks: albumen's slow reaction to light made it unsuitable for negatives where short exposure times were vital, especially for portraits. A faster and more practical glass negative process was needed, and it was pioneered in England.

Frederick Scott Archer published his article 'On the Use of Collodion in Photography' in the March 1851 issue of *The Chemist*. Collodion, used for dressing wounds, was a pale yellow or colourless liquid made by dissolving gun cotton in equal parts of ether and alcohol; its name comes from the Greek *kolla* ('glue') and Archer used it literally as the glue to bind chemicals to the surface of the glass plate. Foreseeing several photographic uses for it, he believed its main benefit would be that, once the negative had been exposed, the pliable collodion could be floated off the glass 'to be fixed at some more convenient time. Thus one piece of glass will be sufficient to make any number of drawings . . .' In practice, the collodion film was left, safely protected, on the glass plate.

The main steps in making a collodion negative each called for great skill and care in their manipulation:

1 Polishing.
2 Covering with a thin coat of collodion and potassium iodide, and draining off the excess.
3 Sensitizing (in the darkroom) in a bath of silver-nitrate until it turned yellow.
4 Mounting (while still wet) in a dark slide.
5 Exposing in the camera by uncapping the lens for a measured time.
6 Removing from the dark slide (in the darkroom) and developing in pyrogallic acid.
7 Rinsing the developed negative in clean water.
8 Fixing in 'hypo' (hyposulphite of soda).
9 Washing thoroughly in running water.

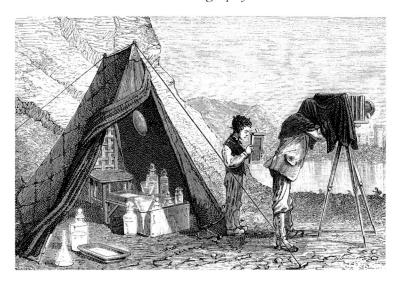

10 Drying.
11 Finally (and optionally) varnishing to protect the emulsion.

All this called for a strong constitution to withstand the noxious fumes and to heave

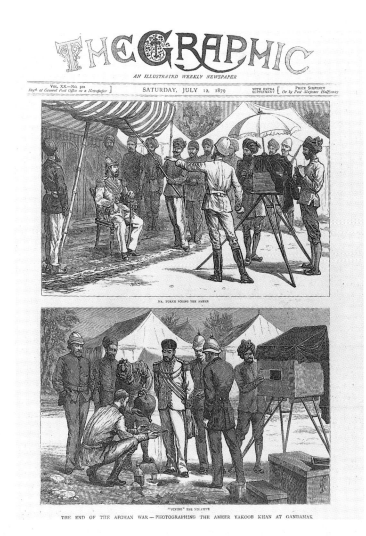

MR. BURKE POSING THE AMEER

"FIXING" THE NEGATIVE

THE END OF THE AFGHAN WAR — PHOTOGRAPHING THE AMEER YAKOOB KHAN AT GANDAMAK

THE GRAPHIC

AN ILLUSTRATED WEEKLY NEWSPAPER

Vol. XX.—No. 502
Reg⁴ at General Post Office as a Newspaper] SATURDAY, JULY 12, 1879 WITH EXTRA SUPPLEMENT [PRICE SIXPENCE *Or by Post Sixpence Halfpenny*

The fascinating glimpses of exotic and far-away places that photographs gave sent photographers all over the world in search of suitable subjects. But the amount of equipment that the photographer had to carry with him on his travels was enormous (ABOVE), and much of it was highly fragile. Many a curse must have been uttered as a valuable glass plate shattered on the rough roads of the time. The wet collodion process, in particular, meant carrying around one heavy glass plate for each picture and a massive array of dangerous and volatile chemicals—not to mention bulky camera and tripod. The problem with this process was that each plate had to be sensitized and developed on the spot, within minutes of the picture being taken. These engravings (LEFT) from *The Graphic* of 12 July 1879 show the trials of an intrepid photographer using the wet collodion process to photograph the Ameer Yakoob Khan at the end of the Afghan War.

ABOVE Another development of the collodion process which caught on in America in particular was the tintype, in which the collodion was coated on black enamelled tinplate. The process was incredibly quick—and cheap.

OPPOSITE ABOVE Increasing simplification of the photographic process opened the way to cheap portrait photography. Crude makeshift studios opened even in the mirkiest parts of London. This shows the 'saloon' of one back-street operator from Henry Mayhew's famous survey of the London poor.

OPPOSITE BELOW In a better-class studio, elaborate backgrounds were provided to convey dignity. This engraving of a studio in Paris shows a range of equipment, such as neck-clamps for holding the subject's head steady during long exposures, and, on the floor, a multi-lens *carte-de-visite* camera with the back open to reveal the four picture apertures.

around the bulky camera, tripods, chemicals, glass plates, etc. Yet photographers found it all worthwhile to achieve those few vital seconds'—or even minutes'—reduction in exposure time. Fox Talbot claimed that the new process infringed his own, but he lost his case in 1853, and wet collodion photography was available to all. Albumen prints, contact printed from wet collodion glass negatives, became the mainstay of the photographic industry for nearly four decades.

In 1852, Scott Archer proposed producing collodion positives by backing underexposed glass negatives with black varnish, paper or cloth, making its dark areas appear light and vice versa. Collodion positives were particularly suitable for portraits, being cheap (about one shilling or 25c for the standard size) and quick—finished portraits normally being handed to the sitter within minutes. Two years later, James Cutting, of Boston, Massachusetts, patented a variant in which the cover glass was sealed to the plate with Canada Balsam. Another American, the daguerreotypist Marcus Root of Philadelphia, named it the 'Ambrotype' (from the Greek *ambrotos* = 'immortal').

Another American development was the 'Union' case. Patented in 1854 by another daguerreotypist, Samuel Peck, this was made of an easily moulded compound of shellac and sawdust, an early form of plastic. Many hundreds of pictorial and geometric designs were registered. Standard daguerreotype cases and frames were also used for collodion positives, as were lockets and brooches, intended to carry a likeness of the wearer's nearest and dearest.

The collodion positive evolved into the even less expensive ferrotype (popularly known as the 'tintype'), in which a black-enamelled tin plate replaced the glass as a support. It could be cut to size, coated, exposed, processed and handed back to the customer within a minute or so. Tintypes, with some improvements, remained in use with beach photographers, and others, for almost a century.

However, as the photographic historian Robert Taft comments, 'the tintype for many years remained a distinctly American form of photograph'. Part of the reason for this lay in its robustness compared to the fragile glass of the ambrotype. In the rough and tumble of the frontier, resilience was a great asset in both men and photographs, and the Civil War only served to emphasize further the tintype's strong points:

Decidedly, one of the institutions of our army is the travelling portrait gallery. A camp is hardly pitched before one of the omnipresent artists in collodion and amber-bead varnish drives up his two-horse wagon, pitches his canvas gallery, and unpacks his chemicals. Our army here is now so large that quite a company of these gentlemen have gathered about us. The amount of business they find is remarkable. Their tents are thronged from morning to night, and while the day lasteth, their golden harvest runs on . . . They have followed the army for more than a year, and taken the Lord only knows how many thousand portraits. In one day since they came here, they took in one of the galleries, so I am told, 160-odd pictures at $1 (on which the net profit was probably ninety-five cents). If anyone knows an easier and better way of making money than that, the public should know it.

By the late 1850s, cheap collodion positives, on glass and tin, were encouraging a new, unskilled breed of photographer, armed only with a £5/$25 camera and a lot of confidence. Henry Mayhew quoted the experiences of one such in his *London Labour and the London Poor*:

I never knew anything about taking portraits then, though they showed me when I bought the apparatus (but that was as good as nothing, for it takes months to learn). But I had cards ready printed to put in the window before I bought the apparatus. The very next day I had the camera, I had a customer before I had even tried it, so I tried it on him, and gave him a black picture (for I didn't know how to make the portrait, and it was all black when I took the glass out), and told him that it would

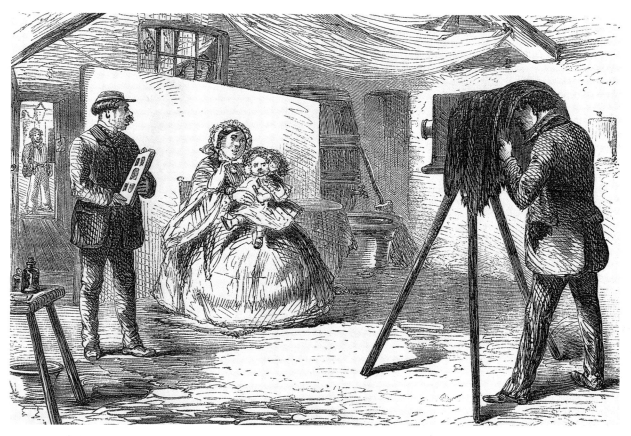

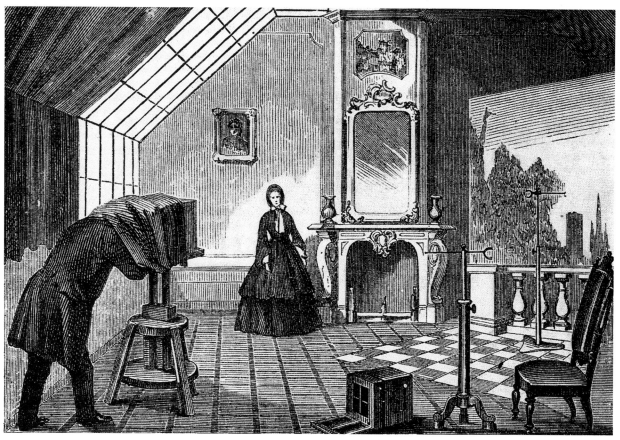

'Cartomania', as the vogue for *carte-de-visite* portraits was dubbed, stimulated a huge upturn in photographic business, and from Berlin to Boston thousands of new studios opened up to meet the demand. Mayall's, who took this set of typical *carte-de-visite* portraits, was just one of 35 studios on London's Regent Street alone. *Cartes-de-visite* all tended to be of a standard size and could be tucked neatly into the cutout openings of the photograph album that became a popular feature of the Victorian home. The four images here are from a contact print on albumen paper made from a single wet collodion negative.

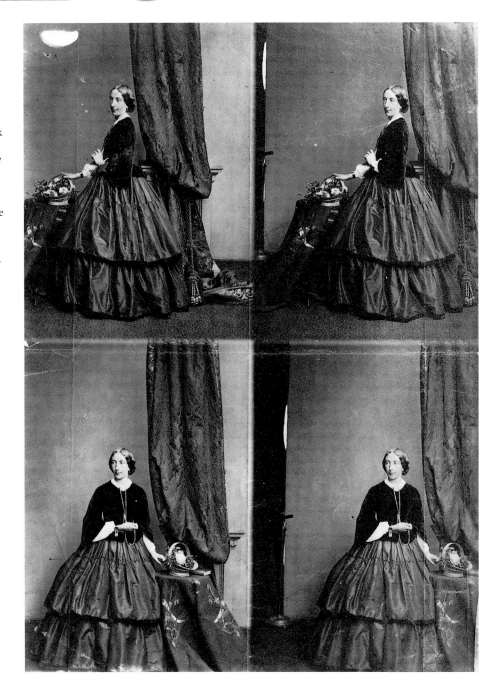

come bright as it dried, and he went away quite delighted. I took the first Sunday after we opened £1 5s 6d, and everybody was quite pleased with their spotted and black pictures, for we still told them they would come out as they dried. But the next week they brought them back to be changed, and I could do them better, and they had middling pictures—for I had picked it up very quick.

Such back-street operators, working in poor neighbourhoods with the bare minimum of equipment, studio props and expertise, hawked their cut-price photographs to innocent passers-by. Though the photographic élite criticized them severely, and *The Photographic News* launched a strong attack on their Sunday operating, they played a major role in publicizing the notion of photographic likenesses. But even their results were,

Grand Mulets, & views of Glaciers.

This beautiful hand-painted setting for a series of alpine and mountaineering views dating from the 1860s shows how much effort was often put in to displaying *cartes-de-visite* in photograph albums. Such 'illumination' was a favourite pastime, often of women, who had the time and inclination to show off their skill as artists.

like all collodion positives, unique images, unsuitable for multiple reproduction. For the next stage, we must cross the Channel again, to France.

On 27 November 1854, the Parisian photographer André Adolphe Eugène Disderi patented the *carte-de-visite* portrait, a small albumen paper positive on a mount the size of a visiting card. It was the mass-production of these small negatives and prints which brought out the true

importance of the fast-exposure glass negative. In the mid-1850s, paper portraits were generally contact-printed from large negatives, usually between $4\frac{1}{2} \times 6\frac{1}{2}$ in (11×15.5 cm)—half plate—and 10×12 in (25×30 cm) in size. This, as Disderi observed, '. . . necessitates manipulations and time which until now have elevated the cost of each print . . .' His system divided the negative into two, four, six eight—and, according to the patent, even

Because *cartes-de-visite* were relatively inexpensive, they brought portraiture within reach of poorer people for the first time. Consequently, surviving *cartes* provide a unique insight into the way our Victorian forebears looked and dressed.

ten—smaller sections, each separately exposed in the camera. All could be contact-printed in the time normally taken for one. At the height of the *carte-de-visite* boom, numerous different cameras were available with repeating backs, multiple lenses, or both, to take advantage of this development.

What actually happened in a *cartes-de-visite* studio in the early 1860s? The following account, though fictional, is drawn from many different descriptions written at the time, and just a little dramatic licence.

Having inspected a number of *cartes-de-visite* of friends taken by Mr D and read some favourable reports, Lady B arrived at his studio at 8.30am for a 9.00am sitting. She had been advised to avoid a midday appointment as the sun's rays directly overhead made it difficult for the photographer to control detail in the light and shade. The receptionist escorted Lady B upstairs to an elegant, well-furnished waiting room where three other customers were awaiting their call. A well-spoken young woman employee in a connecting dressing room suggested Lady B might leave her yellow bonnet and blue shawl, as their tones would reverse in the photograph. Mr D always recommended black silks and satins for the most harmonious picture.

At the allotted time, Lady B was taken up a further flight of stairs to a roof-top studio glazed all around to make full use of sunlight throughout the day. She was amazed by the light and scale of the space, with its array of backdrops, props, reflectors and camera equipment. Mr D, who composed and took all the portraits at his studio, seemed to know instinctively the correct pose and setting; only a lesser photographer would have sought the opinions of his client. Standing before a plain backdrop, with a table bearing a basket of flowers and a drape to her side, Lady B thought how comfortable she felt, remembering the awful false balustrade and gaudy country scene backdrop in her *carte-de-visite* taken last year. This time, a neck clamp was not found necessary.

Mr D disappeared under a black cloth behind his large tripod-mounted, twin-lens camera some 25 feet away. At the same time, he instructed his assistant in the opening and closing of the large window blinds and the positioning of three movable mirror reflectors, directing the right amount of light on to his sitter, monitoring the effects of these operations on the camera's focusing screen. When he was satisfied, his assistant handed him a prepared wet collodion glass plate in a dark slide, which he placed in the camera by removing the focusing screen. Mr D withdrew the dark slide's light trap, asked Lady B to stare at some distant object, and removed the lens caps to make two simultaneous exposures on half of the glass plate. As there was a bright diffused light outside, the exposure was only five seconds; when dull, however, it could have been between fifteen to twenty seconds, and in the winter months more. The lens caps and slide replaced, Lady B's pose and setting were slightly rearranged. Framing, focus and lighting were checked again, and by shifting the slide in the camera's repeating-back upwards, two more exposures were made on the other half of the glass plate. The assistant then removed the light-sealed dark slide to a darkroom for immediate development and fixing. Mr D said goodbye to Lady B, having arranged for the final *cartes* to be ready in a week's time. Lady B trusted him implicitly, and did not see any need to inspect proof copies.

After processing, drying and varnishing, the four-exposure glass plate was identified for the records by scratching a number into the collodion emulsion along one edge. Mr D inspected it for faults, as he was prone to do at each stage in the manufacture of his *cartes-de-visite*—his high reputation depended on it. When he was satisfied, the negative was sent for printing.

The back garden of Mr D's premises had been converted into a veritable factory. In one area stood a large glass house, the back of which was given over to the sensitizing of prepared albumen paper. Yellow glass panels marked this area, filtering the sun's rays to a 'safe light', where albumen paper was floated on to a light-sensitive silver-nitrate bath. The

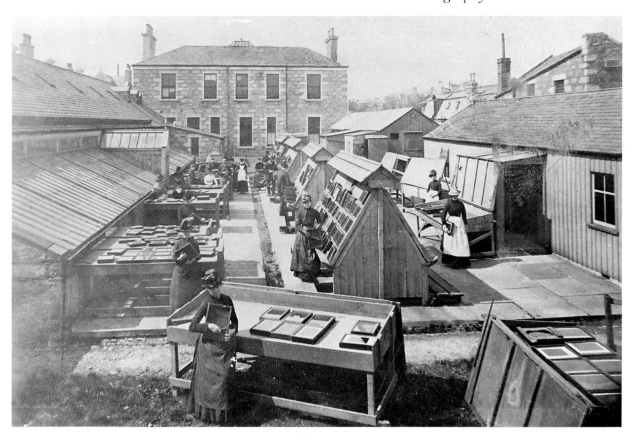

'sensitizers', as they were known, had been busy since 6.00am, trying to keep up the stocks of printing paper, the prepared sheets drying overhead. Also at the sensitizers' table were employees called 'fillers', who took a sheet of dry sensitized printing paper, trimmed it to size and placed it in contact with a glass negative (their respective coated sides face-to-face) and secured them in a frame. Lady B's negative was placed in a frame, collected by a 'carrier', taken out of doors and placed on one of the racks which supported many such frames 'printing out' positive pictures by the sun's rays. In showery weather, the glass house only would be used for printing. Lady B's paper print needed about an hour and was then returned to the 'filler', who replaced it with another sheet of sensitized paper to repeat the printing process. She took Lady B's first contacts to an adjoining shed where in the subdued light other women were busy washing prints over and over again. In between washes they were dipped in a gold-toning bath to improve

the colour from brick red to purple-brown, then fixed in a hyposulphate of soda solution. Mr D constantly emphasized the importance of the toning, fixing and washing procedures, as a carelessly handled final image would fade.

Lady B required forty separate *cartes* and Mr D always liked to have a few file copies, so for her order alone the whole printing operation needed repeating a dozen times. The studio was busy at the time making thousands of *cartes-de-visite*; but many of the thirty-strong work-force were constantly threatened with unemployment, particularly in the winter months, when fewer portraits and prints could be made due to failing light. Their wage was 12 shillings ($3) a week, and less for the women.

Four days later, the dried contact prints of Lady B were passed on to the 'finishing department' in a large shed on the other side of the back garden. As she had not ordered them to be hand-coloured, the prints were trimmed into forty-eight separate pictures, each around $3\frac{1}{2} \times 2\frac{1}{4}$ in

So great was the market for photographs in the third quarter of the nineteenth century that individual photographers and studios set up large factory-like operations where dozens of women would churn out finished topographical photographs by the score. This picture, dating from the 1880s, shows George Washington Wilson's photographic printing, enlarging and publishing works in Aberdeen, which could produce a million or so finished prints a year, mostly of views and landscapes. At any one time, there were up to 1,300 printing frames on the racks in the large exposure yard.

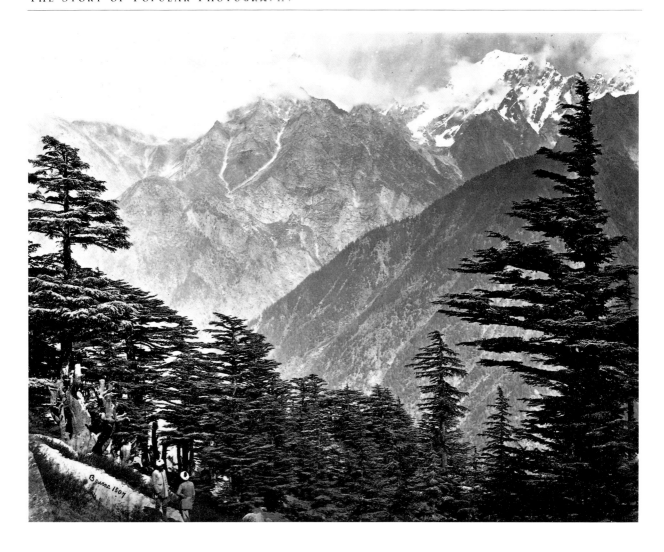

Photography brought the world home to millions of ordinary people who would never have the chance to travel, providing them with a first glimpse of places they had only read about. Faced as we are today with familiar images of exotic places beamed across the world in seconds, it is easy to forget the intense curiosity photographs of faraway lands excited at the time. This Himalayan scene from the 1860s is by Samuel Bourne, a master of large-format landscapes, whose Himalayan views sold well among British officials serving in India. It shows Chini, one of the mountain retreats where the British escaped from the summer heat of the plains.

(8.9 × 5.7 cm). At the day's end all the unwanted trimmings were gathered and burnt, leaving deposits of silver in the ashes, to be reused along with those reclaimed from spent darkroom solutions. Next, Lady B's forty prints were pasted on to 4 × 2½ in (10.2 × 6.3 cm) Bristol boards, with Mr D's business logo on the reverse. When dried out, these were placed on a polished steel plate and pressed in a heavy rolling machine. The eight remaining unmounted photographs were sent to the 'records room' along with the negative, to be indexed and stored in the event of further orders. In the book-keeping office a clerk made out an invoice for Lady B, itemizing forty *cartes-de-visite* at 12 shillings a dozen = £2 ($3 a dozen = $10). In a less high-class establishment, they might have asked for the money first!

The following day Lady B called to

collect her pictures and was most impressed with the results. Her well-set full-length pose was, she felt, very becoming and reflected her station in life. It reminded her of a painted portrait of her dear departed mother. She was so impressed that she ordered another two dozen. Paying her bill, she set off for home, visiting a few of her friends *en route* and of course presenting them with her latest *carte-de-visite*. At home, she added Mr D's offering to her *carte-de-visite* collection of family, friends and celebrities in a purpose-made album.

Lady B, well-known in society circles, later published her memoirs. In consequence, Mr D received an order from a large international photograph retailer to supply 10,000 *cartes-de-visite* of Lady B for a sum of £400 ($2,000) – a lucrative extra!

The story of Mr D and Lady B has introduced us to the parameters of 'up-stairs and downstairs' Victorian life—from the refined waiting room and studio of the terraced house in a fashionable area of town to what was virtually a sweatshop in the back garden. Moreover, we see a highly organized mass-production business trading on its technical expertise, good customer relations, advertising, use of machines, flexible work force earning low wages, quality and quantity control, and recycling procedures, supported by strong consumer demand—the basics of modern industrial practice. This business spread throughout the countries of Europe and America and their colonies; though most were not of Mr D's quality, all fuelled the fever for photography. In Britain alone, hundreds of millions of *cartes-de-visite* were produced and sold during their heyday in the 1860s.

In July 1860, J.E. Mayall, a daguerreo-typist who worked in America and in England, was commissioned to take *cartes-de-visite* of Queen Victoria, Prince Albert and their children. Published in August of that year in the *Royal Album*, they sold in huge numbers as sets and as individual portraits. Soon after Albert's early death in 1861, a commentator wrote:

> . . . no greater tribute to the memory of his late Royal Highness the Prince Consort could have been paid than the fact that within one week from his decease no less than 70,000 of his *cartes-de-visite* were ordered from the house of Marion & Co. of Regent St.

Marion & Co, originally a Paris company, set up business in London and other capital cities, becoming probably the world's largest retailers of *cartes-de-visite*. Their wide range of subjects included celebrities from every walk of life and nation, scenic views, art reproductions, even dogs and cats. All were intended to be mounted with photographs of one's family (taken with equipment probably supplied by Marions in a studio probably equipped by Marions) in a purpose-made album probably sold by Marions. Later, albums were made to take the larger 'Cabinet' cards, suggested by the English-man F. R. Window, who also introduced a sturdy and practical studio camera in the early 1860s.

Cartes-de-visite were by no means the

BELOW LEFT The stereoscope viewer, designed in 1849 by Sir David Brewster (shown here with his design) first made stereo photography a practical reality. When a viewer was exhibited with a set of stereo daguerreotypes at the Great Exhibition in 1851, Queen Victoria ordered one; a few years later, it was estimated that upwards of half a million had been sold.

BELOW RIGHT This mirror stereoscope by Joseph Beck was designed for viewing stereo cards and transparencies, but could be swiftly adapted for stereo book plates by swivelling the hinged slide holders out of the way.

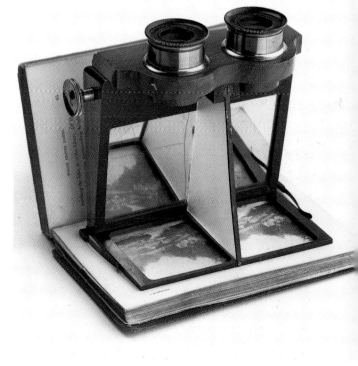

ABOVE Collecting stereo cards became a craze on both sides of the Atlantic. Hardly a middle-class home did not possess a viewer.

BELOW RIGHT Oliver Wendell Holmes found Brewster-type viewers cumbersome so, around 1860, he came up with this compact design. Mass produced by companies such as Joseph L. Bates of Boston, it was a great success in the USA.

OPPOSITE ABOVE C.S. Breese's glass transparency of breaking waves, dating from about 1862, is an ambitious instantaneous stereo shot; the blurring of the waves simply enhances the atmosphere.

OPPOSITE CENTRE The stereo pair of Princes Street in Edinburgh by George Washington Wilson, with even the moving carriages stilled, is one of many 'instantaneous' stereographs that appeared in the late 1850s.

OPPOSITE BELOW This stereo card by leading New York photographers E. & H.T. Anthony depicting 'The Brigade de "Shoe Black", City Hall Park', is one of a series showing various aspects of life in the city around 1860.

only popular product of the expanding photographic industry. It was learning to create and satisfy consumer demand for pictorial records of leisure, amusement, travel, education and the news. And all these kinds of photography benefited from the craze for stereoscopy. At the Great Exhibition of 1851, Queen Victoria was one of many who expressed delight at the three-dimensional effect of a pair of daguerreotypes seen through a binocular viewer on the stand of the French instrument-maker Jules Duboscq. The Scottish scientist Sir David Brewster, its inventor, presented a Duboscq-made viewer to the Queen, and soon they were to be seen in every Victorian parlour.

Brewster later argued that the phenomenon of stereoscopic vision had first been demonstrated in the drawings of the sixteenth-century Florentine artist Jacopo Chementi. But it was only fully understood when the prolific inventor Sir Charles Wheatstone described it to the Royal Society in 1838. Simply, if two flat images are made from viewpoints about the same distance apart as the eyes, and then brought together in a stereoscope (from the Greek *stereos* = 'solid' and *skopein* = 'to look at'), they will appear to be three-dimensional. At first, Wheatstone used drawings, but later paper photographs were placed on two easels

mounted at 45 degrees to each other and fused together on a central mirror prism. Eleven years later, Brewster introduced the concept of his more compact lenticular, or refracting, stereoscope in a paper to the Royal Scottish Society. The earliest examples were made by George Lowden of Dundee, Scotland, and although many designs and improvements were patented, Brewster's basic principle, using reversed half lenses, remained popular throughout the nineteenth century.

At first, Brewster's viewer depended on daguerreotypes, but the reflective problems caused by their silvery surface soon led to the widespread exploitation of paper prints made from glass negatives. One of the first major retailers to take advantage of the new craze, the London Stereoscopic Company, founded in 1854, sold half-a-million viewers in two years with the slogan 'A Stereoscope in Every Home'. At the same time, the number of photographic subjects offered in the company's catalogue of 'Groups and Scenes' grew from 10,000 to a staggering 100,000. The most popular types of picture were paper prints mounted on card, glass transparencies and thin paper or tissue stereographs, the effect of which changed according to whether they were seen by reflected or transmitted light. Hand-colouring was often employed.

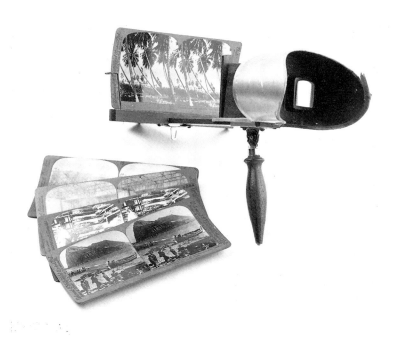

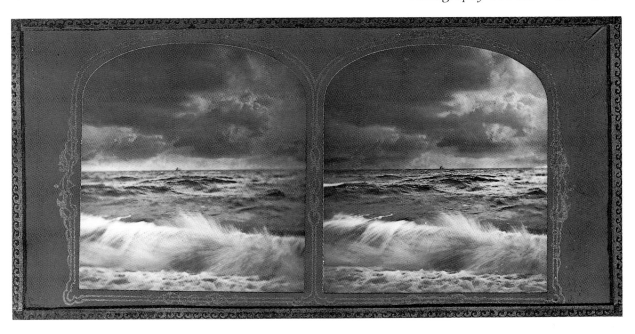

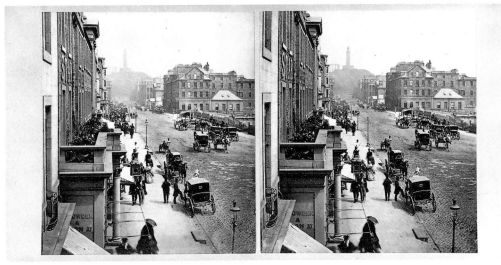

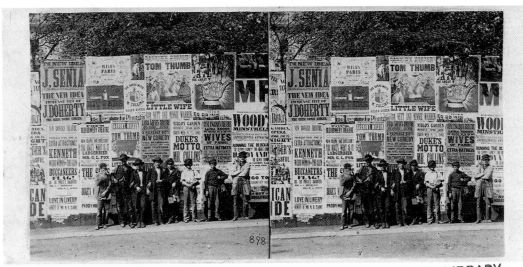

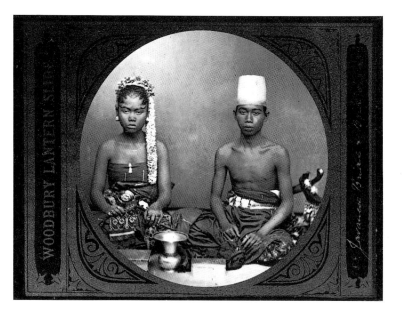

paigns, still lifes and statuary, exhibitions, humorous and moralizing tableaux, circuses, pets and animals, trades and occupations, and so on. One technical innovation was made possible by utilising the potential of this process. 'Instantaneous' photographs were introduced by such photographers as G. Washington Wilson, E. & H.T. Anthony and C.S. Breese. They were an immediate success as they showed, for instance, city workers bustling about their daily business and waves breaking on the shore. And three dimensions certainly heightened the viewer's sense of actually being there.

In Europe, the demand for stereoscopic photographs declined during the 1870s and 1880s, only to be rekindled by the introduction of mass-produced boxed sets imported from the United States and sold with the cheapest and most popular of all the hand-held viewers, the Holmes stereoscope. Throughout the world, unknown lands were being explored, railways were extending frontiers and travel was becoming cheaper. While stereoscopy and other professionally photographed travel views introduced these endeavours and discoveries to home

ABOVE Photographic lantern slides were made as soon as photography on glass became possible, but it was the introduction of bright, easy to operate oil- and gas-lit lantern projectors in the 1870s that made them so popular at home and in public hall alike. Often accompanied by a narrative or commentary, they were steps on the route to motion pictures, and sold in vast numbers—whether it was a series illustrating a popular story or a travel sequence, such as this one by W.R. Woodbury of a Javanese wedding couple. This slide is a 'Woodburytype' in which the image is printed in inks in a press, but most lantern slides were made either by the albumen or the gelatin-silver processes.

RIGHT Throughout the last quarter of the nineteenth century, lantern slide projectors were being constantly improved, making them easier to operate, and giving a brighter, more even light. This advertisement for the Philips New 'Technical' lantern comes from the *Hand Camera and Lantern Review* of December 1892.

The stereoscopic process was best suited to the depth and perspective of topographical scenes rather than the comparatively flat scenario of studio portraits. So the popular stereoscopic pictures tended to be scenes at home and abroad— much the kind of thing one might see on television today. Popular themes included travel and tourist views, city and rural life, industry, wars and military cam-

audiences, they were shown in public halls in the form of lantern slides, providing a link between the development of still photography and the beginnings of motion pictures. Photographs also appeared in such novel guises as books with pasted-in illustrations, reproductions of fine art and fired or transferred onto china. A large substratum of manufacturers and wholesalers evolved to supply specialized equipment and materials for all these applications, creating a demand for chemicals, paper, glass, timber, metal and ceramics. Even chickens became part of the industrial process: in the mid-1860s, it was estimated that six million egg whites were being used each year for the manufacture of photographic albumen paper.

Soon, all this was to change. Dry plate negatives would make exposures shorter, roll films would make cameras more portable and processing laboratories would take over the messy business of developing and printing. Money, leisure time, enthusiasm, patience and sheer strength would no longer be necessary prerequisites for the amateur photographer.

Lantern slides came to be exploited as visual aids for a wide variety of purposes, and many slides were made to accompany Bible-reading sessions. A particularly popular theme was the virtues of abstinence from alcohol, and this photograph for a series of slides illustrating the evils of drink is perhaps typical.

The Rollfilm Revolution

ABOVE The Eastman Walker roll-holder was not the first roll-holder, but it was the first to be manufactured with interchangeable components.

The introduction of the dry plate process brought with it many advantages. Not only was it much more convenient, so that the photographer no longer needed to prepare his materials in advance, but its much greater sensitivity made possible a new generation of cameras. Instantaneous exposures had been possible before, but only with some difficulty and with special equipment and conditions. Now, exposures short enough to permit the camera to be held in the hand were easily achieved. As well as fitting shutters and viewfinders to their conventional stand cameras, manufacturers began to construct smaller cameras intended specifically for hand use.

One of the first designs to be published was Thomas Bolas's 'Detective' camera of 1881. Externally a plain box, quite unlike the folding bellows cameras typical of the period, it could be used unobtrusively. The name caught on, and for the next decade or so almost all hand cameras were called 'Detectives'. Many of the new designs in the 1880s were for magazine cameras, in which a number of dry plates could be pre-loaded and changed one after another following exposure. Although much more convenient than stand cameras, still used by most serious workers, magazine plate cameras were heavy, and required access to a darkroom for loading and processing the plates. This was all changed by a young American bank clerk turned photographic manufacturer, George Eastman, from Rochester, New York.

Eastman had begun to manufacture gelatine dry plates in 1880, being one of the first to do so in America. He soon looked for ways of simplifying photography, believing that many were put off by the complication and messiness. His first step was to develop, with the camera manufacturer William H. Walker, a holder for a long roll of paper negative 'film'. This could be fitted to a standard plate camera and up to forty-eight exposures made before reloading. The combined weight of the paper roll and the holder was far less than the same number of glass plates in their light-tight wooden holders. Although roll-holders had been made as early as the 1850s, none had been very successful because of the limitations of the photographic materials then available. Eastman's rollable paper film was sensitive and gave negatives of good quality; the Eastman-Walker roll-holder was a great success.

The next step was to combine the roll-holder with a small hand camera; Eastman's first design was patented with an employee, F.M. Cossitt, in 1886. It was not a success. Only fifty Eastman detective cameras were made, and they were sold as a lot to a dealer in 1887; the cost was too high and the design too complicated. Eastman set about developing a new model, which was launched in June 1888. It was a small box, containing a roll of paper-based stripping film sufficient for 100 circular exposures $2\frac{1}{2}$ in (6 cm) in diameter. Its operation was simple: set the cylindrical shutter by pulling a string; aim the camera using the V lines impressed in the camera top; press the release button; and turn a key to wind on the film. Since a hundred exposures had to be made, it was important to keep a note of each picture in the memorandum book provided, since

LEFT George Eastman (1854–1932) was the epitome of the American entrepreneur. He was earning a living in a bank by his mid-teens, but soon quit to set up the Eastman Dry Plate company. Though he made breakthroughs in technology, and particularly in mass-production, his greatest contribution to the popularization of photography was a marketing idea. By offering a total package of camera, film and processing, Eastman eliminated at a stroke all the fuss and aggravation that had formerly been associated with photography.

LEFT Eastman's first camera, the Kodak, was very successful, but sold in its original form for less than a year. Eastman was worried at the expense of the camera's ingenious cylindrical metal shutter, which accounted for more than half the manufacturing cost. In a characteristic move, he designed a much simpler and cheaper sector shutter, and in 1889 the No 2 superseded the original Kodak which was then called the No 1.

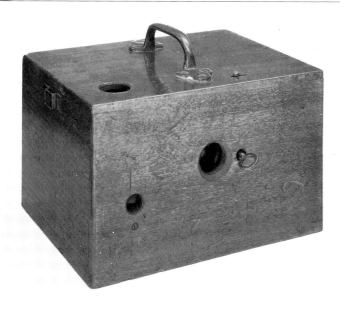

ABOVE LEFT The Stirn 'America' camera of 1888 was the first to be designed exclusively for rollfilm. Despite its name, the Berlin-manufactured camera was sold in England, Germany and Sweden and never in the United States. The America used rolls of Eastman Negative paper, and took 25 pictures, each 3 × 4 in (74 × 102 mm).

ABOVE RIGHT The first rollfilms look little different from those in use today. The celluloid film was backed by a strip of black paper, marked with frame numbers. The first film spools were made of wood; metal replaced the timber core, and today, film is rolled on plastic spools.

there was no exposure counter. Eastman gave his camera the invented name 'Kodak'—which was easily pronounceable in most languages, and had two Ks, which Eastman felt was a firm, uncompromising kind of letter.

The importance of Eastman's new roll-film camera was not that it was the first. There had been several earlier cameras, notably the Stirn 'America', first demonstrated in spring 1887 and on sale from early 1888. This also used a roll of negative paper, and had such refinements as a reflecting viewfinder and an ingenious exposure marker. The real significance of the first Kodak camera was that it was backed up by a developing and printing service. Hitherto, virtually all photographers developed and printed their own pictures. This required the facilities of a darkroom and the time and inclination to handle the necessary chemicals, make the prints and so on. Eastman recognized that not everyone had the resources or the desire to do this. When a customer had made a hundred exposures in the Kodak camera, 'he sent it to Eastman's factory in Rochester (or later Harrow in England) where the film was unloaded, processed and printed, the camera reloaded and returned to the owner. 'You Press the Button, We Do the Rest' ran Eastman's classic marketing slogan; photography had been brought to everyone. Everyone, that is, who could

afford $25 or five guineas for the camera and $10 or two guineas for the developing and printing. A guinea (£1.05, $5) was a week's wages for many at the time, so this simple camera cost the equivalent of hundreds of pounds or dollars today.

In 1889 an improved model with a new shutter design was introduced, and it was called the No 2 Kodak camera. A larger No 2 model was introduced in October. The paper-based stripping film was complicated to manipulate, since the processed negative image had to be stripped from the paper base for printing. At the end of 1889 Eastman launched a new rollfilm on a celluloid base. Clear, tough, transparent and flexible, the new film not only made the roll-film camera fully practical, but provided the raw material for the introduction of cinematography a few years later. Other, larger models were introduced, including several folding versions, one of which took pictures $8\frac{1}{2} \times 6\frac{1}{2}$ in (21.6 × 16.5 cm) in size! Other manufacturers in America and Europe introduced cameras to take the Kodak rollfilms, and other firms began to offer developing and printing services for the benefit of the new breed of photographers.

By September of 1889, over 5,000 Kodak cameras had been sold in the USA, and the company was daily printing 6–7,000 negatives. Holidays and special events created enormous surges in demand for processing: 900 Kodak users

returned their cameras for processing and reloading in the week after the New York centennial celebration.

Despite the enthusiasm of many of Eastman's customers, others had misgivings. The *Weekly Times and Echo* reported in 1893:

> Several decent young men, I hear, are forming a Vigilance Association for the purpose of thrashing the cads with cameras who go about at seaside places taking snapshots of ladies emerging from the deep . . . I wish the new society stout cudgels and much success, and wonder how long it will be before seaside authorities generally take steps to render bathing for both sexes decent, safe and pleasant as it is on the Continent.

Some of Eastman's 1891 range of cameras could be loaded in daylight, by enclosing the film in light-tight card containers with black paper or cloth at each end to protect the film while loading and unloading. This was not very successful, and in 1895 he adopted a system which had been invented by S.N. Turner, of the Boston Camera Manufacturing Company three years earlier. Turner's idea was to attach the film at one end to a longer strip of black paper, on the back of which were printed exposure numbers in white ink. The film and paper backing were wound on to a spool, the ends of which protected the film from light during loading and unloading. A red window on the back of the camera revealed each number in turn as the film was wound on. Turner's Bull's-Eye camera was no great success, but Eastman recognized the potential of the idea, and incorporated it in the Pocket Kodak and No 2 Bullet cameras in 1895. The tiny pocket Kodak camera, which took pictures only $2 \times 1\frac{1}{2}$ in (5×4 cm) in size, was an immediate success, selling over 100,000 at $5 in its first year. In Britain it cost only one guinea, and a twelve exposure rollfilm cost about 50 cents or two shillings (10p) to develop and print.

These two cameras marked a turning point, because they slashed the cost of taking pictures, making photography a more affordable, democratic medium. Eastman soon bought the rival company whose camera had inspired the Bullet camera, and began to sell the No 2 Bull's-Eye camera alongside the Bullet camera. US sales figures for these cheap cameras give some indication of their phenomenal popularity: in 1897 alone the Bull's-Eye and Bullet cameras earned the company $237,000 whereas in the previous half decade, the Kodak camera had generated only $182,500.

Other daylight loading cameras followed, including in 1897 the first of what was to be a very popular range of folding Kodak pocket cameras.

Eastman's advertising stressed the simplicity of the Kodak camera, and the fact that no photographic skills were needed for its operation. Contemporary commentators approved: one remarked that the camera would '. . . bring into the ranks a new class—those who do not wish to devote the time and attention which is necessary to really practise photography, but who desire to obtain records of a tour, or to obtain views for other purposes. Among the latter class will come many artists . . .'

As cameras became easier to use, so they were turned to frame subjects that had not formerly been considered worthy of photography. However, views such as this picture of New York's elevated railway nevertheless contain a wealth of detail about everyday life that is often lacking in the formal, posed masterpieces taken by professional photographers.

By the end of the century, rollfilm photography had become extremely popular. When the Eastman Photographic Materials Company in London held an international exhibition in 1897 for amateur photographs taken with Kodak cameras, over 25,000 entries were received, many of them of a very high standard. The exhibition was international in scope, and the American photographic press did their utmost to whip up enthusiasm for entries. The *American Journal of Photography* remarked:

> The readers of this magazine should enter the lists so that there shall be a large and creditable display from this country, because we know that our friends across the water will take great delight in eclipsing our efforts if at all possible. It is not essential that the amateur do his own developing and printing. He should compose the picture and 'press the button', any one can 'do the rest'.

When the exhibition opened, the London *Daily Telegraph* said:

> Some of the competing pictures are gems . . . but the striking thing is the high average of merit, which means that hand camera photography is far removed from toy-work, and that its influence in training the eye to appreciate points of beauty is greater than those who have never followed it would really appreciate.

Others disagreed. *Anthony's Photographic Bulletin* sniped from New York: 'You jab the jigger and we'll finish the mess', though this view was published by one of Eastman's rivals.

However, the cost of photography was still too high for many, so Eastman asked his camera designer Frank Brownell to create a simple camera which could be mass produced at low cost. Brownell came up with the Brownie camera which was introduced in February 1900. It was a simple card and wood box camera with rotary shutter for time and instantaneous

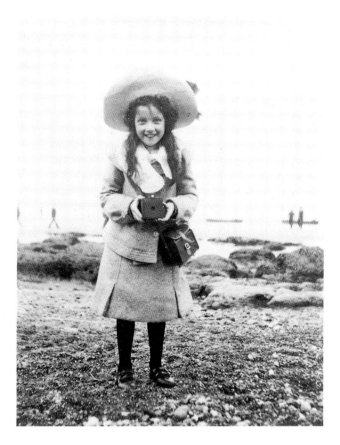

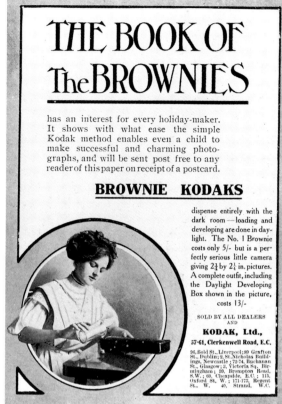

exposures. As with the original Kodak camera, V lines on the top assisted aiming, although a clip-on reflecting finder was soon available as an optional extra. The camera cost only five shillings in the UK and just a dollar in the USA. The name had been chosen to draw on the popularity of the Brownies, little folk featured in the stories by the Canadian author and illustrator Palmer Cox, and immensely popular with children all over the world at the end of the last century. Since the new camera was eminently suitable for children, the choice of name was a clever marketing move. It certainly worked, for over 100,000 Brownie cameras were sold within a year—nearly half of those in Great Britain. Larger models followed, including a range of Folding Brownies, and the Brownie name was used by Kodak for its inexpensive cameras right up to the last Brownie pocket camera in 1980.

Other manufacturers in America and Europe produced rollfilm cameras, many of them close copies of the successful Kodak models, and by the First World

War photography had become a widespread pastime. Significantly, a large proportion of the new generation of photographers were women. There had been, of course, many eminent women photographers in pre-snapshot days, but men were predominant. The simple rollfilm camera changed all that. A Birmingham newspaper reported in the summer of 1905:

> Thousands of Birmingham girls are scattered about the holiday resorts of Britain . . . and a very large percentage of them are armed with cameras, mainly, of course, of the hand variety. The girls snapshot their sweethearts, the young married women take their young hopefuls . . . It is as much a feminine as a masculine hobby nowadays.

Eastman had recognized from the beginning that women were important potential camera users, and almost all the advertising for Kodak cameras showed women with cameras. On 22 April 1910 a

ABOVE LEFT The first box cameras had no viewfinder as such: this youthful photographer is simply aiming the camera approximately in the direction of the subject!

ABOVE RIGHT By 1900, when the Brownie camera was launched, George Eastman had clearly decided that the future for his business lay in constant and growing sales of film rather than cameras. A camera was a natural prerequisite for film consumption, but was itself a once-only purchase.

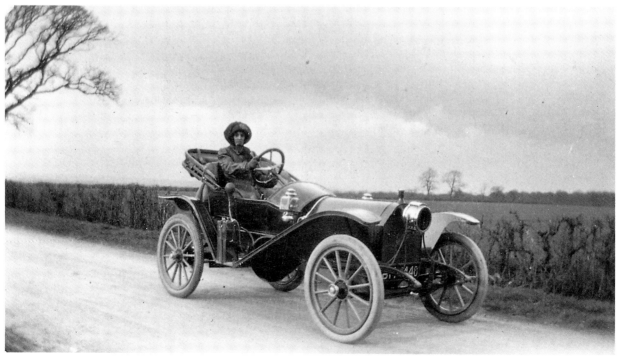

OPPOSITE The Pocket Camera was the first Kodak camera to use rollfilm backed with a light-tight paper strip. Though the camera would not be described as pocket-sized by today's standards, it was a good deal more portable than its predecessors, as photographers were quick to realize. One used a Pocket Kodak to snap this wayward railway locomotive at Montparnasse Station, Paris, in 1895.

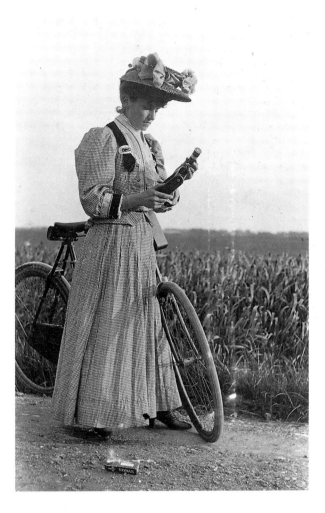

This young lady has not, as would appear, ignored the instructions on the film packet to change rolls in the shade. She was photographed for advertising purposes, and has therefore deliberately broken the rules.

OPPOSITE BELOW Wealthy middle-class photographers used Pocket Kodaks to record the trappings of an extravagant life-style. However, even in 1912 when the camera was launched, the prospect of war threatened to change the social structure for ever.

Unlike today's cameras, which are held at eye level, most of the early popular cameras were held at waist level. The low viewpoint emphasizes the dignity and bearing of this old man with his weighing chair.

The essence of the Vest (waistcoat) Pocket Kodak (BELOW) was portability—folded, the camera was smaller than many of today's 'compact' cameras. VPK owners made ample use of the camera's advantages, used here at the races.

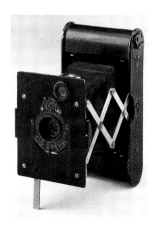

new Kodak Ltd poster was launched, drawn by the leading poster artist John Hassell, featuring the Kodak Girl in a long striped dress. It was an immediate success, and for the next four decades the Kodak Girl in her distinctive striped dress formed the central motif of Kodak advertising. Many of the early designs were by Fred Pegram, 'noted for the beauty of his drawing and the sweetness of his feminine types', said the Kodak Trade Circular.

New Kodak camera designs appeared every year, one of the most successful being launched in 1912. The Vest Pocket Kodak camera was a very compact shape when closed; the lens pulled out on lazy-tong struts. It took a newly introduced film—127—on a compact all-metal spool, giving $2\frac{1}{2} \times 1\frac{5}{8}$ in (6.5 × 4.0 cm) pictures. The VPK, as it became known, was the most popular camera of its day. By the

time it was discontinued in the mid-1920s, some two million had been sold. Many were bought by soldiers during the First World War—sales in 1915 were five times that of the previous year. Indeed, photographic sales of all kinds boomed at that time, until shortages of raw materials and import restrictions dried up supplies. The YMCA ran a scheme by which camera owners photographed families of serving men free of charge, so that snapshots could be sent to the front line.

A new range of Kodak cameras was launched in 1914 incorporating a major innovation, invented by Henry Gaisman. The Autographic Kodak cameras had a hinged flap in the back which, when opened, uncovered the backing paper of the special Autographic film. Pressure on this with a metal stylus provided caused a kind of carbon paper tissue between the paper and the film to become transparent

at that point; light filtering through the backing paper exposed the film. It was thus possible to 'write' information which appeared on the film when it was developed. Dates, photographic information, names—anything could be recorded on the film with this first 'data back'. Virtually all the folding Kodak cameras had this feature until the early 1930s, when improved faster films made it impractical. Several special versions of the Autographic Kodak cameras had another innovation—a coupled rangefinder to facilitate accurate focusing.

The war-time boom in photography continued after hostilities ended and cameras and films came back into supply. During the War, many working people had been able to take up photography as factory wages had increased at a greater pace than the prices of cameras and films. The *Kodak Trade Circular* for April 1916 said:

> Now that they have the means people of the working class may well be looked upon as likely buyers. The liking for pictures is as strongly implanted in them as in any other class. It may even be said that many of them are better able to appreciate the Kodak than some of the people who usually buy it. The craftsman who works a high-speed tool and who has to work to very fine measurements is just the right type of man to admire the mechanical excellence of the Kodak . . . If your shop is in or near a working-class neighbourhood, think this over.

In 1922 a photographic dealer in Glasgow, Scotland said that despite 81,000 unemployed:

> The number of working men in and around Glasgow who own and use Kodaks is really extraordinary and the quality of their work very high indeed . . . Not being in a position to waste film they do not take a picture unless it is worth taking and in consequence it is no uncommon thing for a man of this type to obtain ten really fine pictures out of a possible twelve.

In the 1920s, changing economic

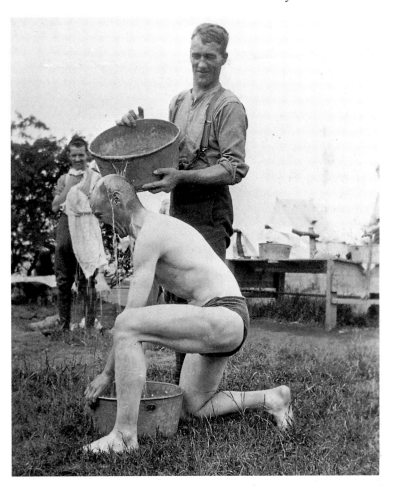

circumstances forced many manufacturers in Europe and America to amalgamate; some went to the wall. The American Department of Commerce announced in December 1922 that sales of photographic products in the USA had fallen by 42 per cent compared to the 1919

ABOVE Thousands of soldiers carried autographic cameras, resulting in a wealth of vignettes of barrack life. In the trenches of France, even ablutions like these existed only in memory and in photographs for the average enlisted infantryman.

LEFT Kodak's autographic cameras, used with special film, allowed photographers to caption or date the pictures they took. This feature was a Kodak exclusive—the Kodak films could be used in other cameras, but other makes did not have the special slot for recording details on the film.

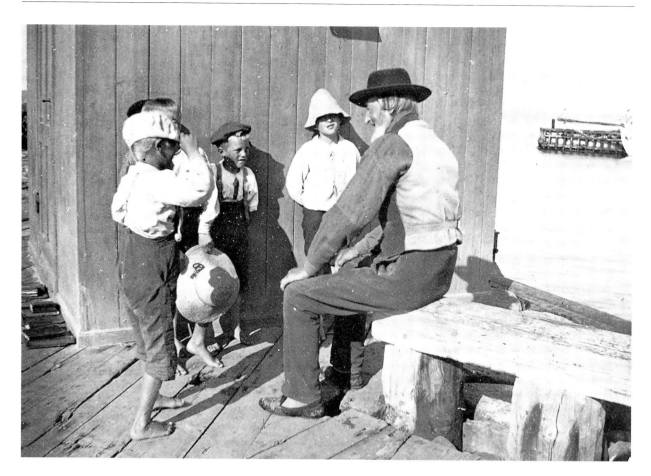

Children were among the most popular subjects for early snapshooters—just as they are today. Youngsters made enthusiastic models and appealing pictures, and these scenes, taken between 1897 and 1912, make a lively contrast with the rigid poses that were commonplace in formal studio portraits of the same era.

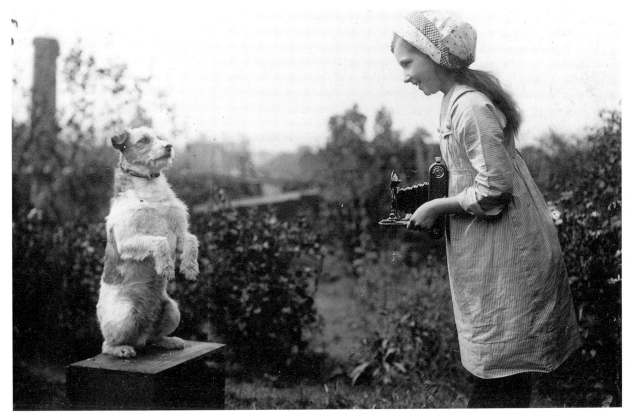

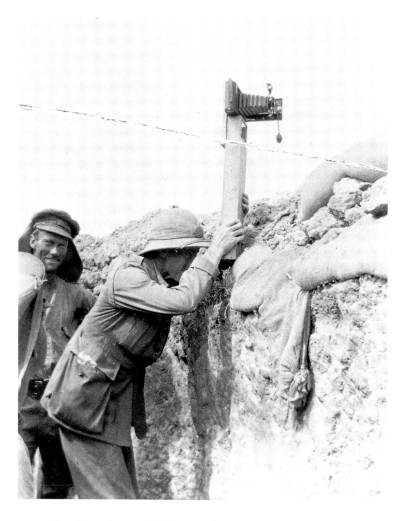

ABOVE Trench warfare provided outstanding picture opportunities for the budding photo-reporter, but the average enlisted amateur evidently regarded safety as a higher priority than precise framing of the enemy forces.

The earliest all-plastic cameras had the folding mechanisms of the Vest Pocket Kodak, but lacked the camera's adjustable shutter. This made them cheap enough for manufacturers of other products to give away as sales incentives. Kodak, of course, was happy to supply the cameras at minimal profit, since every new photographer meant more film sales.

figure. The average number of wage-earners in the American photographic manufacturing industry had fallen from 2,555 to 1,441 over the same period. Shortages of skilled labour had encouraged management to introduce changes in camera production. The older wood and card cameras were labour intensive in production; metal could easily be stamped and formed, making true mass production possible. The most popular sizes of Brownie box camera were made of aluminium from 1924. As improved techniques in moulding from Bakelite plastic developed, this material began to be used. One of the first applications had been for side panels on some of the Autographic Kodak special cameras in 1916. The first camera to use Bakelite moulding throughout was the Rajar No 6 folding camera of 1928, while Kodak Ltd produced the No 2 Hawkette folding camera in 1930. These early plastic cameras were clumsy and inelegant, but they pointed the way to things to come.

Both the Rajar and the Hawkette cameras had been produced as premium cameras, for distribution through coupon schemes run by other manufacturers. This had been a big growth industry in the 1920s; cigarette and chocolate makers, magazine and toiletry producers vied with each other to attract business by offering a range of goods, most of which had been specially made down to a price. Generally, the cameras were of very basic specification, but, as Kodak pointed out in response to criticism from its dealers, these new camera users were likely soon to want something better.

As a result of UK legislation which penalized the import of goods from abroad, Kodak Limited decided to begin manufacturing cameras in England in the late 1920s; until then, all Kodak cameras had been imported from the United States or Canada. One of the first products from the new plant at Harrow in Middlesex was the No 2 Portrait Brownie camera in six coloured finishes as well as traditional black. This was one of a range of cameras in fashion colours specifically aimed at women. The most spectacular was the Vanity Kodak camera, a small folding

CAIRO. LE PONT DU NIL OUVERT.

15,094. P. Z. - BALBEK. VUE GÉNÉRALE DE L'ACROPOLE.

ABOVE and RIGHT Using the Autochrome process, photography in colour was almost as simple as taking pictures in black and white. A conventional camera was used, and the plates were processed in the same way as lantern slides.

PREVIOUS PAGE Early attempts at colour photography utilized three consecutive exposures through different coloured filters, but photographers were restricted to static subjects. The introduction of the one-shot camera, which made three exposures simultaneously, extended the colour camera's repertoire to take in landscape scenes such as these, of an Egyptian canal (ABOVE) and Baalbek (BELOW).

George Bernard Shaw was an enthusiastic amateur photographer and experimented with the new Autochrome plates.

ABOVE By comparison with the soft hues of the Autochrome, pictures taken using the Dufay process look brilliantly coloured, and bear a far closer resemblance to modern colour plates. Like Autochrome, Dufaycolor used a screen of minute coloured filters, but these took the form of a pattern of narrow lines.

OPPOSITE The three plates exposed in a three-colour camera could be printed using pigment paper to make a one-off copy for amateur snapshots or turned directly into printing plates for reproduction in books and magazines.

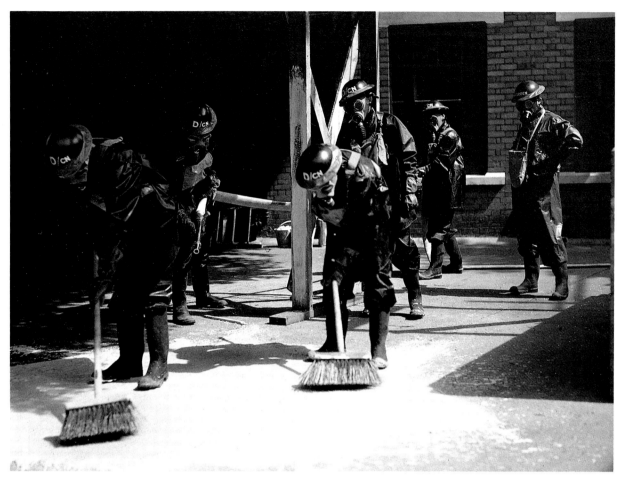

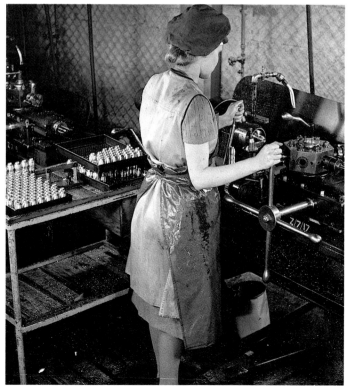

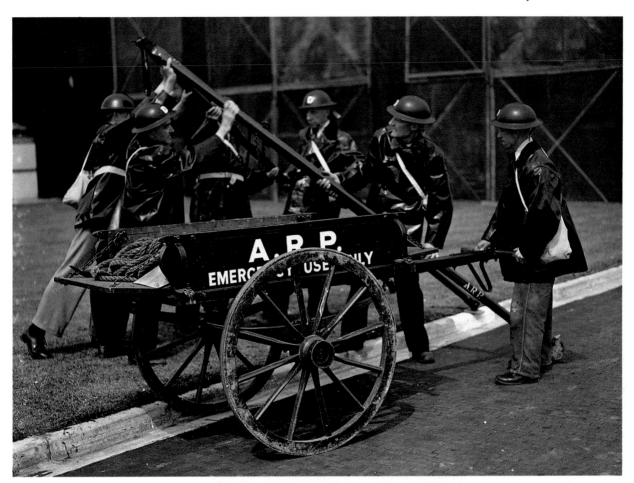

Advances in photo-technology literally colour our view of history. These preconceptions can be misleading, however, and it comes as a surprise to see vividly coloured images like these of an era that we are used to recalling in gritty black and white. These pictures of the 'Home Front' during World War II are of subjects rarely photographed in colour.

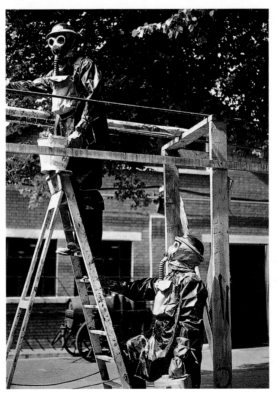

PHOTOGRAPHY'S "SECOND FRONT"

He controls the Jeep with a Tenite steering wheel—strong, tough, and able to stand all climates. Your own car probably has a Tenite steering wheel, instrument panel, accessories.

More than a hundred war products now made of material developed for a better

Kodak Film

FILM BASE IS A PLASTIC—one of the earliest. To make a better film, Kodak long ago began producing from cotton linters a "miracle material"; cellulose acetate.

In the form of TENITE—made by Tennessee Eastman Corporation, a Kodak subsidiary—this plastic is tough as a steer's horn and lighter than wood. It can be molded under heat or pressure, or "machined" like lumber or metal. It can be clear transparent, or in an unlimited range of colors.

Tenite is molded into finished products at the fastest rate ever reached with plastics. It led to a minor "industrial revolution" before the war or wartime shortages were dreamed of...

Now it has more than a hundred war applications—not as a substitute, but as a superior material. As an extra advantage, it does supplant other "critical" materials.

A few war uses are illustrated... In a sense, they all started with photography—the ever-growing need for finer film ... Eastman Kodak Company, Rochester, N. Y.

His bayonet scabbard is Tenite—lighter, tougher, more easily cleaned ... cost is little more than half that of scabbards made with earlier materials.

REMEMBER TORPEDO SQUADRON 8?... *how, knowing exactly what the odds against them were, this heroic band of 30 Navy fliers drove unswervingly into the massed fire of the Japanese fleet off Midway? And only one man survived? A stern example to us at home.*

BUY MORE WAR BONDS.

Snake-bite kit supplied our troops by the Army Medical Corps includes vacuum pump—molded of Tenite—for extracting snake venom.

Doubles for Brass—Molded of Tenite, this bugle once more raises the question, "What will plastics do next?" Before acceptance by the Army, it won the most critical ears by its tone and range.

Serving human progress through Photography

camera in five rich colours, embellished with gold lines and supplied in a matching case with silk lining. Other models sold in the US went even farther, being packaged with matching lipsticks and powder compacts. The humble box camera was transformed in 1930 by the leading American designer Walter Dorwin Teague, who advised Eastman Kodak on the coloured camera range. He designed the Beau Brownie cameras, with a geometric Art Deco enamelled design on the front panels, in a range of four colours. This vogue for coloured cameras from Kodak and other manufacturers lasted only a few years; soon, the traditional black returned.

This courting of the female buyer was based on sound business sense. In the 1920s, women comprised a majority of snapshot camera users, according to dealers reported in the *Kodak Trade Circular*. One said:

> We find that women are more constant users of their cameras, and are more reluctant to put them away after the summer is over . . . Women usually photograph persons. They are not so keen on views except as backgrounds for their companions; as they always have companions with them, their cameras are always used whenever they are taken out.

Another reported:

> It is my experience that women take a more serious view of photography than men; they seem to be kept at a kind of fever heat right from the actual exposure to the finished print. They call for their prints right on time . . . women will listen to all the advice they are given and try to carry it out, whereas a man does not seem to like being told anything . . . I do not think women pay much attention to their cameras; but a man who has got an elaborate camera takes more interest in photography, but only because he will be able to secretly 'swank' amongst his fellow photographers.

Nothing changes, it seems!

George Eastman celebrated the fiftieth anniversary of the founding of his com-

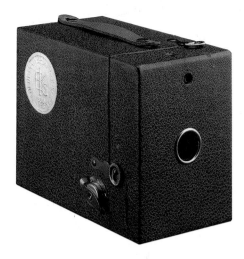

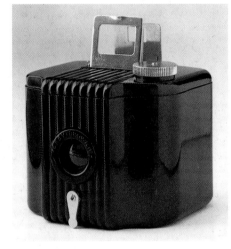

pany in a remarkable way. A special version of the No 2 Hawk-Eye camera was made, with tan leatherette and gilt fittings, and with a gold foil anniversary badge. In May 1930, 550,000 of these Eastman Anniversary cameras were distributed free to any child in the United States and Canada whose twelfth birthday fell in that year. All were gone in a few days.

By the 1930s the rollfilm camera had begun to be taken seriously by the enthusiast as well as the snapshooter. Precision manufacturers like Voigtlander and Zeiss-Ikon were producing advanced specification cameras, and a new generation of orthochromatic and panchromatic films were developed by manufacturers like Kodak, Ilford and Agfa. The plate camera, the traditional tool of the advanced worker, began to lose favour. The

Kodak gave away over half a million cameras to children aged 12 in 1930, in celebration of the company's 50th anniversary. The gift was '. . . in appreciation of the parents and grandparents of these children who had helped amateur photography and Kodak to grow'.

The design of the Baby Brownie camera makes it unmistakably a product of the thirties. Emerging techniques of moulding plastic made possible the sweeping curves, which clearly show the influence of the streamlined shapes that were then rapidly being adopted on fast-moving planes and vehicles.

OPPOSITE Kodachrome was the first true colour film in the sense that we use the word today. It was first introduced as movie film in 1935, but a version for still cameras soon followed. Production of Kodachrome for civilian photographers ceased when the USA joined the Second World War, and Kodak turned their attention to matters of national importance.

'Oh I do like to be beside the sea-side!' The popularization of photography coincided with a fad for sea-bathing (or thalassotherapy), and successive generations of photographers used their simple cameras to document the enduring love affair between the British and the seaside.

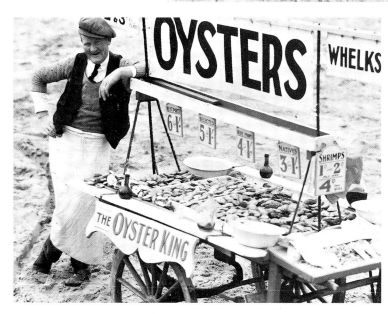

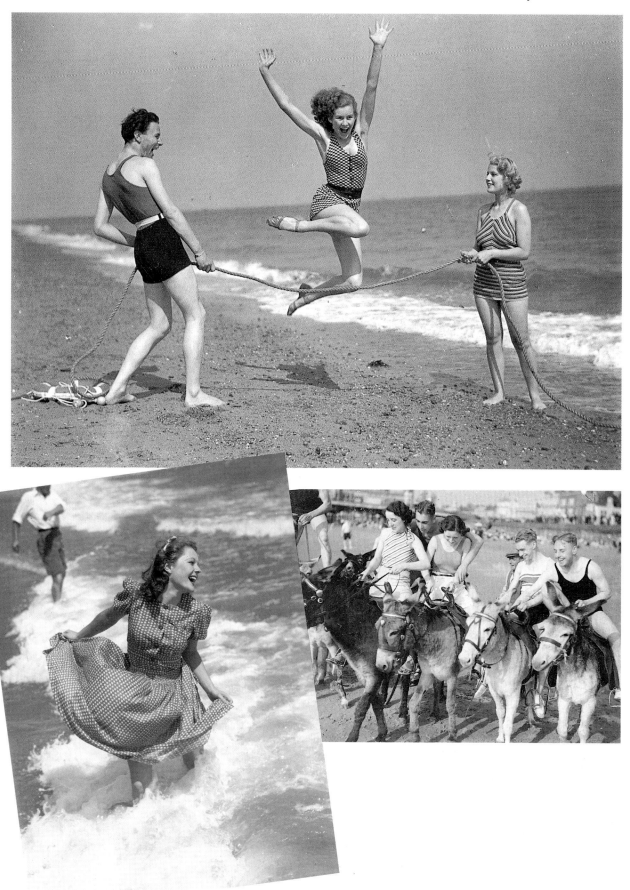

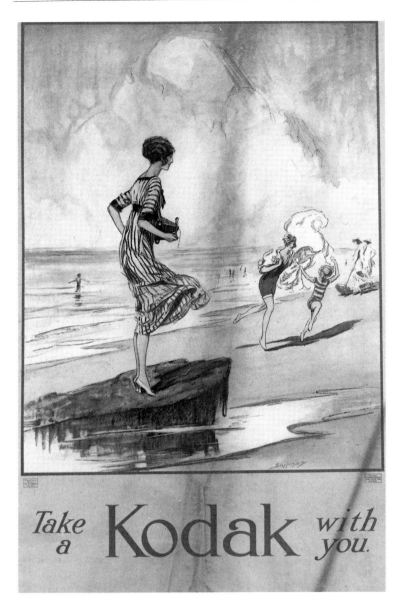

Take a **Kodak** with you.

Many of Kodak's distinctive advertising drawings were executed by Fred Pegram, a popular illustrator of the day.

moulding led to the appearance of cameras like the Baby Brownie camera—another of Walter Dorwin Teague's designs—in which mass production brought the cost down to $1 or five shillings (25p), the same price as the original 1900 Brownie camera, but far less in real terms.

Up to this time, virtually all rollfilm snapshot photography was in black and white. From the early 1930s, additive colour films like Dufaycolor or Lumière Filmcolor made it possible to take colour transparencies with rollfilm cameras, but some skill and a versatile camera were needed to get successful results. The introduction of 35mm Kodachrome film in 1936, followed by Agfacolor in the same year, inaugurated the modern era of colour photography. At first, use of these multi-layer colour films was restricted to owners of 35mm cameras, although Kodachrome was made available in the 828 rollfilm used in the Kodak Bantam special cameras introduced in 1936. Producing colour transparencies, such films were less suited to the mass snapshot market, and it was not until the introduction of Kodacolor negative rollfilms in America in 1942 that colour snapshots became a popular reality.

An important technical step in the 1930s was the development of flash-light. Almost from the beginning of snapshot photography, the adventurous could take pictures indoors by burning potentially explosive magnesium flash powder after opening the camera shutter on a brief time exposure. This was a pastime fraught with peril! The invention of the flashbulb in the late 1920s eliminated most of the hazards, but still restricted the photographer to the same procedure of firing the bulb after the camera shutter had been opened by hand. By the mid-1930s some advanced and professional cameras had synchronized shutters so that the flash bulb was triggered automatically. This feature was added to simple cameras at the end of the decade, the first being the Falcon Press Flash in 1939. The first Kodak flash camera was the Six-20 Flash Brownie camera of 1940. Flash synchronization became an almost universal feature of popular cameras from around 1950.

popularity of the Leica and Contax 35mm cameras was followed in the 1930s by a growing interest in small format. Some, like the Kodak Retina, provided 35mm photography at affordable prices. Others stuck with rollfilms, giving sixteen exposures instead of eight on 120 or 127 films. The development of efficient enlargers for the photo-finishing trade meant that by the end of the 1930s even the snapshooter could benefit from pocketable cameras taking smaller negatives, a trend which was to be accelerated in the 1950s with the development of automatic printers. The continuing improvements in plastics

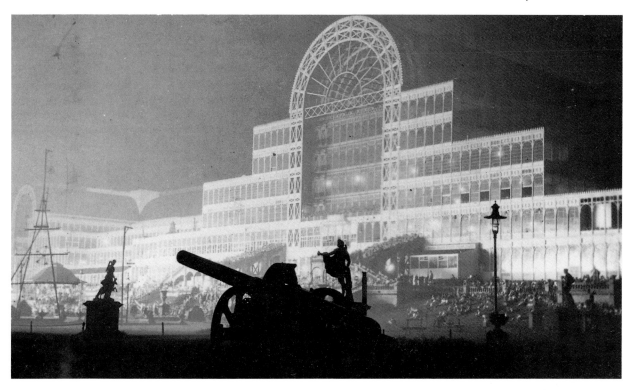

A significant technical innovation was introduced in the Super Kodak Six-20 camera of 1938. A photo-electric cell moved a meter needle, which was locked in position by the first pressure on the shutter release. A spring-loaded sensor connected to the aperture setting then moved until stopped by the locked needle, setting the exposure automatically. It was the world's first fully automatic camera. In no sense a mass-market camera, it cost $225—far more than a Leica camera—and only just over 700 were sold; but it foreshadowed the developments of the 1950s, when cheap automatic cameras using similar principles greatly simplified photography for the non-expert.

By the outbreak of war in 1939, snapshot photography was part of the life of most families. Few homes, even poor ones, did not possess a camera, if only the humble Box Brownie camera. The cost of a dollar or five shilling box camera in 1939 was in real terms a hundredth of the cost of the first Kodak camera in 1888. The trends which were to be greatly developed in post-war years—miniaturization, colour, automatic exposure, flash—had all begun. After the War, snapshot cameras were at first simply restyled versions of the traditional patterns of box

Many of the early rollfilm cameras had a time exposure setting, which locked the shutter open. The film had such broad exposure latitude that for successful night-time photography, the photographer simply had to prop up the camera, and open the shutter for a few minutes. This photograph depicts the Crystal Palace.

FAR LEFT Colour slide film is less forgiving of exposure errors than black and white film, so early colour cameras such as this Kodak Colorsnap 35 had weather symbols for setting the exposures.

LEFT The Brownie 127 camera featured an unusual solution to optical problems. Its simple, single-element lens formed an image in a curved, rather than a flat plane and to ensure that pictures were sharp across a flat piece of film, the designer curved the film path to match the curved image.

85

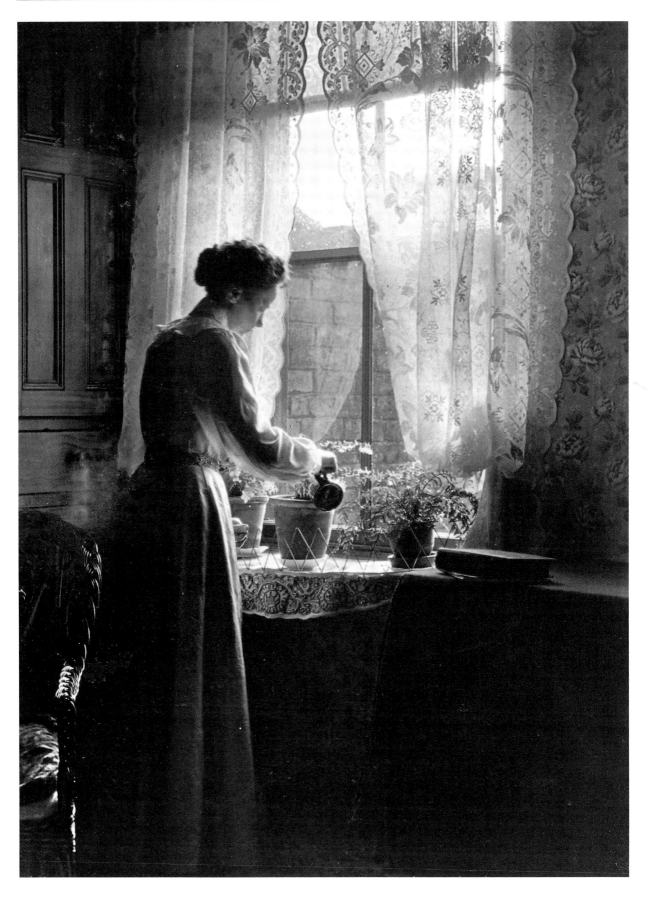

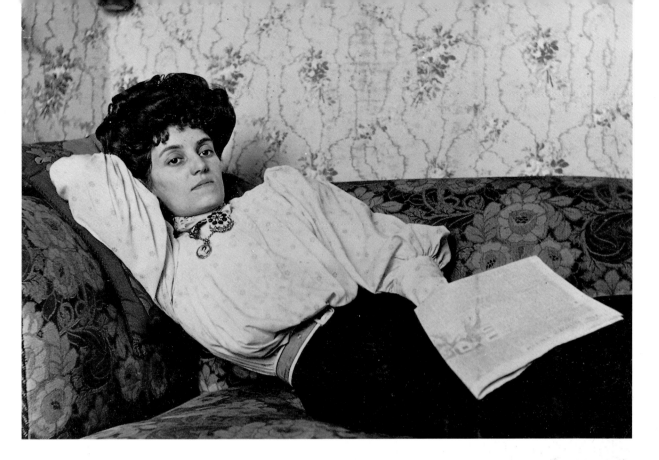

ABOVE Dim indoor lighting taxed the capabilities of the simple box cameras favoured by snapshooters, and this charming portrait was probably taken by an enthusiast using a more sophisticated folding rollfilm camera.

Photographs of domestic tasks such as this scene (LEFT) are surprisingly rare among early snapshots. Even when photography became available to a broad mass of people, the camera was still largely used to record special occasions or quaint, picturesque subjects, such as this smoking Romany (RIGHT), rather than ordinary events.

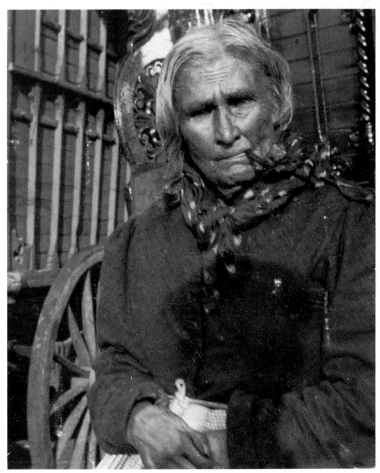

or folding models, albeit with added refinements like flash synchronization or close-up lenses and filters. As after the First World War, economic pressures led to the adoption of new, less labour-intensive, manufacturing methods. Folding bellows cameras gave way to solid moulded plastic designs, with eye-level viewfinders. The increasing use of colour was catered for by cameras such as the Kodak Bantam Colorsnap camera, with integral exposure calculator to simplify the demanding problem of exposure setting, or by the development of simple automatic exposure systems. Cameras such as the all-plastic Brownie 127 camera took over the role of the starter camera for children, and were immensely popular.

There were still drawbacks, however. Loading the rollfilm camera was to some extent a complicated process, and if done carelessly could result in damage to the film and loss of pictures. Many snap-shooters left loading and unloading to the dealer. Another problem was the delay between taking the picture and seeing the results. With most users exposing only one or two rolls a year, months could elapse between these events. This latter problem exercised the imagination of Dr Edwin Land of Cambridge, Mass. Prompted, it is said, by his daughter's impatience at the delay in seeing the results of his photography, he devised a system in which the exposed film was processed in the camera immediately after the picture was taken. The first Polaroid Land camera, Model 95, went on sale in 1948; it yielded a sepia-coloured, deckle-edged print within one minute of removal from the camera. It was immediately popular, and improved films and cameras followed; by late 1956, a million Polaroid cameras had been sold. Colour instant film followed in 1963, and the SX-70 camera in 1972 used a single integral picture unit, doing away with the somewhat messy peel-apart process of the earlier films.

The other problem of loading the camera was solved in 1963 with the introduction of the Kodak Pocket Instamatic camera. These were loaded with a drop-in cartridge which would fit only one way, making loading fool-proof (al-

The impatience of Edwin Land's three-year-old daughter Jennifer pointed the way to the first instant camera (RIGHT). When the child asked to see a picture her father (ABOVE) had taken just seconds after he pressed the shutter, Land thought 'Why not?' and '. . . within an hour the camera, the film and the physical chemistry became so clear that with a great sense of excitement I hurried to a place where a friend was staying to describe to him in detail a dry camera that would give a picture immediately after exposure.'

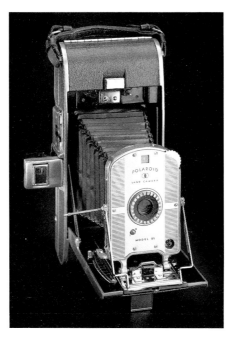

though nervous users would still ask the dealer to do it for them!). A range of films —colour negative, colour transparency and black and white—was available; within a short time, it was apparent that the public preferred colour prints, now of good quality, from the new generation of colour films. The cartridge-loading cameras were a runaway success; something of the order of 70 million were sold by Kodak alone, not to mention those made by many other manufacturers around the world. The same principle was applied to a miniature camera with the introduction of the Kodak Pocket Instamatic cameras in 1972. Great improvements in film quality made it possible to obtain good quality enlargements from negatives as small as $\frac{3}{4} \times \frac{1}{2}$ in (19 × 13 mm). Pocket cameras using the new films were made and sold in very large numbers by Kodak and other manufacturers; they included models with very advanced specifications, as well as simple 'point and shoot' versions. The miniaturization principle was carried even further in the Kodak disc cameras of 1982, in which the concept of a roll of film was replaced by that of a disc, taking fifteen tiny $\frac{2}{5} \times \frac{1}{3}$ in (10 × 8 mm) negatives, carried in a flat, slim camera with built-in flash and sophisticated lenses. This achievement was made possible through the development of new negative materials and advanced photofinishing equipment.

Interestingly, it now appears that the trend towards miniaturization of the snapshot camera, which began with the Pocket Kodak camera of 1895, has been reversed; today, the compact 35mm camera, with fully automatic focusing and exposure control, and integral electronic flash, has taken over in popular favour from the pocket and disc cameras of a few years ago. Yet these modern cameras express fully the philosophy of George Eastman's one hundred-year-old slogan,

'You press the button, we do the rest'. Yielding high quality colour pictures in almost any conditions, these cameras cost, in real terms, less than one eighth of the cost of the first Kodak camera, which worked only in the strongest sunlight to produce indifferent black and white pictures. The results can be processed within the hour by the High Street mini-lab at a real cost per print of one-twentieth of the 1888 price. Eastman would be very impressed!

The Instamatic camera was little different in principle from the box Brownie, but drop-in cartridge loading simplified the commonest cause of problems for the snapshot photographer. The simplest Instamatics, such as this model 100, had no controls save the shutter release, but more sophisticated Instamatic cameras had auto exposure control.

Kodak's 1982 Disc camera was a technological marvel. It had a highly sophisticated lens and a clever film clamping system that held the circular disc rigidly in position. However, the small negatives meant that pictures were grainy, and the snapshooting public never really took to the camera in the way they had to the Instamatics that preceded it.

4

The Inter-War Years

The period between the two world wars was one of the most expansive and stimulating in the whole history of photography. The diversification in its use was greater than ever before or subsequently. The First World War jolted people into facing up to reality, but the particular effect on photographers varied according to their psychological needs. Before the war the Pictorial Movement was almost universally accepted and had a strong following: in Britain, Europe, the United States and further afield, pictorial photography was practised by many of the best photographers of their generation, but one by one these groups of like-minded photographers were dispersed as the war divided Europe into opposing camps.

Photography is essentially a visual language, a means of communication. In the nineteenth century it was used primarily as a means of conveying information of a factual kind about people, places, events and situations. Those who had artistic skills produced pleasing pictures but others were content with a good record of the subject, whatever it might be. Some photographers who had received an art training used photography as an alternative medium to produce pictures of the narrative kind, illustrating themes which were popular with painters of the period. After the war more photographers began to appreciate the power of photography in the expression of ideas. This led to a far greater range of photographic imagery than had appeared in earlier years. The soft-focus images of tranquil and idyllic subjects beloved by the pictorialists gave way to strong, direct photographs with an emphasis on design, whatever the subject. Photographers with this new vision were either newcomers on the scene or adventurous spirits, fully prepared to try out something new. A large number of amateur photographers, associated together in clubs and societies, used photography as a means of escape from the real world; they were wedded to pictorialism, and all that it meant in terms of aesthetic enjoyment, and masters of the techniques and skills it commanded.

Kodak's introduction of the hand camera, in which rollfilm was used and could be processed and printed commercially, before the First World War was an event of great importance for the spread of photography as an amateur pursuit and hobby. Minimal technical knowledge was needed to operate these cameras, they were lightweight and folded into a compact size. The popular Box Brownie camera was so simple to use that it could be operated by children with successful results. The initial enthusiasm was necessarily curtailed during hostilities but was revived as a result of colourful and skilled marketing in the early 1920s. Apart from the fun involved, the value of this basic form of image making, which provided an immediate reminder of loved ones near and far and of happy days spent at home or in the course of travel, was appreciated by people throughout the world. The trade name of Kodak became a household word.

In all social groups photography became a popular pastime. It was a great social leveller as it was a relatively inexpensive hobby during the inter-war years. A Box Brownie camera or folding

Bertram Park. Nude and Reeds, 1923. Representative of the discreetly sensuous interpretation of the human form, this delicate study is typical of Bertram Park's early work. By the mid-thirties he had developed a more robust and low-key portrayal of the nude, more formal and less naturalistic. Changes in nude photography from one decade to the next reflect the changes in attitude to nudity. Bertram Park's name was also associated with the growing of quality roses, his favourite hobby.

camera using $3\frac{1}{2} \times 2\frac{1}{2}$ in $(9 \times 6\,\text{cm})$ frame films could be acquired for a very modest outlay, and films, chemicals and printing papers were cheap. The kitchen or bathroom could be converted into a darkroom for a few hours in the evenings with a minimum of effort to process a film or make black and white prints. It was not uncommon to find an employer attending the same camera club as several of his employees on a weekday evening. Photographic skills, not social standing, counted, when it came to competition time.

As skills improved with practice, ambitions increased and better cameras were acquired which were less limited and gave improved performance. Once the novelty of making prints by contact with the negative wore off, the making of enlargements was the next step. Many enthusiasts made their own enlargers and learnt about the laws of light in the process. Those interested in photographing architectural subjects invested in an appropriate large-format camera, with the essential camera movements and a range

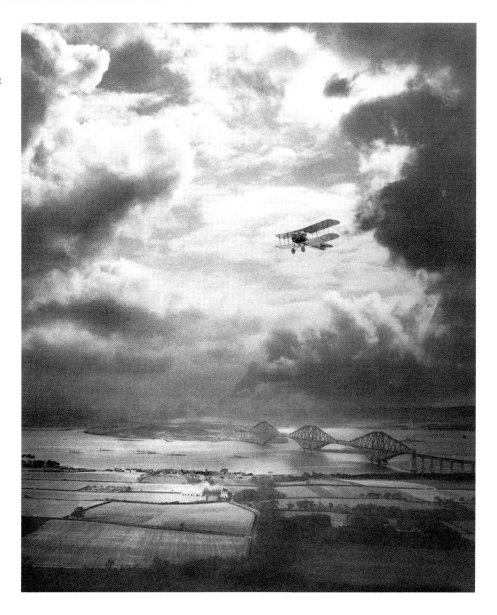

Captain Alfred G. Buckham. The Forth Bridge, prior to 1926. Although exhibited and reproduced in 1926, this may have been taken at an earlier date as Buckham was celebrated for the photographs he took from the air during the First World War. Buckham's romantic vision prompted this combination print. The association between two of the century's most remarkable engineering achievements add an extra dimension.

of lenses. New photography magazines made their debut in the 1920s and '30s expressly to cater for the amateur, containing advice on how to build one's own darkroom and construct an enlarger. The emphasis was on the acquisition of technical skills, but there were also articles on how to compose a picture and on lighting.

The skilled amateur was no newcomer on the photography scene after the First World War; the growth of interest in the subject in the latter half of the nineteenth century was due, in part, to the activities of the many literary and philosophical societies in Britain which encouraged their members to participate in photo-

graphy. Concurrently photographic societies and camera clubs were established to provide a forum for exchange of ideas and a platform for lectures on the subject. Some became quite famous, for example the Camera Club in London (the jewel in the crown), Manchester Amateur Photographic Society and the Croydon Camera Club, all of which boasted photographic celebrities amongst their members. In America, the Philadelphia Photographic Society was one of the earliest, and remained among the most vigorous. There were equivalents in other European countries and elsewhere in the United States of America.

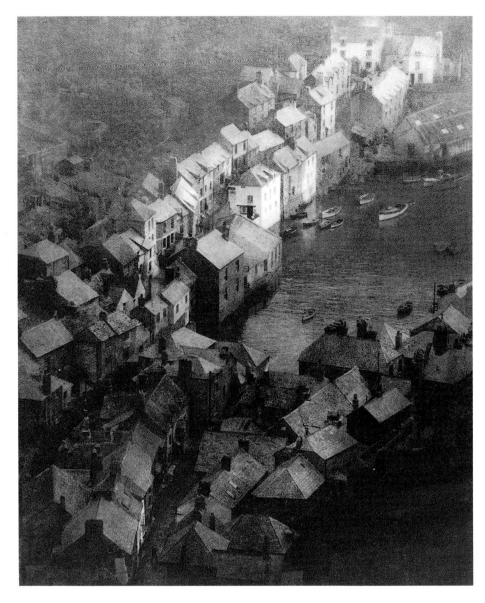

G.L. Hawkins. Polperro, 1944. Bromaloid print. A leading pictorialist in the thirties and forties, Hawkins developed a form of bromoil printing which he called *bromaloid*. This gave him greater control over the tone scale so that he could select and emphasize individual areas of highlight, deepen shadows and reduce unwanted detail in a photographic print. *Polperro* is a good example of what could be done. In a straight print from the negative the top left corner would be as variable in tone as the rest and the disposition of light and shade over all would be uniform.

Some clubs in the north of England had been established as long ago as the 1850s, such as the Leeds Camera Club, the Newcastle Photographic Society and the Liverpool Amateur Photographic Association. In 1930 a map was published in *Photograms of the Year* which showed the distribution of camera clubs and photographic societies in England, Scotland and Wales. This revealed that in the London postal district there were seventy-three such associations, whereas the Home Counties—Essex, Kent, Middlesex and Surrey—had twenty-five between them, Hampshire had four and Sussex five. Wiltshire, Oxfordshire and Cornwall had one in each, and Suffolk and Somerset two. There were none in mid- and North Wales and the Marches, but nine in Glamorgan and remarkably there were ten in Staffordshire. There were sixteen in Northumberland and Durham, but the greatest concentration was in Lancashire and Yorkshire, with forty-two and thirty-nine respectively. In addition there were thirty-six postal camera clubs and thirteen photographic record and survey societies.

Some of the titles of these associations give a clue to their identities: the Working Men's College Camera Club, the Post Office Stores Photographic Society, Guy's

ABOVE *Alexander Keighley.*
The Dayspring from on High,
1917. Keighley's
photographic imagery was
mystically poetic and he
frequently illustrated
religious themes. He was a
highly regarded amateur,
especially in Yorkshire, his
home county.

Nurses Photographic Society, the Great
Western Railway Literary Society (Photo-
graphic Section), Garswood Hall Collieries
Institute Camera Club and the Hudders-
field Naturalist, Photographic and Anti-
quarian Society. The reasons for the
geographical distribution of these societies
have never been analysed, but a poss-
ibility is that the concentration of indus-
tries such as cotton and engineering in
Lancashire, wool and coal in Yorkshire,
prompted leisure activities of a skilled and
creative kind to compensate for the mono-
tonous routine of the everyday task.

In Britain the necessity for some form of
co-ordination of the activities of these
groups, especially insofar as lecture and
exhibition programmes were concerned,
led to the formation of larger regional
units such as the Lancashire and Cheshire
Photographic Union, the Yorkshire
Photographic Union and the Central
Association of Photographic Societies.
During the inter-war years, these fed-
erations became affiliated to the Royal
Photographic Society, the doyen of
photographic societies, through the Photo-
graphic Alliance. This structure made it
possible to devise a system of advance
publicity for exhibitions and compile lists
of approved lecturers and judges for
competitions and print 'battles'.

A similar organization existed in the
USA. The Photographic Society of
America, with its headquarters in New
York, could be compared with the Royal
Photographic Society of Great Britain in
status. Both awarded Associateships and
Fellowships and organized international
exhibitions of photographs as well as
lecture programmes.

The direction and practice of amateur
photography was considerably influen-
ced by the system of organization. Most
clubs and societies grouped their mem-
bers into three tiers: beginners, inter-
mediate and advanced. There were in-
centives to move from one grade to the
next, the ultimate objective being to
become an Associate or Fellow of the
Royal Photographic Society, once the ad-
vanced grade had been achieved. Judges
and lecturers wielded enormous power,
although the majority may not have been

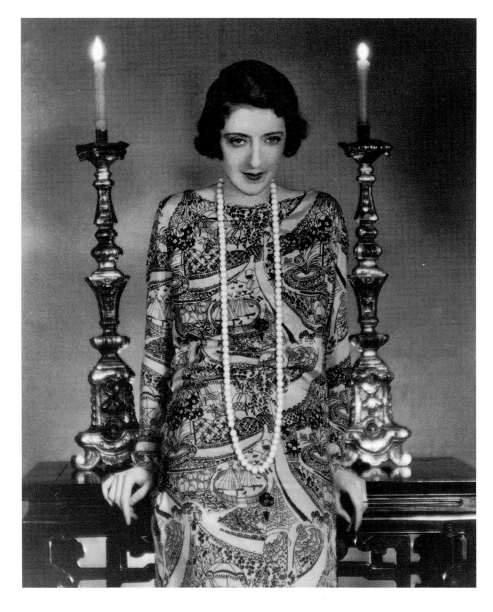

Maurice Beck. Portrait of a Lady, 1934. This is a typical thirties picture with the Art Deco dress, the large candlesticks and the bland facial features caused by over-enthusiastic retouching of the negative. Beck produced many fine photographs in his own inimitable style, redolent of the period. He and his studio partner, Helen MacGregor, were the chief photographers for British *Vogue*. From 1932 he took photographs for Shell Mex and BP.

consciously aware of it, when they expressed approval or disapproval of the artistic and technical qualities in the photographs put before them. Their dictates profoundly affected club members, whose greatest desire was to please the judges in order to move up the ladder of success in the club competitions and at the salons of photography. Nothing was more likely to upset than the maverick judge who saw merit in individual expression rather than in the conformist and repetitious approach of the photographer who obeyed the rules. In those instances in which a controversial or innovatory approach was singled out for the premier

award or certificates of merit, there was consternation and that judge was unlikely to be invited again.

This conservative approach did not always go unchallenged, though, especially in the more progressive American camera clubs. In volume 45 of the US magazine *Camera Craft* appeared a stinging attack on circuit judges entitled 'A Warning to Judges' by author J.H. Sammis who criticized their 'Old World Nostalgia'.

Most judges on the clubs and societies circuit had been indoctrinated with a form of pictorialism which was imitative of the work of the original pictorialists of the

OPPOSITE *Noel Griggs. Dancers, 1938.* This sparkling and imaginative photograph was probably taken to advertise paper production, but was exhibited at one of the major annual exhibitions. It is an excellent example of the creative use of spot lighting and cast shadows to give additional information and an extra dimension to an otherwise flat subject.

ABOVE *Auguste Sander. Carpenter from the Eifel, the Westerwald series, c.1927.* Sander undertook the major project of recording the workers and peasants who lived in the Westerwald region of Germany at this time in a straightforward way without artifice or flattery.

LEFT *Alvin Langdon Coburn. 'The Singer Building, New York' 1912.* A herald of the New Vision of the twenties and thirties Coburn was so impressed by the 'high rise' buildings of Manhattan that he sometimes ignored the conventional viewpoint and angled his camera both upwards and downwards after selecting unusual viewpoints. This is plate 10 from his series of photographs of New York.

RIGHT *Herbert Felton. 'Circular Staircase'. 1939.* An eminent architectural photographer of the period, he worked for the National Buildings Record, concentrating on the churches of East Anglia. He also photographed contemporary buildings for architects and was a friend of M.O. Dell.

Edward Weston. Juniper, Sierra Nevada, USA, 1937. Weston carefully planned the picture content of his photographs well before making the exposure. He worked out everything to the smallest detail on the ground glass screen of his camera. He then used a small aperture to ensure all over sharp focus. His technique was known as 'Pre-visualization'. His subjects were wide-ranging, but he was particularly fascinated by natural objects such as peppers and their resemblance to the human form.

OPPOSITE *Edwin Smith. Chiselborough, Somerset, 1922.* Smith was primarily an architectural photographer but he loved natural forms in landscape and interpreted nature and its moods with sensitivity, and imagination. Trained as an architect, he realized the importance of scale and relevance. The inclusion of the two figures here concentrates the mind on the sturdy form of the tree in the face of the wind.

Linked Ring brotherhood, 1892 and 1910, and the PhotoSecessionists in the USA which came to an end in 1917. The true pictorialists searched for new ways of expression, moving away from the misty, moody pictures they had previously produced into a realistic approach which explored the world afresh and found beauty in new ranges of subject matter such as close up photographs of everyday objects: driftwood, the head of a sunflower, or the interesting textures associated with man-made articles. Amongst the principal exponents of this

movement were A. Renger-Patzsch of Germany, Edward Weston of California and Ward Muir and Malcolm Arbuthnot of Britain.

The fascination of pictorial photography for the average photographic club and society member in the inter-war years is understandable. The deprivations and harshness of the war years could be forgotten in the search for romance in rural scenes, picturesqueness in architecture, rhythm in human forms and beauty in faces. The photographic techniques employed to achieve the desired end, a

W.G. Briggs. Close up of Leaves with Dewdrops, c.1928. The visual exploration of a subject in 'close up' was a special feature of photography in the twenties. There was a strong movement away from pictorialism at this time towards a more realistic approach to the subject. It became known as the 'New Objectivity' in Germany, promoted by the photographer A. Renger-Patszch; 'Straight Photography' in the USA, promoted by Paul Strand and Alfred Stieglitz; and the 'New Realism' in Britain, where Malcolm Arbuthnot concentrated on design in 'close ups' of wheels, boats and horses (1911–14), and W.G. Briggs and his associate, Noel Griggs, led the way in the twenties.

pictorial photograph, were based on former practices: soft and subtle nuances of light and shade, 'contre jour' lighting for romantic effects, delicate 'high key' prints for subjects such as young children, a sombre tone range for 'mood' landscapes, and an overall soft focus to provide atmosphere and the avoidance of critically sharp rendition of detail. The controlled print processes, such as gum printing and bromoiling, were encouraged. These processes yield an image similar to etching and aquatinting, and require considerable skill to achieve the best results.

The universal appeal of pictorialism is evident from a study of the imagery. The same techniques were employed on both sides of the Atlantic and there were ample opportunities for the exchange of exhibition pictures between Britain, Europe and the USA. There are many examples of the work of American pictorialists in the photograph collection of the Royal Photographic Society (the best collection in the world of pictorial photography). They were also included in the popular photography annuals of the period published in Britain, several of which contain commentaries on the work

Alvin Langdon Coburn. A court where the children are at play. Whitehorse Close, Edinburgh, 1905. Taken during Coburn's pictorialist period, he included this with twenty-two of his other photographs to illustrate *Edinburgh, Picturesque Notes,* by Robert Louis Stevenson. This book was originally published in 1879, illustrated with etchings of drawings and a few woodcut vignettes in the text. An American, Coburn took photographs in Edinburgh on a visit to Britain in 1905. He returned several times, taking the final photographs for the 1954 edition of the book in 1950.

ABOVE *Edward Weston. Zabriskie Point, Death Valley, USA, 1938.* Weston won a Guggenheim Fellowship which permitted him to wander at will and experiment with his chosen medium. He spent the time well, producing photographs of wonderful vision and clarity.

RIGHT *Mark Oliver Dell. Ourtigue,* c.1936. Dell combined hill walking with photography on his summer holidays and was encountered, clad in Norfolk jacket and breeches, between five and six in the morning in the misty sunshine of a Pyrenean landscape.

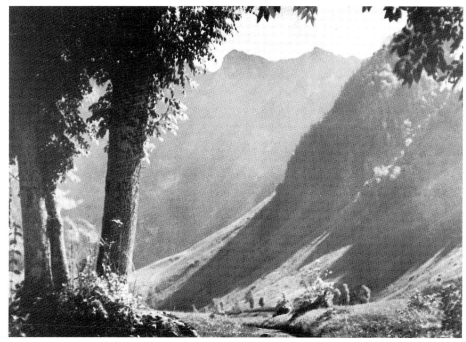

submitted from countries as far apart as France, India and the USA.

The purpose which prompts the taking of a photograph is all important to an assessment of its merits or otherwise. For many amateur photographers it was escape from the monotony and drudgery of everyday life to creating something of aesthetic merit. The satisfaction to be gained from the production of a technically perfect print, irrespective of the subject, must not be underestimated. For many, the practice of photography was a therapy.

One of the promoters of pictorialism during this period was Stephen H. Tyng of New York, an Associate of the Royal Photographic Society who, in appreciation of the guidance in the practice of landscape photography given him by Bertram Cox and A.C. Banfield on a number of visits to England, established a fund for the acquisition of outstanding examples of pictorial photography. No restriction was made as to the origin of the pictures selected. The administration was placed with the RPS Pictorial Group Committee, who appointed the selectors. The prints to be added to the Stephen H. Tyng Collection were purchased in duplicate, one being retained by the Society, the other being sent to the Foundation in New York. The Collection was started in 1927.

Some of the best pictorialists at this time were involved in photography in a professional capacity in one form or another. For instance Mark Oliver Dell, whose luminous Pyrenean landscapes and picturesque old village scenes were matched by his equally fine architectural photographs taken for architects, town planners and the architectural press. The Liverpool photographer, E. Chambré Hardman, was a well-known portraitist, professionally, and a devotee of landscape and townscape in his spare time, whose strong sense of design emerged powerfully in his photographs of local scenes. Both James Sinclair, the camera designer/manufacturer, and Fred Judge, the owner of the picture postcard firm of that name, were sensitive photographers capturing mood and atmosphere in photographs of street scenes and country life.

Three professional portrait photographers, at least, exhibited widely in the international exhibitions: Charles Borup, Herbert Lambert of Bath (renowned for his portrayals of musicians) and Marcus Adams, the fashionable child photographer. In the USA Pirie MacDonald of New York earned a deserved international reputation in the thirties for his pictorial portraiture; Adolf Fassbender's landscapes and townscapes were highly regarded; Nicholas Haz exhibited lively work of a journalistic character and Mrs Mildred Hatry was a dedicated pictorialist. The mill owner, Alexander Keighley, of the High Hall, Steeton, Yorkshire, was amongst the most prolific of the pictorialists, whose idyllic pastoral scenes were interpretations of biblical narratives.

Some photographers experimented with the controlled printing processes,

Mark Oliver Dell. Billingsgate, 1922. Gum print. The senior partner in the leading firm of architectural photographers, Dell and Wainwright, he was a pictorialist at heart and a perfectionist in photographic printing.

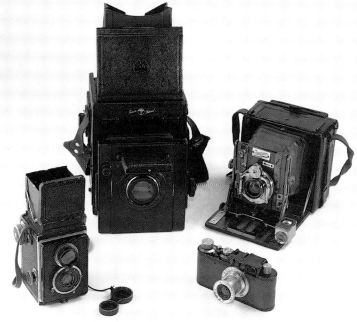

developing them to suit their own purposes. G.L. Hawkins of Britain adapted the Bromoil transfer process and called it Bromaloid; William Mortensen of the USA called his adaptation of the photographic process the Mortensen Technique, which he published as well as practised, and José Ortíz Echagüe of Spain made his prints by the Fresson Process, which is a form of carbon printing.

Other serious photographers had discarded pictorialism during the twenties and looked at the world afresh with a realistic vision. A number like Paul Strand (USA) were prepared to photograph the harsh realities of life instead of turning away from its problems in search of an ideal world. Some, like the German photographer Renger-Patzsch, were entirely objective when taking their photographs. He considered it wrong to allow the ego of the photographer to come between the camera and the object photographed. Although technically superb and well designed, these photographs possess an uninviting detachment. Others, like Edward Weston of California, regarded the photographic image as supreme and endeavoured to incorporate all the medium's finest qualities. All was revealed and nothing obscured in his photographs and those of his fellow members of the F.64 Group of West Coast photographers, who left nothing to chance and used the smallest aperture available.

Another important aspect of amateur photography in the inter-war years must not be overlooked. The interest in what many consider to be the most important attribute of photography—its use for the making of visual documents—was reflected in the photographic record and survey societies. These groups were responsible for recording aspects of the towns, villages, rural communities and local events in their environs. The aim was to give maximum information in the photographs, a pictorial treatment being regarded as undesirable. They usually worked as a collective, and their photographs, mostly anonymous, are housed in the appropriate local history libraries. If these valiant groups had not undertaken this work, the visual documents which

ABOVE LEFT *W.J. Day. In South Deep, Poole Harbour, c.1920.* Carbon print. A frequent exhibitor of seascapes and harbour scenes, Day was in the picture postcard production business. He exhibited carbon prints in a range of colours from green and blue through to sepia and dark brown (the latter being used for sunset scenes and the occasional landscape).

BELOW LEFT *Francis J. Mortimer. Two Reef Weather, 1930.* An enthusiastic yachtsman, F.J. Mortimer specialized in marine photography. There is a fine sense of movement and mood in many of his photographs which ranged from pictures of racing boats to near abstract studies of waves.

OPPOSITE *Eric Hosking. Tawny Owl (Strix aluco), c.1938.* The doyen of nature photographers, Hosking is world famous for his photographs of birds. Hosking lost an eye when an owl he was photographing defended its territory.

OPPOSITE BELOW *Popular Cameras of the Period* LEFT TO RIGHT: *Twin Lens Reflex.* Hand held chest level, between lens shutter, 2 × 2 in format; *Single lens Reflex.* Hand held or tripod, focal plane shutter, 4 × 5 in format; *Hand/Stand Conical Bellows Camera*, compur shutter, 3 × 4 in format; *35mm Camera (Early Leica).* Hand held eye level, focal plane shutter.

Fred Judge. The Jewellers' Shop, 1923. Gum print. The proprietor of Judges Postcards, he was a distinguished pictorialist, photographing street scenes as well as landscapes in an impressionistic style. As an acute observer of human nature he made a series of photographs of London and Londoners by night, printed by the gum bichromate process. These photographs give an interesting insight into the life by night of the capital city in the twenties.

add so much to our knowledge of Britain during those years would not exist. It seems strange that this interesting and important form of photography attracted so little attention at the time and later.

Apart from competitions and exhibitions, outlets for the work of advanced amateur photographers were the annual publications such as *The Year's Photography* (published by the Royal Photographic Society), *Photograms of the Year* (which claimed to be a review of 'the world's pictorial photographic work'), the *British Journal of Photography Almanac*, and in the thirties *Modern Photography* (a 'Studio' publication) and *Photography Year Book* (published by *Photography*, a monthly magazine). The last two named covered photography on a broad front, including the work of professionals as well as amateurs. These publications are good sources for discovering what was popular in photography at the time. There were equivalent publications in the USA. Most editors made no distinction between

amateur and professional and the subjects represented were wide ranging; they included natural history subjects, architectural photographs and examples of scientific and technical photography.

American amateurs formed outlets for their work in the inter-war years in the magazine *Camera Craft*, which ran a monthly competition, divided into 'Amateur' and 'Advanced' categories. Winning entries were published, and a larger selection of pictures was made up into a series of exhibitions which toured the camera clubs. *Camera Craft* was eventually incorporated into *American Photography* in 1942, and at that point the regular competitions and club-interest features disappeared. *The American Annual of Photography* also widely published work by amateurs, and carried listings of camera clubs throughout the nation. *Photo Era Magazine* of Wolfeboro, New Hampshire, ran monthly beginners and advanced competitions, and even an Exposure-Makers Competition 'for

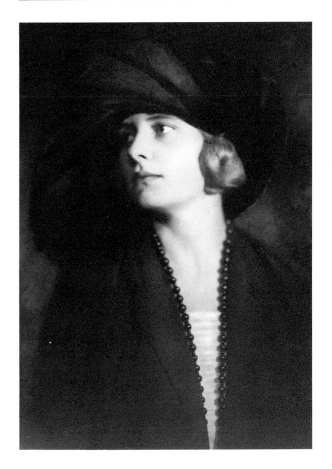

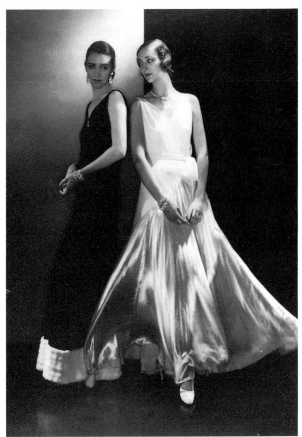

amateur photographers who, for lack of time or equipment, cannot do their own photo-finishing'.

Nature photography gained in popularity. With improved cameras and lenses, and faster films, a wider range of creatures could be photographed successfully. As a specialized subject, it is not surprising that the practitioners were naturalists first and photographers second. The brothers Cherry and Richard Kearton were leaders in the field, closely followed by Oliver Pike and, in the thirties, by that most outstanding of bird photographers, Eric Hosking.

The photographic manufacturing industry responded well to the upsurge in popular demand for smaller and better cameras, faster and less grainy film and quality printing papers for the exhibition-minded photographer. Although the optical firms of Dallmeyer, Ross and Taylor, and Taylor-Hobson produced some of the best lenses in the world, they were in the main designed for large format cameras

and professional photographers. Likewise in Britain the well-known camera manufacturers, such as Sanderson, Sinclair and Gandolfi, employed skilled craftsmen whose quality workmanship was of the finest but not suited to mass production. Popular hand cameras were produced in quantity by firms such as Eastman, Kodak and Ensign. One of the finest British-made cameras of the period was the Soho Reflex, beloved by press photographers and the contemporary portrait photographer, who preferred mobility in the studio and favoured a reliable hand camera. This enabled him to view the sitter in the ground-glass screen right up to the moment of exposure in preference to the heavy, intractable studio camera on its stand, which interrupted that vital visual contact with the sitter for several seconds whilst the camera was prepared for an exposure. The hand-made Soho Reflex cameras cost £20 10s ($100) in 1927.

It was in Germany, however, that the

ABOVE LEFT *Charles Borup. Gabrielle, c.1928.* Borup's portraits are characteristic of many of the period, being naturally lit to emphasize form but not texture, well-designed and impressionistic rather than realistic.

ABOVE RIGHT *Edward Steichen. Evening Dresses for Vogue, 1930.* One of the most distinguished photographers of the period in America, formerly a pictorialist and a friend of Alfred Stieglitz, Steichen specialized in fashion and celebrity portraiture.

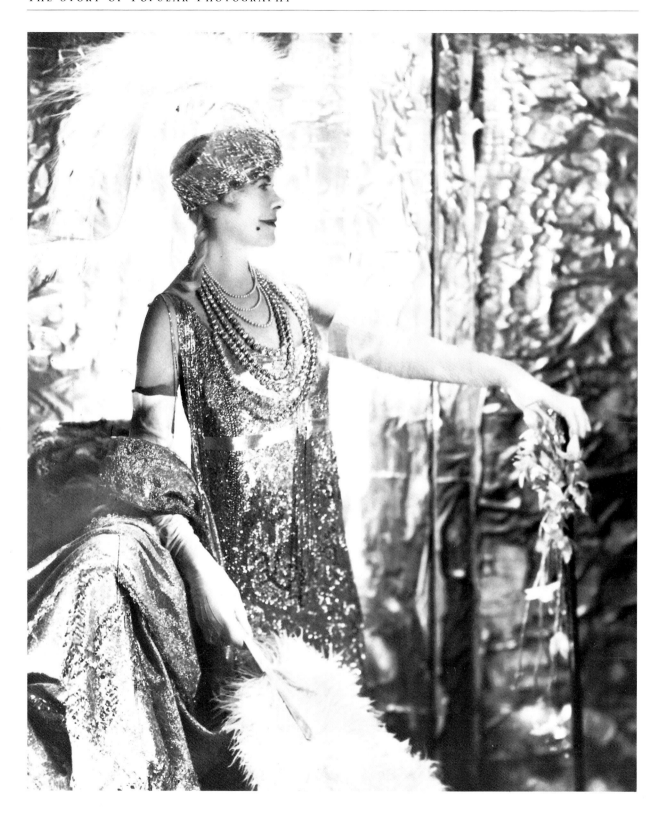

*Cecil Beaton. Lady Alexandra as 'Silver' in Pageant of Jewels, June 13, 1931.*The demand for 'society' portraits was reflected in the comparatively large number of fashionable photography studios which flourished in the major cities during the inter-war years. Cecil Beaton was one of the most successful of these photographers.

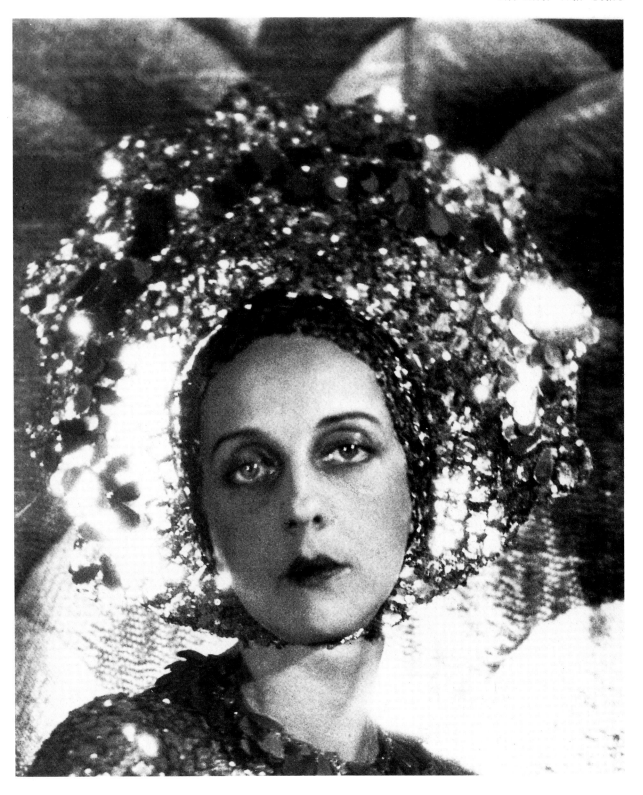

Cecil Beaton. Portrait of his sister, Baba Beaton, c.1925. Beaton specialized in glamour portraiture, following in the footsteps of the Baron Adolf de Meyer. He photographed many of the most beautiful, chic, as well as eccentric women of the period.

*Noel Griggs. Chimney,
c.1934.* This very talented
photographer was the star
operator at Studio Briggs.
He specialized in industrial
subjects and creative table
top studies for commerce.
The angled camera shot was
innovative at the time and a
daring thing to do to please
clients who had probably
never viewed the subject
from this position. He was
very successful, his
photographs appearing
regularly on the front
covers of company reports
and in glossy magazines. A
good eye for design was an
essential pre-requisite of the
photographer who took
photographs in this manner.
The effectiveness of this
bold type of photography
was not lost on other
camera users who began to
emulate Noel Griggs with
varying degrees of success.

trump card of the camera market was
produced in the early twenties with the
ace of the small format cameras: the Leica.
It was designed to be light in weight,
unobtrusive in handling and quick to use,
with inter-changeable lenses of excellent
design. When these features were com-
bined with a film (initially cine film strip)
which was reasonably fast, but had a
granularity which permitted big enlarge-
ments to be made without too much
deterioration in image quality, the
camera's future was assured. Leitz's suc-
cess was swiftly followed by other
German camera manufacturers, in par-
ticular Zeiss Ikon, one of whose early
cameras, the Ermanox, found favour with
the new band of documentary photo-
graphers and photo-journalists. The
Ernostar anastigmat lens, incorporated
with a focal-plane shutter camera, had an
open aperture of f/1.8 which permitted
the production of instantaneous expo-
sures in ordinary electric light conditions.
The camera was an immediate success in
spite of a certain awkwardness in hand-

ling. One of the earliest and best of photo-journalists, Erich Salomon, used the Ermanox discreetly to photograph court trials and gatherings of politicians as well as covering social occasions in Germany in the late twenties and thirties. Zeiss Ikon paralleled the success of Leitz when they introduced their 35 mm camera, the Contax, in 1932. In 1928 Franke and Heidecke started to manufacture a new form of reflex camera which had twin lenses, one for viewing and the other for taking the photograph. It was called the Rolleiflex, and was designed to use 120 rollfilm on which twelve exposures of $2\frac{1}{4}$ in (6.3 cm) square format were obtained. All these cameras were expertly designed, precision engineered, and quick and easy to use. Germany became the centre of small camera production.

The major photographic film and paper manufacturers, Ilford, Kodak, Agfa and Gevaert, competed with each other for patronage of the swelling world-wide army of photographers in the production of improved film stocks, combining in-

Alvin Langdon Coburn. New York, number 9 in the series, c. 1912. Coburn travelled extensively between the USA and Britain and was most active in photography during the first decade of the twentieth century. He was a British resident during the inter-war years and lived in North Wales, devoting most of his time to mysticism.

*Walter Bird. Dancing Torso,
c.1938.* As a professional
studio photographer, Bird
specialized in powerful
portraits of business men,
destined for the boardroom,
and glamorous portraits of
stars of stage and screen,
using the strong, dramatic
lighting effects seen on the
cinema screen. He changed
his style completely when
photographing women, both
dressed and in the nude, to
a softly lit and delicate
interpretation.

creased speed with better definition, to
use with the small-format cameras. The
research laboratories urged their staff to
produce greatly improved printing
papers with longer tonal ranges but of
sufficient speed to make them suitable for
enlarging miniature negatives. A big
selection of both bromide and chloro-
bromide papers with linen, 'old master',
stipple, velvet or matt finish was available
in white, ivory and cream. Chloro-
bromide papers were popular with por-
trait photographers as they found the rich

tone scale and agreeable warm brown
colours well suited to the popular portrai-
ture of the period and the nude studies
which adorned exhibition walls and were
reproduced in *Photograms* and other
photography magazines.

In 1939, for instance, thirteen of the
sixty-four plates were of nudes, a high
proportion considering the fairly wide
range of subject matter. There is variation
in style from the decorative formalism of
Adoration by Yvonne (the female com-
ponent of husband and wife professional

W.G. Briggs. Portrait of Baby, c.1935. A frequent exhibitor at the major London Salons of Photography, he was the proprietor of Studio Briggs, one of the largest and most influential professional photographers from the 1920s to the 1960s. The studio was renowned for the quality of its photographs for industry and commerce. The work of the studio featured prominently in the early days of photography in advertising and public relations. W.G. Briggs was at his best when photographing babies and children.

photographers, Bertram and Yvonne Park, *née* Gregory) in which three Ivor Novello type males encircle a blonde female model, to *Moderns* by Dr Frank Neubert (a distinguished amateur photographer who was not a devotee of pictorialism) which portrays a physical tug of war between man and woman. Shot from a low viewpoint in light which glistens on the well-oiled skins of the participants, it is a typical thirties picture. It is interesting to note that by the end of the period nude photography is a good exemplar of the changes in style which had taken place. Gone are the soft, sinuous forms of the twenties when the photographer practised the art of concealment by subdued lighting and clever arrangement. The more revealing but inoffensive studies of the late thirties are more natural and less static. Walter Bird's *Dancing Torso* (reproduced in *Modern Photography*, 1939) is one of the best. Dorothy Wilding, the Bond Street portrait photographer, produced many fine photographs of the nude. Bertram Park and

Edward Steichen. Maurice Chevalier, 1929. One of the greatest exponents of photography, Steichen went through a number of different phases in his career. He was a graphic artist when he first became involved in photography, at which time (*c.*1894) pictorialism was at its peak and he worked in that mode initially, using the gum process for his prints. During the next decade he discarded 'soft focus' when photographing Rodin in Paris, George Bernard Shaw in London and J.P. Morgan in New York. In the twenties he became one of the most successful fashion and advertising photographers when working for Condé Nast publications: *Vogue* and *Vanity Fair*. He was one of the first photographers to make effective use of spot lighting in the studio, incorporating cast shadows into the overall design of his photographs. He was appointed Director of the Photography section of the Museum of Modern Art in 1947 and in 1952 embarked on the three-year project which led to his greatest achievement: The Family of Man exhibition.

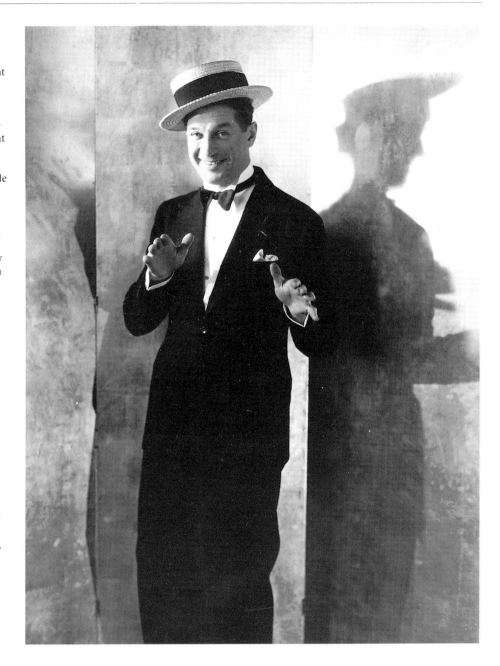

Yvonne Gregory produced a book on the subject in 1926; entitled *Living Sculpture*, it was illustrated with paintings of the nude as well as their own photographs. The text commenced with the admission that 'the Human Form, admittedly the highest manifestation of beauty in nature, is not found in perfection in any one person. The perfect figure, therefore, must remain an elusive ideal, ever luring man to struggle towards his own physical improvement and development.' During the whole of this period photographers were ever-mindful of the penalties of indiscretion in the portrayal of the nude. This was done by casting shadows across the relevant parts of the body, using the hands or thighs to conceal the pubic hairs or by pencil retouching on the negative. Edward Weston, one of the finest American photographers of his generation, adopted a different approach: he photographed peppers and artichokes in such a way that they resembled parts of the human body, in addition to live human forms.

Edward Steichen. Fashion Advertising photograph, c.1928. Reproduced in one of the Condé Nast publications by whom Steichen was employed, this reveals the photographer's flair for design and his use of 'contre-jour' lighting to emphasize the special features of the dress and hair style.

A favoured form of photographic image presentation in the twenties was the $3\frac{1}{4}$ in (8.25 cm) monochromatic lantern slide. Many amateur photographers made up lecture sets of slides with which to entrance fellow photographers on cold winter evenings. The best known of these slide makers was J. Dudley Johnston, a prominent Fellow of the Royal Photographic Society.

Many of the most distinguished photographers of the period were professionals. It was not unusual for those who earned a living by photography to have started as amateurs. In those days there was a small number of schools of photography, which offered one year full-time courses or a range of specialist courses in the evenings, such as printing, portraiture, commercial photography and colour photography. Examinations were even more limited and were conducted by the City and Guilds of London Institute. In the twenties and thirties there was still a big demand for portrait photography. This was a branch at which women

Howard Coster. Portrait of G.K. Chesterton, 1928. Self-styled 'Photographer of Men', Coster photographed many of the most eminent artists, authors and men of action of his time. He drew out the characters and personalities of his sitters as is evident in this portrait.

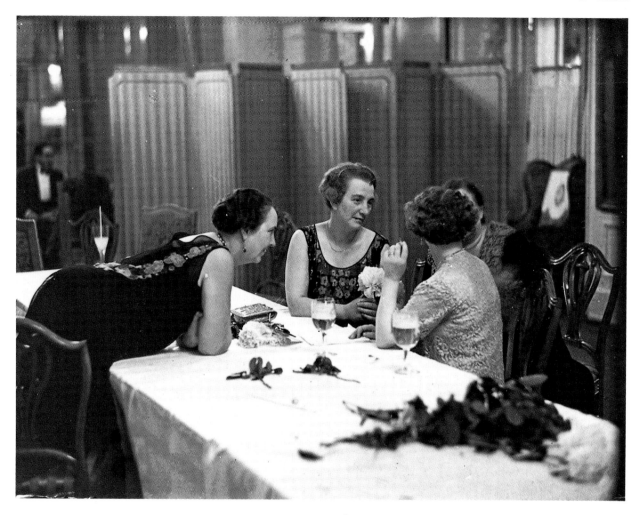

ABOVE *Erich Salomon. The ladies get together, Berlin, c.1929.* Salomon was not always popular with the ladies he photographed. He made no attempt to show them at their best, only one of this four would have been happy to see the photograph published.

LEFT *Erich Salomon. Anglo–French–American discussions at the Disarmament Conference, Lausanne, 1932.* Salomon trained as a lawyer before becoming a reportage photographer in Germany in the twenties. He was notorious for sneaking pictures on occasions barred to other photo journalists. Here Viscount Samuel (GB), Norman Davis (USA) and Edouard Herriot (France) are unaware of the camera.

Zoltan Glass. Happy Family at Seaside, c.1937. This Hungarian born photographer became pre-eminent in advertising photography during the forties and fifties. (He became resident in Britain in the thirties and began to practice photography as a professional.) Although this photograph looks like a successful holiday snap it was a very carefully planned and well-organized photograph to be used for publicity purposes. It could have turned out to be obviously contrived and unnatural but the great skill of the photographer has produced a spontaneous and happy family 'snap'.

excelled: Ramsay and Muspratt, two intrepid women photographers, had studios in Oxford, Cambridge and in Wessex; Lally Charles, Dorothy Wilding, Yvonne Gregory, Vivienne and others were in London's West End and Madam Yevonde had her studio in Kensington. There were many others throughout the country. There were many equally gifted male portraitists, such as Howard Coster, Hugh Cecil, John Erith, Anthony Beauchamp and Paul Tanqueray amongst them.

The Professional Photographers' Association, established in 1901 had been formed to co-ordinate and promote professional photography. A monthly magazine was published, a Code of Conduct established, meetings were organized and exhibitions of work were displayed. In 1938 the name was changed to the Institute of British Photographers, a qualifications system came into being and the introduction of examinations for students of photography was under consideration. The equivalent association in the USA is the Professional Photographers' Association.

On the professional front big advances were made in photography for commerce, advertising and industry. The major developments in communications were followed by improved marketing strategies and more powerful and intensified advertising campaigns and publicity

John Gay. Paddling at Blackpool, c.1930. It is unlikely to have been a casual snapshot, in which case the paddler would have been taken facing the camera. It is a typical subject of the period in that it shows Blackpool beach, with tower in mid distance, during a Wakes week when it would have been thronged with holiday makers from the industrial towns of the north west of England.

J. Dixon Scott. Salisbury Cathedral, c.1923. An eminent art critic as well as an enthusiastic photographer, Scott preferred the straight approach to photography rather than impressionistic pictorialism. His photographs are tranquil, featuring noble subjects in a peaceful setting with gentle skies. He contributed a stimulating and thought-provoking introductory essay to the special summer number of *The Studio* magazine in 1908 on colour photography.

Bill Brandt. Parlour Maid at a Window in Kensington, c.1933. Brandt established his reputation on a series of social documentary photographs, at a time when photo-journalism was barely recognized. This unique set of photographs reveals the strict social order between the wars, distinguishing the very different lives led by domestic servants from that of their masters and mistresses. Brandt went on to take a fine series of London under the blitz and at night. He was a discerning portrait photographer and produced an unusual perspective on nudes ranging from full-length studies to 'close-ups' of the body's extremities: fingers and toes.

Edwin Smith. Lakeside summerhouse in grounds of Stourhead, Wilts, c.1936. Although this photographer did not profess to be a pictorialist, he was one at heart and adhered to the principles involved. His work was both sensitive and romantic and reflected his love of nature and the picturesque. He made full use of the qualities of the photographic medium to reveal form and textures and knew how to make the best of light and shade to create impressions of dimension and depth as well as mood and atmosphere.

OVERLEAF *Angus McBean.* (LEFT) *Self Portrait with Umbrella, 1950* and (RIGHT) *Dorothy Dickson, 'surrealized', 1938.* A brilliant and imaginative photographer, McBean was fascinated by surrealistic imagery and the anti-art of the Dadaists. He used techniques such as combination printing and photomontage to produce his photographs in surreal terms and specialized in photographing personalities of the stage and screen and theatrical productions.

James Jarché. Princess Marina sits for her Portrait, c.1937. One of the most penetrating press photographers of all time, Jarché never missed an opportunity for a little touch of humour in an otherwise serious situation. He was always well to the fore at important national events and at everyday happenings which might yield a human story. He was a wonderful raconteur and held his audience spellbound or doubled up with laughter.

OPPOSITE *Howard Coster. Portrait of John Piper, c.1933.* When Coster encountered what he considered to be great qualities in his sitters he selected one or another means of revealing these in his photographs One way was to fill the frame with the head of the sitter, as in this portrait of the artist, and by the use of a strong lighting form.

techniques. The need for pictorial representation of products in a bold and arresting form became acute. Manufacturers and company directors looked to photographers to supply the images which could give their products and services the prominence which they desired. Several of Britain's finest photographers responded superbly to this challenge in the twenties and thirties. Companies of photographers were formed such as W.G. Briggs and Scaioni Studios, and large advertising agencies, J. Walter Thompson for example, established their own photography studios. Full advantage was taken by these photographers of the latest trends in image making and the most recent developments in photographic technology. A number of the most creative and talented of Britain's photographers were engaged in these pursuits: Shaw Wildman, J. Challoner Woods, John Havinden (brother of the designer Ashley Havinden), Nancy Sandys Walker, Angus Basil, Noel Griggs and Clive Cadwallader who produced unusual and effective photographs of Natural History subjects for Shell advertisements,

The work of these photographers was used to illustrate company reports and was reproduced in glossy magazines; it accompanied editorial features in newspapers, and was an integral part of poster designs for advertising campaigns. The medium they employed in the main was monochromatic. The use of colour photography was restricted in those days. The rewards were high but competition between photographers was keen, and advertising agencies could be ruthless. They were pathfinders in their own way, exploring new approaches, discarding old conventions, looking at the world afresh. They exploited the close-up and the angle shot, the instantaneous reaction, the spontaneous expression. Their ideas in photographic image-making eventually penetrated the ranks of amateur photography.

The cinema, especially the films of Eisenstein and other great creative film makers, influenced the most imaginative

professional photographers. This was first exemplified in the work of the society and early fashion photographer, Adolf de Meyer. From pictorialist beginnings he developed lighting techniques which glamourized his models and accentuated the clothes they displayed. He was followed at Condé Nast in America by Edward Steichen, one of the greatest photographers of all time. It was said that whereas de Meyer made every woman look like a cutie, Steichen made his models look as every woman wants to be seen.

Another distinguished photographer of the period with a flair for fashion who settled in the USA was George Hoyningen-Huene. He became chief photographer at French Vogue in Paris in 1926. Horst, Paul Outerbridge and, towards the end of the period, Martin Munkacsi, were innovatory professional photographers of their time.

The 1930s are often called the golden age of documentary photography in America. The plight of the migrant workers in the central band of the USA was cause for great national concern. Roy Stryker, Head of the Historical Section of the Resettlement Administration, commissioned a group of dedicated young photographers to document the conditions of the unprecedented migration and resettlement during this period, producing a social document of great importance. One of the most creative of these photographers, Dorothea Lange, wrote an associated text with her pictures. Most of this was based on conversations held with the migrant workers she photographed and added an extra dimension to her memorable photographs. Her work was an example to photo-journalists the world over.

In Britain photographers were also at work on the social scene in the thirties. The irrepressible James Jarché produced the best of news pictures, many of them rich in humour. The most famous of these photographers was Bill Brandt, on whose series, taken in a well-to-do house in Kensington, the *Upstairs-Downstairs* television series was based. With growing pressures in Nazi Germany, several talented photo-journalists, such as Hans Baumann (Felix Man) and Kurt Hubschmann (Kurt Hutton), fled to Britain and added their talents to an increasingly prestigious form of professional photography. In France, several brilliant photo-journalists photographed all social types with remarkable understanding of the human condition: they included Cartier-Bresson, Brassaï and André Kertész.

It was during the inter-war years that the manufacturers produced a range of materials for taking photographs in colour. Dufaycolor rollfilm became popular with amateur photographers, whereas tri-chrome carbro printing appealed to professionals with permanence in mind. This was followed by the Eastman Kodak Wash Off Relief process introduced in 1935. The invention of the Vivex colour print, based on carbro printing by Dr Douglas A. Spencer (later managing director of Kodak Limited) represented a significant step forward. Unfortunately the war intervened before Spencer could produce it as a commercial proposition in a form that was easier to handle. Less permanent processes such as Agfacolor, Kodacolor and Ektacolor materials for print making made their appearance after the war.

The Second World War brought major changes. Photography was an essential tool for documentary and propaganda purposes, and considerable advances were made in its use as an aid to science and medicine and for aerial surveys. But pictorial photography continued to be practised, as a relief from the strife and tension of war. There was a big increase in portraiture with more emphasis on reality and less on glamour and mood. Looking back, the inter-war years can clearly be seen as a period of unprecedented growth and development in the practice of photography and in its popularity as a medium for communication.

Photograms of the Year provided talented amateur photographers with a prestigious showplace for their work between the wars and after. These images provide an impression of the high standard achieved.

ABOVE LEFT *Foundry Workshop* by Skurikhin (Moscow) 1940.

ABOVE *The Chrysler Building NY* by Gordon H. Coster (Chicago) 1931.

LEFT *The Road Back* by Vladimir Dimchev (Bulgaria) 1955.

Colour Comes to All

illius of family photograph albums record the present day in lifelike, glowing colour, yet in the same album, the dog-eared snapshots of past generations appear in muted shades of sepia and grey. Most people regard colour photography as a recent invention; in fact, nothing could be further from the truth.

The earliest colour pictures had the hues of nature patiently added by hand. Almost as soon as there was a way to make permanent camera images, people wanted to add the dimension of colour to the straightforward shades of black and white, and some of the earliest daguerreotypes were brush tinted to add colour to the cheeks and brighten the hues of flowers. That dates colour, or 'coloured', photographs right back to the early 1840s.

Even movie pioneers were quick to recognize the commercial appeal of colour, and the first cinema films in colour were produced by the laborious process of hand colouring each frame, so basic was the need to see natural hues.

Hand colouring has continued ever since, despite the ability to take pictures in colour in the camera, and some devotees still believe that hand colouring is the best way to combine Art with the machine process of simple photography.

However, hand colouring was simply a means of crudely mimicking nature, and photographers soon looked for ways to make colours copy themselves onto the photographic plate, without the help of an artist. The earliest successes were all based on the experiments of James Clerk Maxwell. He demonstrated that it is possible to make a colour picture by photographing the subject three times,

through filters in the three primary colours—red, green and blue. Processing produced three black and white pictures of the subject, but if these were superimposed and viewed through the same filters, natural and lifelike colours appeared once more.

Maxwell's 1861 demonstration of this 'colour separation' process paved the way for colour photography as we know it today, but ironically his experiments succeeded only because of a fluke. Maxwell's photographic plates were not sensitive to red light so, in principle, red parts of the tartan bow he photographed should have appeared black. However, by happy coincidence, the red dye in the ribbon also reflected some infra-red radiation, to which the plate was sensitive. Since Maxwell's other two filters stopped infrared, the colours appeared correctly.

Though the process worked in the laboratory, it was barely practical in the studio. It was time-consuming, exacting in technique, and expensive. The need to make successive exposures through three different filters was very limiting, and the subject had to be static, leading to numerous colour still-lifes and landscapes; portraits were virtually impossible.

An American, Frederick Ives, was the first to make use of Maxwell's discovery in a commercial context. Over a period of seven years from 1890 he took out a number of patents, and in 1895 introduced his Photochromoscope system, which was (fortunately, perhaps) later renamed the Kromskop for commercial sale. The camera made separate images through red, green and blue filters, and after reversal processing, the glass plates

Colour Comes to All

LEFT Once the initial
excitement of the
photographic process had
worn off, people began to
notice that black and white
pictures were a little dull—
particularly daguerreotypes,
which had a cold, metallic
look. So daguerreotype
portraits, like this one from
the 1850s, were often hand
coloured. A daguerreotype
could easily be rubbed off
by careless handling, so
colour had to be applied
very gently. Usually fine
powders were dusted on
and set by breathing over
the plate, so the colours are
usually pale, and applied to
limited areas of the picture.
Prints, however, could be
painted brightly with
watercolours or even oils.

were put back into the camera to unite the
three images in a full-colour picture
which was viewed through the lens.

Perhaps the finest expression of this
method was the original Technicolor
movie system, which used a beam-splitter
camera to produce the separation nega-
tives, which were then dyed and super-
imposed. The Technicolor process was
colossally expensive, but is still unsur-
passed for the range and subtlety of
colour made possible by 'dye imbibition'
as it was known. Its finest monument is
the 1941 film *Gone with the Wind*.

Frederick Ives's beam-splitter camera
may have been practical, but its high price
put it out of reach of all but the very
wealthiest enthusiast, and popular colour

640 THE BRITISH JOURNAL ALMANAC (1936) ADVERTISEMENTS.

A THREE-COLOUR CAMERA . . .

It is widely recognised that a Three-
Colour One-Exposure Camera is
the very best means of producing
sets of negatives for colour-printing
especially for portrait, commercial,
and even advanced amateur work.
Only by such means moving, or even
" liable-to-move " subjects can be
handled with any degree of certainty,
while for studio portraiture in colour
—an up-to-date and highly-remunera-
tive line—the One-Exposure Camera
is indispensable.

Single-Exposure Three-Colour Camera size 9 × 12 cm. with barrel focussing device.

BUT THE CAMERA MUST BE GOOD, the product of a maker
of repute who embodies in every instrument the accumulated ex-
perience of years. Any camera in the BERMPOHL Series fulfils
these and all the other exacting requirements of colour work.
Examination of a BERMPOHL Camera, or even a set of
BERMPOHL negatives, will convince you. Literature on request.

A Few Outstanding Points :

Camera suitable for Ilford and Kodak
materials ; no parallax or double image;
suitable for daylight, arc, or incandes-
cent (separate screens supplied) ;
mirrors strongly mounted ; and, most
important of all, colours true to nature.

In addition, we recommend our
Repeating-Backs and Repeating-Back
Cameras, precision instruments that, despite
their lower price, also embody the well-
known " Bermpohl quality " of workmanship.

BERMPOHL & Co. *Single-Exposure Three-Colour Camera, size 5˝ × 7˝ with bellow focussing device.*

Write mentioning B.J.A. to :
Bermpohl & Co., Bluecherstr. 32, Berlin SW 29, Germany or
Johannes Herzog & Co., Hemelingen, Bremen, Germany

For 30 years before the
invention of Kodachrome in
the mid-1930s, the only way
to produce high quality
colour photographs was the
laborious three-colour
process, in which three
separate black and white
photographs of the subject
were taken through red,
green and blue filters and
then printed or projected
together. For simplified
operation, the three
photographs had to be
exposed simultaneously
with a specially constructed
three-colour, one-shot
camera, as this Bermpohl
advertisement from 1936
emphasizes.

129

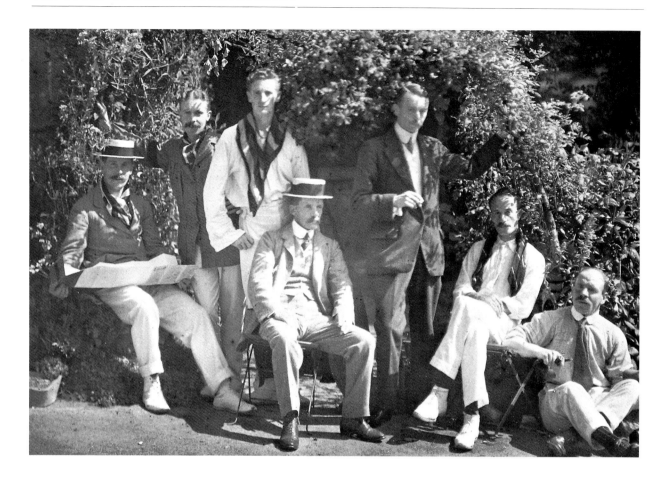

The Autochrome process launched in 1904 by the French Lumière brothers was the first genuinely popular and practical colour process, for the glass plates could be loaded into an ordinary plate camera and processed simply and quickly to give a full-colour slide. No wonder, then, that when the great American photographer Alfred Stieglitz first encountered the process, he exclaimed, 'From today, the world will be color mad!' And though the world did not quite go 'color mad', the numerous Autochromes that have survived, such as this atmospheric Edwardian group, testify to the success of the process with amateur photographers.

photography had to wait until 1904 when the Lumière Company of France put on general sale its Autochrome process. This used plates dusted with grains of potato starch, dyed in the three primary colours. The fine grains were thoroughly mixed and sprinkled onto a glass plate before it was coated with a standard black-and-white emulsion. A single exposure in an ordinary camera (with the glass side of the plate facing towards the lens) was all that was necessary. The grains of starch acted like tiny filters, so that the three 'separations' were made in one emulsion. After processing, the original subject was visible in natural colours when the plate was held up to the light. For the first time photographers could buy a box of colour plates, load one into whatever camera they normally used, make a single exposure in the normal way, process it, and an hour later view a colour slide. Even a modern high-street minilab cannot do much better.

The process was a breakthrough, and

the editor of the *British Journal of Photography*, George E. Brown, capitalized on the Lumière brothers' success by sending an assistant to France to buy some of the first Autochrome plates. He then exposed one, processed it in the *BJP* gentlemen's toilet, and sent a sandwich-board man down London's Strand advertising 'Come and See the Colour Photograph'.

New York got its first taste of the novel colour process soon after London, because the eminent American photographer Edward Steichen was supplied with plates before they became available to the general public. He showed his colour pictures, together with examples by Stieglitz and Frank Eugene, in November 1907 at the Little Galleries of the Photo-Secession.

The Autochrome process was imperfect because the grains of starch clumped together, causing fuzziness and a grainy effect. A bright light was also needed to view the picture because the system of primary colours used in the 'separations' was additive—creating white areas meant

adding all three colours together. Since the coloured grains of starch all absorbed some light, the brightest parts of the picture were at best a pale grey, and never a pure white. Additive colour is not widely used in photography today, though it is the colour system most often viewed by the public, in the form of the TV screen. The electronically scanned cathode ray tube, with its three separate colour guns, can easily provide the strength of light necessary to give a good white.

In addition to the Autochrome process, there were other systems of additive photography in the early years of the century and, like the Lumière brothers' process, all used patterns of minutely small coloured filters to separate the spectrum into three. Most processes used brightly coloured stripes or grids to ensure that each section of the light-sensitive plate was exposed to only one of the primary colours. Agfa in particular developed a plate similar to the Autochrome, but sharper, finer-grained and more subtle in colour. Both types had a quality of image which even today makes the viewer linger over them. The systems were successively improved and widely used by amateurs up to the mid-1930s. However, high-quality colour work was usually done with separations made with beam-splitter cameras or, for static subjects, using three separate exposures in a conventional camera.

By the end of the twenties the stage was set for the final breakthrough to the form of colour photography we use today. As far back as the turn of the century, there were suggestions that the problems of separating the spectrum into three

Let Kodak keep your vacation

Autographic Kodaks, $5 up

Eastman Kodak Company, Rochester, N. Y., *The Kodak City*

Autochrome was available only in the form of slow plates—so these nautical photographers had to be content with black and white pictures until later processes ushered in colour rollfilm.

could best be solved by coating three different light-sensitive layers onto a single sheet of film. If each layer was sensitive to only one colour of light, there would be no need for a set of filters to divide the subject's colours into three.

Such a 'tri-pack' system would overcome the drawbacks of the Autochrome and other similar processes. The greatest of the problems was fragility, and Autochromes were limited to glass plates—the layer of dyed grains was too delicate to be coated onto flexible film.

Flexible or rollfilm was introduced by George Eastman in the 1880s (see page 60), thereby bringing photography within reach of the general public, and changing it from an élitist pastime for the rich to a popular hobby. Eastman's rollfilm turned photography into what the great American photographer Steichen was later to term the 'folk art of the masses'. Those masses were by the 1930s a massive market indeed, and colour photo-

graphy was barred to them. What was needed to realize the potential of this market was a convenient rollfilm process that could be loaded into simpler cameras.

The tri-pack system was clearly the answer, and though the principles were understood, practical problems had prevented this dream from being realized. Two major interested parties were working towards this goal along parallel but quite different paths. At the suggestion of two young musicians, Leopold Godowsky Junior and Leopold Mannes, the Eastman Kodak company was developing a complex tri-pack system. Mannes and Godowsky proposed coating film with three black and white emulsions, each sensitive to a different part of the spectrum, so that the colour image could be formed with just a single exposure in the camera. Processing produced three exactly superimposed black and white images, which could be individually dyed to produce a perfect colour picture.

The multi-stage processing of the film was complex, time-consuming and finicky and relied on a viscous bleach diffusing through the film to remove unwanted colour. Kodak itself had doubts about the practicality of the system, but Mannes and Godowsky enjoyed the support of Kenneth Mees, a British photo-chemist who had been brain-drained by George Eastman to found his Rochester state research laboratories. Encouraged by Mees, Kodak went ahead with the project. Pressure to do so came from outside the company, as well as from within, because America was gripped by the worst depression it had ever known, and the new film —dubbed Kodachrome—meant assured employment for Kodak workers.

On the other side of the Atlantic, Agfa were working on a similar tri-pack colour film, but they had solved the problems in a different way. The Agfa film used the same three layers, sensitive to red, green and blue light, but instead of incorporating the colours during processing, as Kodak did, Agfa put colour-forming compounds right inside the film's emulsion. These compounds, called couplers, were initially colourless, but in the processing solutions they reacted with the by-products of development to produce brilliantly coloured dyes.

This elegant solution to the tri pack problem was not without its drawbacks. The dye couplers had a tendency to wander from one layer of the emulsion to another, causing unwanted colour distortions. Agfa's chemists stopped this by literally anchoring the dye couplers to long-chain molecules of inert organic chemicals.

These two systems account for virtually all colour material in use today. The vast majority are based on the 'substantive' Agfa system with its simpler processing cycle. However, a greatly improved Kodachrome film still sells well, for a number of reasons. Because the dyes are incorporated after processing—a 'non-substantive' system—Kodak's technicians can choose from a wider range of colours. Kodachrome slides therefore have a different palette, which some photographers and their customers prefer. Also, the use of a plain black and white emulsion, without dye couplers in it, gives finer grain and better detail.

Kodachrome and Agfacolor films opened the door to colour photography in another important way; the old processes were additive, starting with black and producing white by adding three colours, each a third of the spectrum. The new films used the subtractive primaries— yellow, cyan and magenta—that are produced when blue, red and green are taken away from white light. In the subtractive system white is represented by clear film, not by equal proportions of red, green and blue. So when the subtractive slide is projected, the white light goes straight through, almost unweakened, to give a bright white on screen.

At once the need for powerful lamps was gone. A mere 100–150 watts in a simple low-cost projector was enough to give a bright, colourful image on a makeshift screen formed by a sheet pinned to the wall. The smaller grains of the newer films gave sharp, detailed images, even when blown up to mural proportions.

Kodachrome film was available at once for the movie-maker; it could be used with existing cameras, and shown with

OPPOSITE The attempt to woo the still infant snapshot market for colour is clearly demonstrated in this 1950s advertisement for Ilford colour film.

the projectors already in use for black and white. The film was welcomed with euphoria by the photographic public. At first, only 16mm movie stock was available, but reaction to this anticipated the enthusiasm that would greet the arrival of 35mm still material the following year: 'The big screen filled with a motion picture in color—color so clear, unblurred, so utterly natural that my first impression was not of seeing a movie at all. It was more like looking out of a window at reality'. The *Boston Sunday Post* raved: 'House movies in color! Movies which give you a permanent and true record of your sweetheart's youthful complexion, with all its colorful loveliness . . .'

Kodachrome film for still cameras appeared in September 1936, in the form of 35mm film in 18-exposure cassettes, and 828 film, which took 8 pictures in the popular rollfilm cameras (see page 84). The 18-exposure 35mm roll cost about the same as today's price in money terms, but in real terms, colour photography in 1936 was many times more expensive than it is today.

The writer well remembers when, as a lad in 1937, he had to wait a whole day for Dad to return home in the evening to open the package that had arrived in the post that morning, containing the unbelievable miracle. The paternal supper purposefully delayed the moment still further; eventually there we all were, moving in COLOUR, stunned into silence, tears in Dad's eyes: photographic utopia had arrived. Today that film has faded to little more than a purple shadow but a similar moment must have been repeated countless times around the world in one way or another, our first experience of photography in colour.

However, Utopia was short-lived, for just two years later Europe was embroiled in the Second World War, and society was never to be the same again. In Britain, the major domestic photographic material manufacturer, Ilford, had its research into colour photography curtailed by government directive to concentrate on black-and-white emulsions. In America, however, Kodak's research continued the development of colour, branching out into a substantive system similar in some ways to that used by Agfa. The war actually accelerated this research, because the military demanded colour film for reconnaissance, and Kodachrome film was too complex to process on the battlefield. Kodak scientists therefore produced a negative-positive process which was to become Kodacolor film, the ancestor of the colour negative film used almost universally today. Later this evolved into Ektachrome film for substantive colour transparencies.

American amateurs embraced Kodacolor film whole-heartedly when it appeared in 1942. *American Photography* announced that 'the sample prints which we have seen made by this process are brilliant and beautiful and there is no doubt that color photography is slated for an enormous increase in popularity in the near future.' By 1950 the film shelves of an American corner drug store looked much as they do today, with Ektachrome and Kodachrome films for slides, and Kodacolor film for prints.

The situation in England was much bleaker, especially during the war years. Films of all types were available to the public only rarely, and then usually 'under the counter' for friends or good customers. My own supply worked out at one roll of exposures a year, which concentrated a schoolboy's mind wonderfully on making sure that each shot told.

Even after the war, supplies of colour film were restored only very gradually, and colour became available long after black and white film: Kodachrome film was in short supply for many years, and was eagerly sought by amateur British enthusiasts. However, by the early fifties the foundations of colour photography as a real alternative to black and white had finally been laid. The breakthrough for the amateur was the availability of materials that could easily be processed at home, notably Ferraniacolor. As part of the programme of 'reparations' imposed on Germany, the Allies made generally available the patents of German companies. The Agfa patents had been forfeited, and they were taken up in the USA by the Ansco Corporation, then a force in

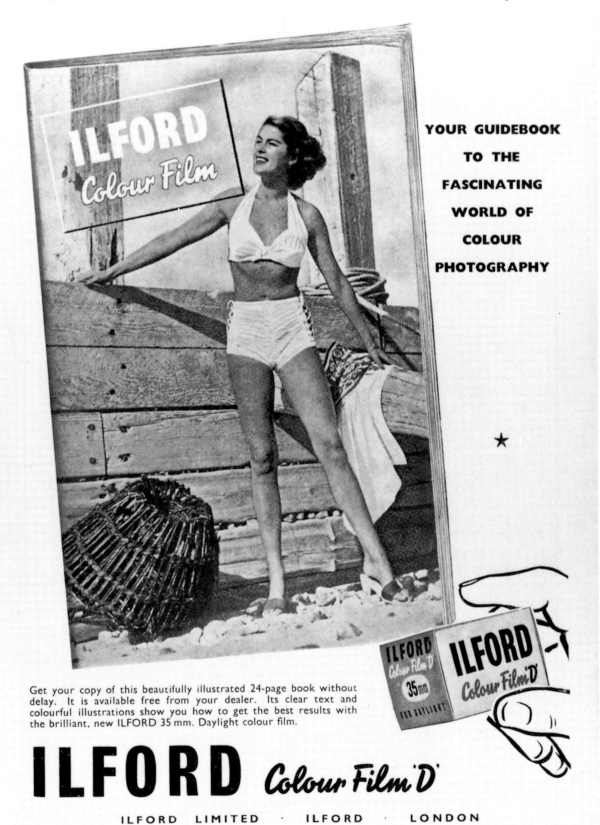

**YOUR GUIDEBOOK
TO THE
FASCINATING
WORLD OF
COLOUR
PHOTOGRAPHY**

★

Get your copy of this beautifully illustrated 24-page book without delay. It is available free from your dealer. Its clear text and colourful illustrations show you how to get the best results with the brilliant, new ILFORD 35 mm. Daylight colour film.

ILFORD *Colour Film 'D'*

ILFORD LIMITED · ILFORD · LONDON

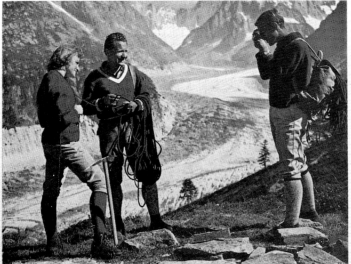

TRUE KODAK COLOUR STORIES

Punch, April 25 1962

London lecturer finds colour so easy with his new 'Colorsnap' camera

AFTER scaling the 25,850 ft. peak of Nuptse in the Himalayas, lecturer Christian Bonington, of Hampstead, does some holiday climbing in the Alps. Before taking his friends on a climb up the Grépon, he snaps them in glittering colour with his new Kodak 'Colorsnap' camera. "It's so easy to use" he says. "You just dial the weather on the front of the camera and get the right exposure every time. The 'Colorsnap' gives brilliant, needlesharp colour slides to illustrate my mountaineering lectures".

You, too, will find colour easy, with the 'Colorsnap' camera and Kodak colour film. You can take colour slides, colour prints and, of course, black-and-white pictures. Choose from two models of 'Colorsnap' cameras. See them at your Kodak dealer's.

COLORSNAP 35 CAMERA Just dial the weather on this precision 35 mm camera to get colour pictures full of brilliant detail. Top quality 'Anaston' lens **£10.18.1d.**
BANTAM COLORSNAP CAMERA For fewer exposures at a loading — takes 'Kodachrome' film in 12-exposure rolls **£9.14.6d.**
The 'Colorsnap' cameras take: colour slides on 'Kodachrome' film; colour prints with 'Kodacolor' film; brilliant black-and-white pictures; and flash (Flasholder extra).

A colourful memory of a happy climb. This is one of the vivid colour pictures Christian Bonington took with his new Kodak 'Colorsnap' camera on famous 'Kodachrome' film.

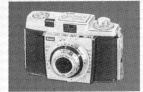

IT'S **Kodak** FOR COLOUR

Kodak's Bantam Colorsnap was the most famous of a series of 35mm cameras introduced in the 1950s to so simplify colour photography that even those with little experience could take successful colour sides. Nicknamed 'Auntie's camera', it had a simple 'dial-the-weather' exposure calculator on the back, where the photographer found an Exposure Value (EV) to set on the aperture scale.

the film market, to enter the colour field. In Europe the two companies which benefited most significantly from the Agfa colour film patents were the Belgian firm Gevaert (ironically taken over in the sixties by Agfa to form Agfa-Gevaert) and the old-established Italian film-maker, Ferrania, later acquired by 3M. Both produced good 'Agfa type' colour slide films, and, because Ferraniacolor seemed more tolerant of errors in processing, it enjoyed great popularity among amateurs.

Processing kits for Ferraniacolor were widely available, and the *British Journal of Photography* began to publish substitute formulae for those who preferred to mix up their own solutions from the raw chemicals. Many amateurs did this for their black and white work, and wanted to do the same in colour.

These pioneer films played an important role in popularizing colour photography, but they were gradually edged into the background with the appearance of Kodak Ektachrome film and better Agfa colour slide films. In the early fifties Ektachrome film began to be manufactured in Britain, and Ilford introduced Ilfochrome slide film, based on the Kodachrome process on which some of the early patents had begun to expire.

By the late fifties, colour negative film began to find a limited market among amateurs, and Agfa was initially more successful than Kodak. Nevertheless, colour photography for the mass of snapshooters was still a closed book. Much

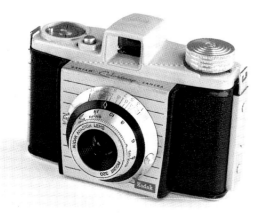

colour work was confined to photo-enthusiasts, and photographic societies and camera clubs provided a focus for these keen amateurs.

Membership of the clubs was largely white-collar, and local photo dealers were often prominent. Many clubs were affiliated to the Royal Photographic Society, with the result that values were handed down from the top and broadly based on the idea of traditional pictorialism—the search for beauty and harmony of form in pictures, taking its cue from the tenets of classical painting.

In the United States, the situation was a little different. The USA lacked an umbrella body as powerful as the Royal Photographic Society, and club activities and exhibitions tended to be much more local in nature. There were other differences, too, as this account brings out:

> The societies were better housed, and the interest taken in their work and the percentages of members in regular attendance at the meetings were greater than in Britain. The subscriptions were much higher, but, as a result, every society of standing provided good conveniences in the way of rooms open every day and all day, good laboratories (with the necessary apparatus and fittings), often a studio, and in several cases the further advantages of a good middle-class club, with comfortable reception and smoke rooms, and even a billiard room. The societies' business was conducted more formally and with more business-like precision than in Britain, and in some of the societies the meetings were followed by informal club suppers, which tended to produce useful discussion and exchange of experiences.

British clubs were centred around photo-technique. It was fundamental that photographers carried out their own processing and printing, since only then could the result be said to be personal, and show evidence of skill and artistry. This almost by definition excluded colour, because in processing colour film there was practically no margin for error. The photographer simply followed the

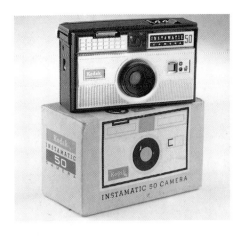

The appeal of the Instamatic to the snapshot market when it was introduced in the 1960s was obvious. Clean-cut, lightweight design combined with an ease of use rarely seen in a camera before. Colour films were now so tolerant that Kodak could get away with very simple exposure controls—there is just a 'sunny' and 'cloudy/flash' setting on this Instamatic 50.

manufacturer's instructions, and for most of the process creative interpretation was out of the question.

The equipment used for 'serious' amateur work was, if possible, a camera taking plates measuring $3\frac{1}{2} \times 2\frac{1}{4}$ in (9×6 cm) or $4\frac{1}{4} \times 3\frac{1}{4}$ in (11×8 cm). Such cameras had rudimentary adjustments to allow the foreground of the picture to be cut out, and to ensure that parallel lines in the subject remained parallel on film. Photographers using smaller cameras often seemed to have the single aim of proving that their miniature films could produce results as good as those from much larger cameras.

The club emphasis on the rules of pictorialism led to stilted imitative work by the less gifted, but at least pictorialism provided a framework of common standards against which personal progress in the craft could be measured. There were some who tried to broaden the photographic amateur's mind, and a major contribution is generally ascribed to the Australian Norman Hall, who edited the monthly magazine *Photography* and its associated annual, *Photography Year Book*.

But it was colour that really began to break the mould of staid amateur practice, and curiously it was the equipment factor that was the initial influence. Plate cameras—those in which each exposure was made on a separate glass plate—had for years been fitted with interchangeable rollfilm backs, and in this form they were used by enthusiasts for less serious work, such as family events. Most post-war colour films were available only in 35mm

or rollfilm forms, so to use colour, hobbyists had to use a small-format camera, or a rollfilm back on a plate camera.

The larger cameras, though, did not give good results with colour film in a roll holder. Projected pictures were not sufficiently detailed, and colours were washy. The fault lay in the camera bodies, which had a lot of internal reflections. With monochrome film, this could be corrected in printing, but in colour there was less margin for error, and the results were disastrous.

By contrast, the bodies of the most up-to-date miniature cameras were specially designed to reduce flare, and the advent of coated lenses in the fifties further enhanced the quality of colour pictures. As a result, good rollfilm cameras like the Rollei twin-lens reflex gave results several times superior to the old plate cameras beloved by serious amateurs. The final blow came with the introduction of high-sharpness black and white films in the 35mm and rollfilm formats. These films, from Adox in Germany and Kodak, were as susceptible to flare as colour film, but produced excellent pictures in the new, smaller cameras.

Market forces had a hand in the change, too. The cost of a 36-exposure cassette of 35mm colour film was virtually the same as the cost of a 12-exposure rollfilm; additionally, rollfilm cameras were more costly, and there was less choice than in the 35mm format. Newcomers to photography, particularly the growing youth sector, unhesitatingly opted for 35mm.

A new industry grew up, surrounding 35mm photography with a host of colour accessories such as slide mounts and mounters, hand viewers, projectors and so on. Because the volume of 35mm sales grew and there were many competing firms, prices of the smaller format fell in relation to rollfilm. Needing a new camera, the traditional serious amateur had to be strong-minded to hold out against the trend, and the withdrawal of Kodachrome film in roll form helped to push photographers towards 35mm.

The effect on the club scene, the core of amateur photography, was quite rapid considering that in essentials the clubs had remained the same since Victorian times. Colour categories were established for exhibitions and competitions; modern projectors and light-boxes for display

The burgeoning popularity of 35mm colour slide photography in the late 1950s and '60s spawned a whole new accessory industry supplying everything from slide mounts to projectors. Hand-viewers, with a simple battery-powered light and magnifying lens such as this Halina, became very popular. The slides (a square 2 × 2 inches when mounted) were slotted into the top and the light came on when the slide was pressed against a spring.

were brought in. For a while there were separate categories for trade- and home-processed colour in an attempt to carry over the element of personal processing skills from black and white. But Kodachrome film, indisputably the best, could only be processed by Kodak, and there was so little scope for variation in home processing of other films that the separate categories soon disappeared.

To achieve the age-old dream of perfect photographs in colour, the film had only to be exposed and sent away, and within a week the results were returned ready to view. All the old darkroom work was unnecessary; the rigid black and white criteria no longer applied in judgement of quality; and the meritocracy based on processing and printing skills, on which club life had largely been built, was no longer relevant.

In the space of a few years the serious amateur could be a good and admired photographer without possessing a dark-room or any of its related skills. Novice photographers no longer needed access to a pool of processing and printing know-how (and this had formerly been a prime reason for joining a club), so new member-ship declined, and the average age began to go up.

The process was completed by the social changes of the sixties, when the rejection of traditional values became almost an end in itself. To the emerging youth culture the club scene was anath-ema to the new illusions and beliefs.

The body politic of photography in-herent in the clubs did not die out, but its ideas and influence waned. Only now, in the late eighties, are there signs of a revival, with more young members re-sponding to a club's social attractions, but still the majority of modern amateurs remain outside. The network is thinner, but forward-looking clubs are flourishing in some areas. 'Print battles' between clubs have been joined by 'slide battles' with the advent of colour, and remain popular, however much the purist may dislike the concept.

Today's amateur enthusiast almost cer-tainly uses a 35mm single-lens reflex camera of good quality, loaded with colour slide film for serious work (the hobbyist market is the largest non-professional group using reversal film). Some colour prints will be made on

Few things confirmed the arrival of simple colour photography for the amateur more resoundingly than Polaroid's introduction of instant colour pictures in 1962. No longer did the photographer even have to send pictures off to a laboratory for processing; he just pulled a tab at the end of the film, waited 50 seconds then peeled off the backing to reveal the full-coloured picture. In tune with the vibrant, 'swinging' '60s, Polaroid called their new instant colour camera the Swinger, and this Super Colour Swinger is one of the early versions.

TOP LEFT It was on neat 35mm cameras like this Ilford Sportsman Vario that so many keen amateurs took their first steps in colour photography in the 1960s. Inexpensive and compact, yet with a full range of apertures and shutter speeds from 1/25 to 1/200, it was both easy to use and capable of giving colour slides of a fairly high quality in experienced hands.

BOTTOM LEFT The Canon AE-1 shown here was the first of the electronic single-lens reflex cameras which were to transform colour photography for the enthusiast, and persuade many of the less experienced that they, too, could use these highly automated cameras to achieve the kind of results which were once the exclusive preserve of the professional.

TOP RIGHT Compact 35mm cameras, like this Olympus 35-ECR, were the 1970s forerunners of the sophisticated electronic marvels of the 1980s that were to bring about what is little short of a revolution in photography for the snapshooter. With automatic exposure control and rangefinder focusing, the Olympus ECR could give good quality colour pictures with a simplicity that would put off only the greenest novice.

BOTTOM RIGHT The Pocket Instamatic range of cameras superseded the original Instamatics in 1972. The cameras were smaller, and some were a good deal more sophisticated. For example, notches cut in the tiny film cassettes keyed the film's sensitivity into the camera.

reversal paper, but for the majority of enthusiasts, these prints will be trade-processed, rather than printed in the home darkroom. The reasons for this swing away from home processing are easy to understand: despite considerable simplification, colour printing is still time-consuming, and there is little scope for modification and adjustment to the final image. An evening's work in the darkroom might produce a set of prints no better than those obtainable in hours from a fast turn-round colour processor— and at considerable extra cost.

THE MASS MARKET

The distinction between amateurs and snapshooters is held to be that, whereas the former devote most of their photography to making pictures that they and hopefully others will admire, the snapshooter's aim goes no further than recording family, friends, places and events. None the less, in the late thirties the family photographer probably owned a cheap box camera with a simple lens.

The black and white rollfilm was trade processed and contact printed, since the negative size, usually $3\frac{1}{4} \times 2\frac{1}{4}$ in (8×6 cm) was sufficiently big for comfortable viewing without enlargement. Quality was good enough for the maximum honour— sticking in the family album.

In the fifties, snapshot cameras improved in design, appearance and convenience, and more and more use was made of plastic. The Kodak Bantam camera was just good enough to take colour pictures, and Kodachrome film was supplied in a format to fit the camera. However, colour film was seldom used by the snapshooter. Kodak aimed to change this, and after working in secrecy launched in spring 1963 the Instamatic camera series.

It was probably the best-judged market coup in commercial photographic history —a complete new system of snapshot photography with a new format, the 126, and colour slide and negative films to match. The lens and camera design were good enough even in the cheapest models to give satisfactory prints.

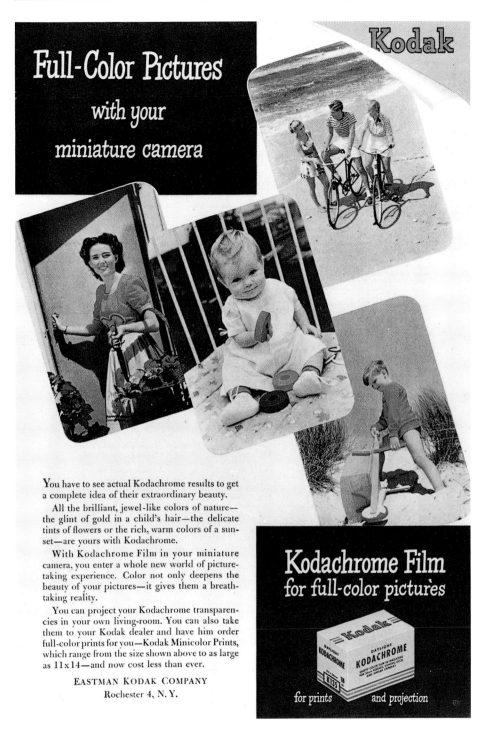

Full-Color Pictures with your miniature camera

Kodak

You have to see actual Kodachrome results to get a complete idea of their extraordinary beauty.

All the brilliant, jewel-like colors of nature—the glint of gold in a child's hair—the delicate tints of flowers or the rich, warm colors of a sunset—are yours with Kodachrome.

With Kodachrome Film in your miniature camera, you enter a whole new world of picture-taking experience. Color not only deepens the beauty of your pictures—it gives them a breathtaking reality.

You can project your Kodachrome transparencies in your own living-room. You can also take them to your Kodak dealer and have him order full-color prints for you—Kodak Minicolor Prints, which range from the size shown above to as large as 11 x 14—and now cost less than ever.

EASTMAN KODAK COMPANY
Rochester 4, N. Y.

Kodachrome Film
for full-color pictures

Kodachrome

for prints and projection

The appeal of Kodachrome film was so immediate that Kodak had little need to advertise—demand exceeded supply, and the company were obliged to open new processing plants in order to satisfy the craze for colour.

Kodak had correctly judged that the new generation wanted smaller, easy-to-load and easy-to-use cameras. The film cartridge did away with the laborious and sometimes perilous rollfilm procedure of loading, threading, then, after exposure, reeling on for unloading, and sticking down the trailer. Now one simply dropped the cartridge in the back of the camera, took the pictures and removed the cartridge for processing.

The system was the perfect technical and practical answer to the need, truly in the spirit of George Eastman's famous slogan, 'You press the button, we do the rest'. The Instamatic could not fail, and

although Agfa tried to compete, with its 'Rapid' easy-load system based on the 'Karat' cartridge they had introduced some years previously, the Kodak Instamatic began to sweep the board.

There was serious discussion about whether the Instamatic camera spelt the end of 35mm photography, but the Japanese industry, apart from passing recognition with a few models, stood aloof. Japanese manufacturers were not interested in a system that lacked the precision engineering tolerances needed for 35mm photography, and correctly foresaw that that format would not be displaced. Then as now, 35mm equipment formed the core of the Japanese production of cameras.

Part of the success of the Instamatic camera lay in the timing of its introduction. Rejecting the dull grey world of post-war austerity, the younger generation of the sixties saw colour itself as an expression of freedom and life, and the brighter the better. The colours of the sixties were vivid, whether applied to clothes, cars or psychedelic design and paraphernalia. The quality Sunday newspapers started to publish colour supplements. In 1968 the BBC commenced colour transmissions. Colour photography in the Instamatic camera system fitted the scene perfectly.

Judicious retailing incentives helped establish the Instamatic camera, too. Some dealers offered 10 shillings for the humblest box camera in part exchange for a new Instamatic camera, and for a better-quality camera the trade-in value was even higher. Such incentives spelt doom for many an old favourite, and never again would the family box camera be a symbol for snapshot photography.

In 1963, too, Polaroid introduced the first instant colour film and a camera to go with it. The first cameras were expensive, and featured automatic exposure control, but later on cheaper models were introduced. In particular the 'Swinger', named after the trend-setters of the permissive sixties, brought instant colour photography within everyone's reach.

Around the flourishing colour snapshot market grew a new photofinishing industry to serve its needs. The existing photofinishers were primarily equipped to process and print black and white film, and the industry now needed automated large-scale processing equipment to cope with rising demand. Local chemists and photographic shops, which had often run back-room black and white developing-and-printing services, could no longer cope with the stringent chemical and physical requirements, or the rising demand, and they gradually became collection points from which print orders could be forwarded to large laboratories.

Competition spawned new forms of business. It soon became apparent that a processor's throughput depended on the photographer having a film constantly in the camera. Thus began the 'free' film trade—when films were sent for processing, the prints were returned with a new roll of film. Processing by post emerged, and promotional tie-ins with manufacturers of other consumer items helped draw processing trade away from the traditional chemist and photo-retailer.

Marketing ploys such as these helped move snapshooters from black and white photography to colour, but the evolution of equipment also had a hand in the change. At the upper end of the snapshot market, exposure automation was increasingly available, ensuring that even someone with no photographic knowledge could achieve a large score of satisfac-

It was Kodak's introduction in the 1960s and '70s of slot-in film cartridges—first the 126 Instamatic and then the miniature 110 format—that, more than anything, brought colour photography to the snapshooter. These films and their cameras were so easy to use that colour photography was no longer difficult—it was actually easier than black and white. The photographer simply dropped the cartridge into the camera, shut the back and fired away. Once the film was finished, the cartridge could be plucked out and sent off for processing.

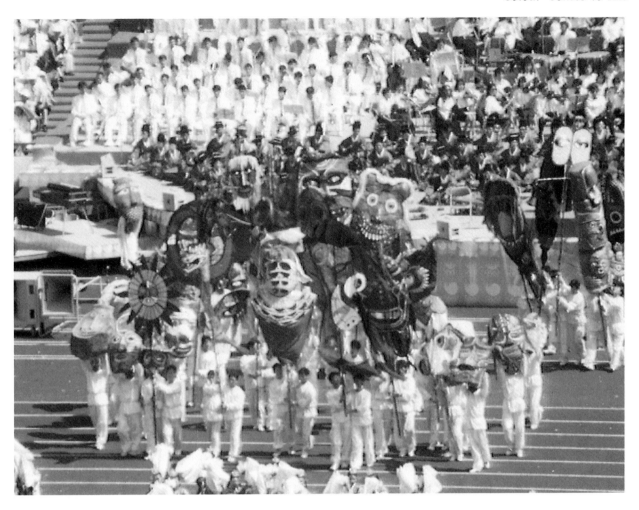

Some believe the future of colour photography lies in electronic still cameras exploiting video technology. Processing time and wet chemicals are eliminated, and electronic still pictures can be transmitted. This is the still video camera (BELOW LEFT), Nikon QV-1000C and the Nikon QV-1010T transmitter (BELOW RIGHT). The picture of the Seoul Olympics (ABOVE) was taken with this camera.

torily exposed photographs from every roll. By the end of the sixties, colour photography accounted for nearly all mass-market photography—a revolution in under ten years.

Encouraged by the success of the Instamatic camera, Kodak took the logical step of introducing an even smaller format, the 110 or pocket Instamatic format. These cameras were truly pocket-sized, but the smaller format had other advantages besides compactness: in general, the smaller the film format, the more of the subject is sharp, so only the most expensive pocket Instamatic cameras were fitted with focusing controls.

For the lower end of the snapshot market the new, smaller cameras made colour photography even easier and more convenient, but for those seeking quality the 110 format was a retrograde step. The small negatives produced grainy images when enlarged much bigger than a postcard, and Japanese camera manufacturers responded by pushing the advantages of the larger 35mm format. The Japanese began to prosper, exploiting the upper end of the snapshot market for those who demanded sharper pictures than the Instamatic camera could produce.

In order to improve the quality of pictures taken on the smaller formats, Kodak invested millions in the research, development and production of films with improved sharpness, grain and colour. This bore fruit in the mid-seventies with a new range of colour negative films, which gave Kodak the crucial quality advantage over the competition. Their lead did not last long though, because Japanese manufacturers Fuji and Sakura were quick to acquire the technology (according to rumour, the Japanese government undertook to lower import tariff barriers on Kodak products in return).

The Japanese emulated not only Kodak film, but the printing paper as well, and thus gained a foothold in a market that was at least as big as that for film. European manufacturers also recognized that even a small share of this massive market represented a considerable fortune, and gradually colour film and paper

technologies became more and more standardized on Kodak's processes. Uniformity progressively replaced a diversity of different chemical processes, until colour negative films of different makes were virtually indistinguishable by mass-market photographers, and could be processed side-by-side.

Faced with a declining share of the market, Kodak responded with what they expected would be a technological coup. Again working in secret, the company launched its Disc camera and film in 1982. This was a high-technology product offering a cigarette-box thin, ultra-compact camera that took tiny colour negatives on a film disc. To make the camera so compact, Kodak produced a special lens with an aspheric surface, and manufactured the lens under conditions of maximum industrial secrecy.

The disc system extended further than just camera and film, though. The disc could be encoded with processing and reprint information so that—potentially at least—colour laboratories could completely automate developing and printing, right through to the wallet of prints packed for return to the customer.

Despite the Disc camera's revolutionary nature, or perhaps because of it, the system was not a great success. Pictures were grainy, even at postcard size, and the most naive snapshot photographers could see that the larger 110 and 126 formats gave sharper results. There was resistance to the cameras themselves, perhaps because people liked a camera to look like a camera, not like a cigarette box. The processing industry resisted change, too; changing processing equipment to suit the new format was a costly business, and processors could reap the benefits of the new technology only if photographers switched to Disc cameras in huge numbers. In the end, they did not, and in 1988 Kodak ceased making the cameras, though film production continues.

While Kodak were making their ill-fated move to a yet smaller format, 35mm colour photography was expanding. The Japanese, by the mid seventies the unchallenged world leader in small-format cameras, had proved correct their

Successive simplifications in
the early part of this
century brought colour
photography several steps
closer to today's snapshot
ethic.

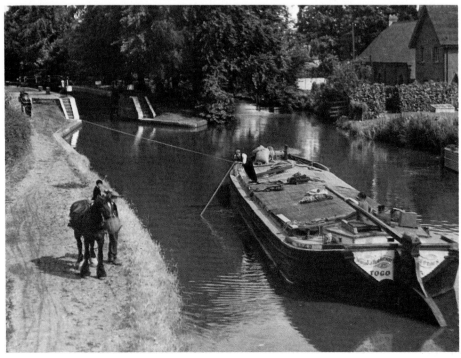

RIGHT AND BELOW The widespread introduction of colour negative films in the 1950s greatly broadened the appeal of colour photography. Early print films lacked the colour fidelity of their modern counterparts, though, and portraits in particular look raw and far from natural.

FAR RIGHT By the 1970s, colour film and camera technology had improved by leaps and bounds, and even casual snapshots have colours as good as professional portraits taken a decade earlier.

The Painter, taken by G. MacDominic in 1955, is typical of a more casual post-war approach to colour photography.

Today the huge bulk of colour pictures are shot on negative film. The film tolerates even quite large exposure errors, so it is ideally suited to applications such as holiday photography (RIGHT), where the photographer does not want to be bothered with the niceties of photographic technique. The film shrugs off colour errors, too, because colour imbalances can be corrected at the printing stage. Thus scenes that contain a diversity of different light sources (BELOW) can be shot without the special filtration that is needed with slide films.

ABOVE In marked contrast
with colour negative film,
colour transparency film is
very much the choice of the
professional. Though the
film demands more careful
exposure, it yields sharper
images and richer hues.

Introduced in 1946, Ektachrome, Kodak's sheet film for colour transparencies, soon became the standard in professional studios throughout North America and Europe. This cheerful studio fashion plate (RIGHT) is typical of the bold, colourful work of the 1950s and '60s. In their infancy, Ektachrome and other colour films were insensitive to light, and had other drawbacks. However, extensive research has greatly improved the film's sensitivity and rendering of colour and tone, and modern Ektachrome films take in their stride scenes that would have proved difficult for their predecessors to handle (ABOVE).

ABOVE AND ABOVE RIGHT
Kodak ciné cameras were
equally at home in the thick
of the battle, or around the
Christmas tree, as these two
advertisements spell out.

Some of the shadow puppets that anticipate movie films
were highly complex. This magnificently gilded example
from Java has separate rods for articulating arms and legs.

decision to stay with the 35 mm format. The advent of microprocessor control meant that exposure automation was cheaper to build in to a camera, and soon even inexpensive cameras had this feature.

Japanese 35mm cameras developed along two parallel lines: at the lower end of the market pocketable 'point-and-shoot' models provided snapshooters with much better quality than the 110 and 126 formats, in a package that was little bigger than the cartridge-load Instamatic cameras. Enthusiasts were offered precision single-lens reflex cameras that were highly versatile and gave superb results. In real terms, the price of both types of cameras fell rapidly throughout the seventies and early eighties, and with the introduction of automatic focusing, built-in flash and other convenience features, 35 mm colour photography came almost totally to dominate the market.

So now, barely fifty years after Kodak and Agfa made their separate research breakthroughs and opened up colour photography as a practical medium for all, the world is sold on 35mm photography using colour negative film. The through-put is colossal—some 17,000 million colour prints are turned out each year by machines that can print as many as twenty pictures a second, and the figures are rising. Electronic/magnetic still photography is still in its infancy and hardly threatens the status quo—most systems still need two minutes to make an inferior postcard-size print. The conventional colour negative process is thus the clear favourite to be the medium of popular picture-taking well into the next century. Colour photography is now the undisputed folk-art of the masses.

From Home Movie to Home Video

Photography was described by Fox Talbot in 1839 as 'a process by which natural objects may be made to delineate themselves without the aid of an artist's pencil'. For the public, not least those without artistic ability, it was an exciting development. But for everyone intrigued by the possibility of capturing images of life, more was to come. Daguerreotypes and the calotypes of Fox Talbot were mere fragments of reality, and with the lengthy exposure times involved those fragments often had a frozen and inanimate appearance.

Only when a rapid succession of still photographs could be strung together was the realism of the cinema made possible—described in 1896 by one viewer as 'so faithful to life that one longed to be there'. The idea of displaying or reproducing moving images had been around for centuries either as live action with the elaborate silhouettes of the Chinese shadowgraph or, much later, as flicker-books of animated drawings.

With the magic lantern slide, Victorian family gatherings in the winter evenings had already been offered some diversion —enhanced not only by photography in place of earlier hand-drawn slides, but even by ingenious devices where parts of the slide were articulated so that the operator could introduce movement.

To turn still photographs into moving pictures, however, it took the tenacity of a number of inventors from France, England and the USA—names now legendary in the history of cinematography, such as the Lumière brothers, Edison, Demeny, and Acres, who often worked in isolation from each other, at times in competition. As with photography, and indeed television, it is impossible to attribute to any one person the invention of cinematography.

It was, however, an Englishman living in the USA—Eadweard Muybridge—who made the first credible demonstration of animated photography, albeit without having the means of turning his pictures into real movies. In 1878, Muybridge set out to photograph the sequence of movement of a galloping horse—allegedly for a Governor of California who wanted to settle a bet as to whether the horse ever had all hooves off the ground at any one moment (a story now disputed). Muybridge arranged a line of still cameras so that each would be triggered off by a trip wire stretched across the path of the galloping horse. The resulting picture series led Muybridge to develop the techniques of what came to be called chronophotography. The French were not idle either—Dr Etienne-Jules Marey was carrying out similar work, especially to study the movements of birds in flight.

Putting these picture series on to a medium that could display them in rapid succession—recreating the original movement—was not so easy. Various devices already existed for displaying short strips of animated drawings, but these were little more than drawing room toys. For example, the Zoetrope used a spinning cylinder with vertical slots through which the strip of drawings inside the cylinder was viewed. But cinematography could only be realized when photographs, taken in rapid succession, could be printed on to a continuous viewing strip capable of projection.

The idea of moving pictures has a history that predates cinematography by many centuries. In South-east Asia, shadow puppets and shadowgraphs have been used for hundreds, if not thousands, of years to accompany narratives, both religious and secular. The puppets are cut-out figures supported on rods and held behind a translucent screen in front of a lantern, so that their shadow can be seen on the screen.

The first attempt to do this was made by Louis Le Prince in the 1880s. Le Prince was working in the unlikely location of the Institute for the Deaf at Washington Heights, New York. His wife was employed at the institute, and Le Prince obtained the use of a well-equipped workshop there. The first true movies, albeit 'dim outlines of figures', were projected on to a whitewashed wall in the basement of the institute.

Le Prince applied for a US patent in 1886, and followed this with a UK patent two years later. At that time he was working in England where he exposed a 'film' sequence on paper at about 8 to 12 pictures per second, shot in his father-in-law's garden in Leeds. Another view, of Leeds Bridge, was described by a colleague 'as if you was on the bridge itself. I could even see the smoke coming out of a man's pipe, who was lounging on the

Moving pictures were popular even before the invention of photography, and many a family had a magic lantern which projected painted pictures onto a screen. These were made to move in all kinds of ingenious ways—levers for joggling the picture, cranks for turning it and string drives for rotating it and much more besides—as these three lantern slides show.

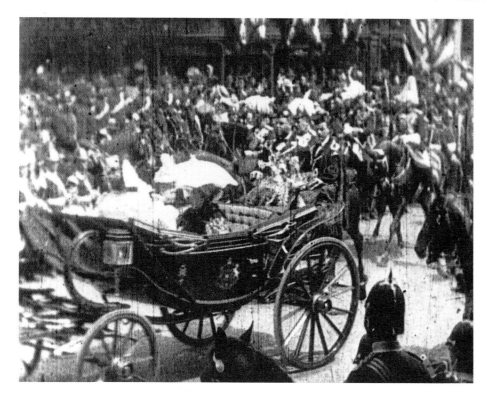

A remarkable window on history, this is a still from one of the earliest surviving motion pictures. It shows Queen Victoria, then nearly 80 years old, riding in her state coach during the Diamond Jubilee in London in 1897. 'It was like a triumphal entry,' the Queen wrote of the occasion, and the crowds formed 'one mass of beaming faces', cheering her from Paddington to Buckingham Palace. Fortunately, the day was hot and sunny—which is why we are able to see these images so well.

bridge.' Although Le Prince is said to have later projected his 'film', paper was not of course a suitable medium and it was not until George Eastman, the founder of Kodak, introduced celluloid rollfilm in 1889 that a basis for true cinematography became possible.

Although Eastman's celluloid rollfilm was introduced for still photographers and heralded the beginnings of popular photography, it was also exactly what was needed by the movie pioneers. Thomas Edison saw this as the answer to projecting movies and in 1895 the Lumière brothers Auguste and Louis used celluloid for the first projection of film to a paying public in Paris. To the Lumières also goes the credit for establishing (if not inventing) the name 'cinematographe'.

The gauge of film used by the Lumières was 35mm, setting the standard that the commercial cinema adopted and which survives (in modified form) today. But 35mm was a relatively bulky and expensive medium, as were the combined camera/projectors used with it, preventing cinematography being suitable for amateurs, least of all in the home. It was at the same cumbersome stage that photo-

graphy had passed through earlier with its large-format cameras and heavy ancillary equipment.

An Englishman, Birt Acres, soon had the idea however of splitting 35mm down the middle so that smaller equipment could be used, even in the home. In 1899, Acres demonstrated this new 17.5mm gauge to the Croydon Camera Club, using his own design of a combined camera/projector. Other narrower gauges came at around the same time—21mm, 15mm, 13mm—and even a disc carrying the frames in a spiral.

Although some films had been amateur in the sense that 'gentlemen' of private means were using cinematography for scientific amusement as well as profit, the arrival of narrower film gauges served to focus attention on the practicability of home movies for the public. By 1912, the concept became a reality with the introduction by Charles Pathé of the KOK Pathéscope home cinematograph.

Pathé was to become a name synonymous with home movies. The KOK projector and camera used 28 mm cellulose acetate safety film, avoiding the hazards posed by the highly inflammable nitrate

ABOVE It was the Pathéscope KOK projector, introduced by Charles Pathé in 1912, that made home movies a reality. As Pathé's advertisement of the time pointed out, 'Hitherto it has not been possible to introduce the Cinematograph into private houses and schools. The reason for this has been the danger in using (highly inflammable nitrate) films'. The Pathéscope, however, used cellulose acetate safety film, and an electric light, rather than the gas lights often used.

ABOVE RIGHT It was in magic lantern shows that the first seeds of cinematography were sown. In the public lantern slide shows, with their sequence of images and accompanying narrative, could be seen many of the elements of the modern cinema. And the development of slide projection apparatus, such as this gas-illuminated Monarch Ethopticon from the 1890s, was a vital prerequisite for the motion picture.

stocks current at the time. Indeed, nitrate film certainly was responsible for at least one death in an English home. But it was the arrival in 1922 of 9.5mm safety film, again the Pathé, which brought the cost of both equipment and materials within the reach of a wider public and signalled the real beginning of the home movie story.

In the earliest days of amateur cinematography, it was either the rich or the technical enthusiasts who dabbled in movies as a pastime. A few people even built their own projectors to show the films that were beginning to be made commercially: one English enthusiast who later became a doyen of the amateur cine movement, Harry Walden, built a 35mm 'viewing machine' in about 1912, inspired by the book *Animated Photography* which had been written by Cecil Hepworth, one of the great film-makers of the time.

The ability to show films in the home, even without electricity, created a demand for film libraries; one of the first on record started in Germany in 1900. The machines were hand-cranked, used oil lamps or gas burners as illuminants—extremely dangerous with nitrate film—and in England were sold in general stores, even sports shops. By the early twenties, newsreels or shortened ver-

sions of films being shown in cinemas and fairgrounds were the mainstay because the early projectors had a limited spool capacity. Newsreels such as *Pathé Gazette* were the equivalent of the modern TV current affairs programme for home viewers, albeit weeks, months, even years out of date. Queen Victoria's Diamond Jubilee on film was typical of the great favourites, but so too were those of film stars of the day like Douglas Fairbanks Snr and Charlie Chaplin.

Some enthusiasts were, of course, beginning to shoot their own films, mostly as simple records of family life or events of interest. The first claimed amateur movie was shot as early as 1896 by a Russian, A. P. Fedetsky, as a record of a Cossack riding display. Some of the earliest examples of British film-making in the National Film Archive almost certainly include amateur footage although not identified as such (in those days the distinction might be a subtle one): 'children paddling in the sea' (1899), and 'boys playing in the snow' (1900). Children rather than just babies on the lawn seem to dominate; another—'children in a tent' —is specifically claimed as a home movie on 9.5mm film (but wrongly dated as 1920, two years before the gauge arrived).

The shift from trivia to more serious home movie-making was not to start in earnest until the mid-twenties. In Britain the first amateur cine club was started at Cambridge University in 1923, to be followed in 1925 by the first film society —the beginning of a movement that saw in film a new cultural experience (the members of that first society, which met in a cinema in Regent Street, London, included many of the intelligentsia of the day, such as Roger Fry, Augustus John, George Bernard Shaw, and H. G. Wells).

There were parallels in America: the growing numbers of 'little movie camera' owners found a voice with the organization in December 1926 of the Amateur Cinema League, which pioneered 'the advancement of amateur motion picture photography and the promotion thereof . . . and the organization of clubs of amateur cinematographers . . .'. The non-commercial League also published a magazine to advance the cause.

The *New York Times* was prompted to comment on the organization in a leader, remarking that its establishment 'expresses the wish for assistance of the thousands who like taking their own motion pictures', and continuing, 'people who have regarded the commercial movie as the true child of nickleodeon, born for no greater heights, are bringing their complex and exacting standards to bear on the Little Movie. Their understanding, once focused on amateur work, will be valuable to the commercial movie . . . New developments are bound to come from an alliance among the most intelligent and cultivated minds interested in both big and little movies.'

The movie, whether as an entertainment or a do-it-yourself medium, was now attracting more than just the attention of the dilettante and the wealthy parent. On the one hand it was now establishing itself as a new art form worthy of the same public acknowledgement as literature; and on the other it was about to become more widely accessible to home moviemakers and viewers with the introduction of simpler, better and cheaper equipment.

The novelty stage was passing, and the arrival of 9.5mm made the equipment and

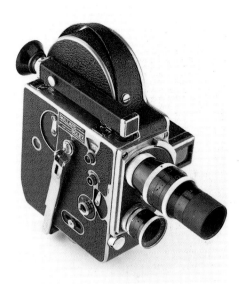

For many years up until the mid-1960s, the Paillard-Bolex H16 (LEFT) and the Bell & Howell, along with the Kodak Cine-Special, were the cameras used by amateur moviemakers who took their craft seriously. Using the larger 16mm film format, rather than the 8mm preferred by the casual family user, these cameras gave the kind of quality that eventually converted the professionals—and in turn spelled the end for these cameras, as the professionals demanded more sophisticated 16 mm equipment.

the film stock relatively less expensive. Silent movie shows were becoming the ultimate in home entertainment—albeit still enjoyed by the few who could afford about £6 ($30) for the projector alone (equivalent to several weeks' wages for the average middle-class man). The availability of more significant entertainment on amateur gauges and the rising stature of the cinema generally meant that the home movie show was a social event, an occasion to which friends were specially invited.

Silent classics of the commercial cinema were now available on 9.5mm, such as *Metropolis* and *The White Hell of Pitz Palu*. But the limited capacity of film spools demanded some judicious editing by the distributors, so that for example *Metropolis* was squeezed on to five reels when versions of the original occupied between ten to fifteen.

A challenge to 9.5mm appeared, however, with the introduction by Kodak in 1923 of 16mm film. Although the cost of this wider gauge made it strictly an indulgence for either the totally dedicated or the wealthy, it was later to become a significant development in narrowing the gap between the commercial cinema and the home user. Titles released on 16mm

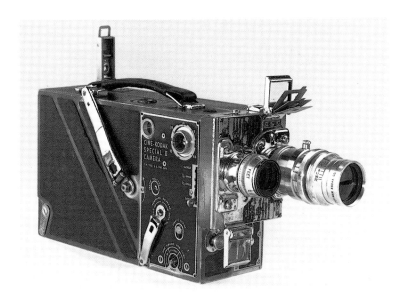

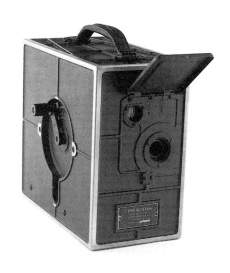

ABOVE When introduced in 1933, the Cine-Kodak Special was one of the most sophisticated cameras yet designed for the amateur market, and it was to become a standard with 16mm users. A review of the time enthused, 'Cine-Kodak Special is the most remarkable 16mm motion picture camera ever produced . . . The introduction of the Cine-Kodak Special opens up entirely new fields for advanced and specialized work.'

ABOVE RIGHT In 1923, just a year after Pathé launched the revolutionary 9.5mm format, Kodak stepped in with a new format, 16mm, that was to prove more durable, and indeed is still a film industry standard today. The Cine Special was Kodak's first 16mm camera. It was bulky and cumbersome and, for a few years, had to be hand operated, so a tripod was essential. However, the availability from the 'Kodascope Library' of full-length feature films for hire in 16mm—9.5mm versions were cut heavily—was a telling point in favour of the format.

were available in uncut versions, the quality of the projection equipment was better, and cameras of improved design were introduced by a number of companies.

Amateur movie-making was also becoming a more serious hobby, with cine clubs starting to produce complete films and a few enthusiasts trying very hard to emulate the style, if not the quality, of Hollywood. One such club, Ace Movies in Streatham, London, operated a tiny studio in the cellar of a chemist's shop. And what has been claimed to be the first magazine on the subject, Amateur Films, was launched in Britain in the twenties. In 1927, a US popular magazine, Photoplay, even ran a $5,000 competition for the best amateur film, inviting entries on 35 mm, 16 mm, or 9.5 mm.

Despite this rising consumer interest in the home movie, it was still a hobby for the rich. There were a few enthusiasts who were prepared to make great financial sacrifices in order to pursue their interest, but the popularization of cine-matography, even for fireside screenings of rented films, awaited a fall in the cost of both the equipment and the film stock.

The turning point came in 1932 with the introduction of 8mm film. This was run in the camera as 16mm film, exposed down only one half of the width, reloaded to run the second half, then split and joined to make one length of 8mm film.

Although technically offering less than the existing 9.5mm gauge, its effect was to open up the market to more manufacturers, more competition and more innovation in all three amateur gauges.

The motion picture equivalent of the family snapshot was now coming within the reach of a wider public. And not only for 'baby-on-the-lawn'. The film of the summer holidays in Cornwall or Maine also became the star attraction of living-room screenings at Christmas. The spread of interest was inevitable, encouraged further by the gradual arrival of colour film stocks.

Colour film had been available to the amateur in some form or another since the early 1920s, either as hand-colour prints or later as an additive colour process for film-making. But the additive system, which required exposure through a microscopic grid of red, green and blue filters built into the base of the film, reduced the light output on projection and was not really satisfactory. The breakthrough with colour came when Kodak introduced the first so-called integral tri-pack movie film in 1935, first as 16 mm and the following year in 8 mm.

The integral tri-pack system, which survives in principle today, made it possible for the amateur to achieve almost the ultimate in one-upmanship; at a time when most movies in the commercial cinema were still black-and-white, the

The Cine-Kodak Outfit

Making motion pictures with the Cine-Kodak is as simple as making snapshots with a "Kodak"—you press the button, we do the rest.

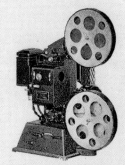

The Cine-Kodak	The Kodascope
Takes Motion Pictures	*Projects Motion Pictures*

The Cine-Kodak

COMPACT—Measures $8\frac{5}{8} \times 4\frac{5}{8} \times$ 8 ins. Weighs $7\frac{1}{4}$ lbs.
EASY TO USE—Is loaded quickly in daylight. Easily and accurately trained on the subject. Will photograph action continuously for four minutes without reloading.
RELIABLE—It produces results of the finest quality with ease and certainty.
ECONOMICAL—It reduces the cost of motion pictures by 80 per cent., compared with cameras using the standard width film.

The Kodascope

SAFE—Uses only safety film.
EASY TO USE—Can be attached to any house circuit not under 100 volts Threads simply. Is operated quietly by motor. Focusses and frames conveniently. Rewinds quickly by hand.
RELIABLE—It provides constantly the full enjoyment of motion pictures, through clear, steady projection, free from any annoyance or danger.
ECONOMICAL—At a distance of 18 feet it throws a brilliant 40 × 30-inch picture on the screen, yet its running cost is very small.

The Cine-Kodak Outfit containing Cine-Kodak, Kodascope Splicer, Screen and either Motor Drive or Tripod. Price, **£80** complete.

Write for a copy of "The Cine-Kodak for Motion Pictures," Post free.

Kodak Ltd., Kingsway, London, W.C.2

Kodak's advertisement for the Cine-Kodak and Kodascope projector.

home movie-maker could invite the neighbours in to see the family holiday last August *in colour*.

The response was dramatic, and even at a price of £2 ($9) for a 100-foot length, Kodak could barely keep up with demand for the new film. In June of 1935 they advertised that 'Kodachrome film is being processed as rapidly as possible at [laboratories in] Rochester NY only. As soon as practicable, other processing stations will be equipped to handle Kodachrome.'

Sound film projectors were also becoming available for amateur use, first in 16mm and later in 9.5mm. The church hall screening of 'talkies' was now an event no longer staged exclusively by commercial operators. Clubs, schools and other groups were able to put on their own shows—at least, as long as a well-off member or parent was in the élite ranks of those who owned a sound projector.

The film society movement was also blossoming. This was not just another

RIGHT The Kodascope 'Kodatoy' motor-driven projector for 16mm film proved to be very popular with amateurs, particularly after the price dropped to £15 in 1925. Some people used the projector primarily for showing their own home movies, made on the Cine-Kodak and processed at Kodak's new laboratories, but many more just liked to show films hired from the increasingly successful Kodascope Library. The spools took the 16mm standard 100-foot film lengths and had to be rewound by hand.

While the 16mm format appealed to more serious film-makers, 9.5mm was preferred by the casual family user, and many 9.5mm cameras and projectors appeared in the 1920s and '30s. The Dekko (FAR RIGHT) was a neat, easy to manage spring-driven camera, dating from the early 1930s, and could give a film speed of up to 64 fps.

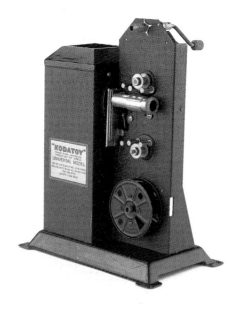 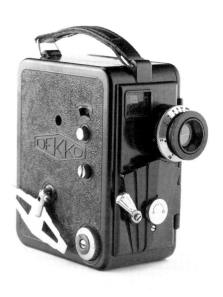

example of enthusiasts wishing to play adult games by imitating the commercial cinema but a genuine response to a public need. The standard fare at local cinemas during the 1930s was fantasy and escapism: Hollywood actresses shot through soft-focus lenses, an aristocratic Leslie Howard giving the French a run for their money as the Scarlet Pimpernel, and riotous comedies ranging from the sublime (Buster Keaton) to the ridiculous (The Three Stooges). If the public wished to see some of the more serious films being made, especially foreign films from countries such as France, Germany and the USSR, the local cinema was unlikely to provide an opportunity.

Film societies dedicated to screening such material started to spread across the UK, the USA and other countries, although obliged to operate mostly on 35mm because of the limited availability of titles on 16mm. What was now happening was the lowering of the technical and economic barriers that had originally caused the cinema—and film-making—to be a strictly commercial or rich man's activity.

In the early 1930s, the serious amateur film-maker was to be found in the cine club—a body dedicated to enjoying the fun of film production. Cine clubs were springing up all over the Western world,

and in Britain the movement was given added strength through the formation in 1932 of the Institute of Amateur Cinematographers.

The prevalence of the middle classes and the wealthy in this new hobby was still inescapable. A photograph of the first annual banquet of the IAC at the May Fair Hotel in London in 1933 probably says it all: very few young faces are in evidence, and the dinner-jacketed males in the assembled company nearly all wear *white* ties. Early supporters or members of the Institute included Sir Malcolm Campbell (the land-speed record driver), Sir Frank Newnes the publisher, and Viscount Combermere; the IAC's first President was the Duke of Sutherland, later to be followed by Viscount Dunedin and then J. Arthur Rank (Lord Rank).

Some clubs of the period such as Ace Movies of Streatham, aspired to ambitious heights. Like a few others in Britain, this club had its own studio, but was also building sets, using special effects and models, and filming on semi-professional 16mm equipment. Another club, the Planet at Palmer's Green, boasted a projection theatre as well as a studio, and the Eltham Cine Society even had dressing rooms 'for the players'.

The serious business of British amateur film-making reached a new plateau in

1935 when the first Ten Best competition was held. This event, which was to continue after the Second World War and become internationally well known, had modest beginnings when first announced by the magazine *Amateur Cine World*. In that first year some 457 films, which had been previously submitted to the publication for review, were used to arrive at a short list. A judging panel which included the documentary pioneer John Grierson made a final selection of ten, the range of which typifies the ambitions of amateurs then: *The Speckled Band* (from the Sherlock Holmes story), *The Blackmores Gave a Party* (a thriller from a unit at Leatherhead), and, less pretentiously, *Airport*, a documentary about Croydon Airport (but not to be confused with another of the 1930s with the same subject and title but produced by the distinguished documentarian Edgar Anstey as the first film to be made by the famous Shell Film Unit). But family movies were not absent from the winners: *No. 3 Arrives* is described as such and surely must have referred to baby on the lawn once more?

The depression stimulated this trend in America: in 1932 the magazine *Movie Makers* ran an article headed *How to plan a Social Welfare film*, and reminded readers that 'the film is one of the best mediums possible in which to present social problems, to publicize relief plans, or to ask for definite support for specific welfare programs'. In Europe, this activity was thrown into sharper focus when the Second World War began.

The pre-war ambitions of the amateur were not, however, confined to producing fiction or family movies. The idea of using the movie camera as an instrument of social record was finding favour with some amateurs. The Ten Best competition

By the early 1930s, there were enough serious amateur film-makers for cine clubs to begin to appear all over Europe and America. The British Institute of Amateur Cinematographers was formed in 1932, and this picture shows their first annual awards banquet, held the following year in the May Fair Hotel. The predominance of middle-aged, dinner-jacketed, white-tied men among the guests only serves to underline, however, just how film-making was still restricted to the affluent middle class.

The advent of 9.5mm in 1922 made silent movie classics like *The White Hell of Pitz Palu* (FAR RIGHT) and Charlie Chaplin's *The Champion* (NEAR RIGHT). readily and not too expensively available for the home movie enthusiast. The only problem was that the limited capacity of the film spools meant that the distributors had to cut films drastically, often by as much as two-thirds.

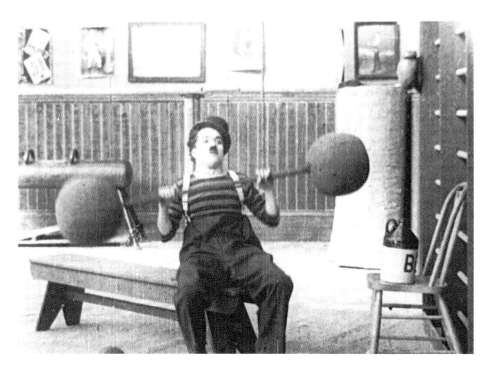

was modelled on a similar contest that had been running in the USA for some eight years, and the 1937 line-up there was even more varied than in England: winners included Dr Milton Cohen's *Complete Operative and Prosthetic Technic for Porcelain Jacket Crown Restorations* (24,000 feet, colour), and a comedy that owed a debt to Conan Doyle only in the title—*Little Sherlock*. Most of the winners, though, fell into the vacation category: *Western Holiday*, *Beach Holiday*, and *Glimpses of a Canoe Trip* were among the titles.

Some of those early Ten Best winners were following the tradition of cinematography in its earliest days—holding a mirror up to the world and recording important historical or social situations. Winning Ten Best films in 1937 included a probe into the housing conditions of rich and poor (*Where Can they Go?*), a film about traffic problems (*Safer Beckenham*), and another housing documentary, *Plan for Kensington*. Perhaps the choice of winners also reflected the presence on the jury of John Grierson, whose commitment to the use of film as a weapon in social education created a radical generation of professional film-makers.

The early days of the war gave added impetus to the social role of film, and many amateurs, even simple home-movie users, began turning their equipment to more purposeful ends. Palmers Green Cine Society produced a recruiting film for the ARP—the Air Raid Precautions battalion that was set up to provide help on the home front during attacks by enemy aircraft. Film stock ceased to be available, of course, and film-making of this kind was short-lived. But projectors and prints of films still existed, and during the early period of the war, when cinemas were closed, the home movie show came into its own.

Such activity reached the zenith of patriotism when the editor of *Home Movies and Home Talkies* promoted the idea of amateur film shows during the black-out with this rallying message: 'Such hobbies as ours are an essential, if humble, part of the way of life for whose preservation we are fighting . . .'

There were, however, more serious things for the amateur to do during times of war. Some who had acquired film-making experience found themselves in the armed forces with an occasional chance to grab a camera and sneak some film from a nearby film unit (or as likely as not from an American air force base). The

PUNCH, OR THE LONDON CHARIVARI.—MAY 22, 1929.

Kodacolor

You can now make your own movies
in FULL COLOUR — *with a Ciné-Kodak*

A wonderful new 'Kodak' invention has made it just as easy to make *colour* movies at home as ordinary black-and-white pictures. Just think of the joy of making films of your children at play, of the many interesting incidents that happen in your life in the surroundings you know and love so well—*and showing them in the glorious colours of nature, faithfully reproduced in every tint and shade!* After years of costly experiment the Kodak Company have produced this greatest wonder of photography. With a Ciné-

'Kodak' Camera (lens *f* 1.9), fitted with a small Kodacolor filter and special Kodacolor film, the most inexperienced amateur can make perfect motion pictures in colour. Then they can be shown on your own screen at home with a Kodascope projector, with which you can also show famous 'star' films borrowed from the Kodascope Library. All the film is safety film, and it costs you nothing to have your reels developed and finished. Ask your nearest Ciné-'Kodak' dealer for a booklet and a demonstration.

KODAK LTD., KINGSWAY, LONDON, W.C. 2.

A 1929 advertisement for Kodacolor cine film.

results in a few instances have become important historical records. One cache of such film, shot in colour by an enthusiast in the RAF, was turned into a unique video programme about forty years later under the title *Night Bombers*—an on-the-spot record of British bombing flights into Germany.

The activity was not peculiar to the British either. Possibly one of the most important home movies ever shot, a very early sample of Agfacolor film, shows Hitler and Eva Braun in off-duty relaxation at Berchtesgaden during the war. Attempts have been made to use lip-reading to discover what was actually being said by the world's most infamous tyrant, but with little success.

Home movies continued longer in the USA, of course, and the amateur cine organizations met and filmed each other much as usual: in 1941, for example, the Long Beach Cinema Club watched the club president's film of her recent visit to Hawaii (900 feet synchronized with sound on disc). The effects of war were never far from everybody's mind, though, and this was reflected in the titles circulated at no charge among cinema clubs and home-movie buffs. *Goodyear Shoulder Arms* depicted 'the important part played by rubber in the national defense', and *In Defense of the Nation* was designed 'to show how the community can help to protect soldiers, sailors and defense workers from social diseases . . .'. Newsreel footage from the European war was also popular: advertisements screamed 'NOW —FOR THE FIRST TIME . . . HOME MOVIES OF ALLIED TRIUMPHS! . . . Keep your record of the wars complete . . . See Il Duce's dream explode! . . . Battle in the Eastern skies! War in desert sands! . . . Sound, 750 feet $17.50.'

Home movies started to boom after the war as 8mm film became more established as the amateur gauge. Very slowly, 9.5mm was squeezed off the scene (although even in the 1980s the gauge had some adherents). Whether for screening commercial films or home movie-making, the amateur market began to settle down into a choice between 8mm and 16mm film.

The smaller gauge obviously came into the ascendancy for the casual movie-maker who wanted a movie record of the family holiday or daughter's wedding. At the height of its popularity in the early 1970s, about 9 per cent of UK households owned an 8mm camera—and in West Germany, where the gauge was very popular, some 20 per cent of homes possessed an 8mm camera. A minority of occasional users were equipping themselves with 16mm equipment, which although expensive was beginning to yield results approaching the quality of 35mm cinema films.

The addition of sound to home movies provided another spur. It had been

With the launch of 8mm in 1932, the home movie 'snapshot' finally became a reality. Even for those who wanted nothing more than a record of family occasions, neither the camera nor the film was too expensive, enabling users to be liberal in shooting film. This still from early amateur footage entitled *Baby on Lawn* by G. McKel tackles a subject that attracted literally thousands of others in those early days —as it does now.

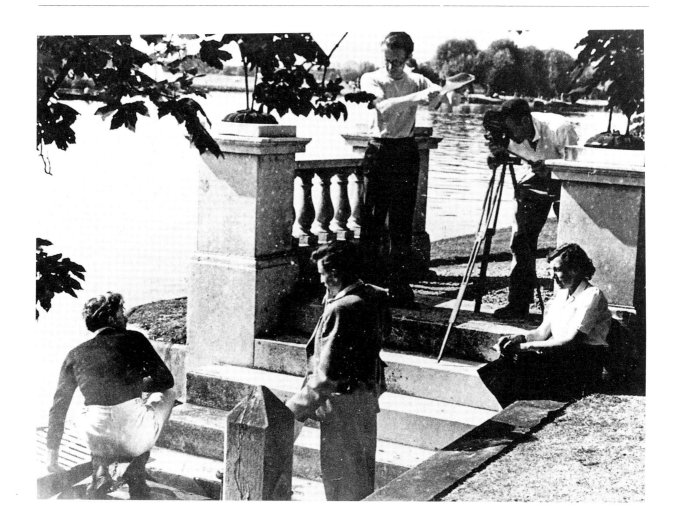

ABOVE The amateur cine clubs that blossomed in Britain and America in the 1930s and '40s were often quite ambitious in their aims and went to some trouble to acquire all the necessary production skills. This picture shows the High Wycombe film society shooting a scene from *The Paper Boat*.

One of the most famous home movies of all time is the footage discovered by Lutz Becker of Adolf Hitler and Eva Braun relaxing at Berchtesgaden during the Second World War. Shot on an early version of Agfacolor, it provides a unique insight into the private life of the Führer—which is why historians regret that it is a silent movie.

available for home cine projection before the war, first from discs and later, in the early 1930s, as sound-on-film. But it was the war which stimulated the wider use of sound on the so-called narrow gauge films. Optical sound projectors using 16mm film had become a common educational aid for the armed services, and now 16mm sound was no longer a rarity.

The first impact of this was on the film society movement, which began to switch its operations away from the expense of 35mm as more commercial titles became available on 16mm. And once more the wealthier enthusiasts were able to keep ahead of the Joneses by showing real 'talkies' to gatherings of friends. Although this activity was centred on 16mm sound film, 9.5mm optical sound was also available.

Home film shows of this kind were for the privileged few, however, and became less of a novelty as broadcast television started to make its impact on the general public. By the mid-1960s amateur interest in 16mm shifted to production, whether for more ambitious cine club activity or just those babies on the lawn again. (The film society movement, specializing in public screening of classic films, flourished none the less, reaching a peak of 700 societies in Britain in the early 1970s and virtually abandoning the 35mm gauge of cinemas.)

Despite the rising interest in amateur production, further developments in 8mm during the sixties made it possible to have sound movie shows in the home at a cost affordable to the many rather than the few. The introduction of magnetic stripe made talkies on 8mm practicable, whereas optical sound on this very narrow gauge, although accomplished, was fraught with technical difficulties.

Kodak's movie camera advertising stressed economy first, but a new theme was beginning to emerge: capturing memories and preserving them like insects in amber. This underlying theme continues even today.

For decades, amateur film-makers longed to be able to add a soundtrack to their films just as the professionals did, and all kinds of methods were experimented with. One idea was to record a commentary on a gramophone, as this 1938 advertisement (LEFT) for the 'Phono-disc' proclaims. The introduction of $\frac{1}{4}$ in tape recorders for home use in the early 1950s made things much easier, but synchronizing the tape to the film was still a real problem. These advertisements (FAR RIGHT) for a mechanical synchronizer show just one of the many ingenious solutions tried by amateurs and commercial organizations. The use of women in advertisements continues the tradition established by Kodak (RIGHT).

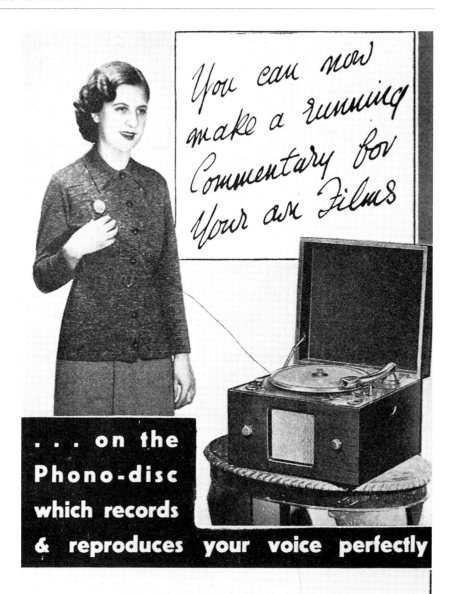

You can now make a running Commentary for your own Films

. . . on the Phono-disc which records & reproduces your voice perfectly

The introduction of the Phono-disc at long last enables the Amateur Cine owner to make his own Running Commentary at a reasonable cost.

Libraries specializing in the release of commercial films in 8mm began to enjoy a short period of success. But the new technical developments were encouraging more attention to movie-making rather than passive viewing—a not unnatural response to the competition of television.

The developments that fuelled this interest were twofold: magnetic sound recording made the production of amateur sound movies practicable; and Kodak had another surprise for the industry when it introduced Super 8 film in 1965.

The preoccupation with sound afflicted serious amateur movie-makers everywhere, and had started as early as the 1950s when $\frac{1}{4}$ in tape recorders became available. The problem initially had been to find satisfactory methods of synchronizing the tape to the film, so that music and sound effects added after the picture editing always came over the right

living sound

gives a new dimension
to home movies

capturing for ever
mean so much.

LIST OF

PROJECTOR
Bell & Howell

Bauer
Bolex
Kodak
Eumig
Cirse Oregon
Cirse Nilus
Specto
Specto
Zeiss 9
Nizo
Siemens
Bolex

New projectors are constal

sequences. This led to the most extraordinary range of solutions, with mechanically and electrically linked devices that strove to adjust the speed of the film to keep it in step with the recorded tape. Most systems belonged to the realms of the mad inventor, and virtually all of them meant it was impossible for amateurs to exchange films because their different systems were incompatible.

The arrival of magnetic striping on prints soon overcame that difficulty, but serious amateurs wanted to put more than just music and sound effects on their films; they wanted to shoot them with sound and have lip-synchronized dialogue. The provision of magnetic striping on unexposed film finally solved that

problem, and in 1974 Kodak introduced a Super 8mm cartridge system with cameras and projectors that made the lip-synchronized amateur film easy for anyone to shoot. Now baby on the lawn could cry as well.

The new format of Super 8 had been designed to narrow the quality gap between what then existed as 8mm (renamed Standard 8) and the semi-professional 16mm gauge—but without a penalty in running costs. Super 8 abandoned the larger sprocket hole of Standard 8 inherited through its 16mm lineage and thus squeezed more picture area out of the available width of film.

The resultant improvement in picture quality started in earnest the battle of the

FAR LEFT In the end, 8mm won the battle of the formats for the casual home moviemaker, and by the 1960s, Kodak and many other manufacturers were offering a wide range of 8mm equipment with often quite sophisticated specifications. The Kodak Zoom 8 was one of the first cine cameras to give the amateur film-maker power zoom and reflex viewing.

LEFT It was the introduction of the Super 8 format by Kodak in the 1960s that really opened up the world of sound for the home moviemaker. Super 8 cameras, such as this Ektasound 130, were the first amateur format cameras capable of giving lip-synchronized dialogue, recording sound on a magnetic stripe down the side of the film. The Ektasound came complete with external microphone.

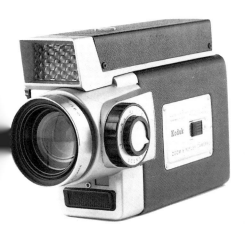

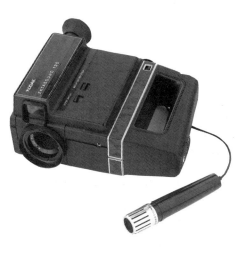

The adoption of 16mm by professionals in the 1970s opened up to the dedicated amateur a range of equipment, materials and facilities almost matching those used in feature film production, and cine clubs began to try their hands at some ambitious films. This picture shows the Altrincham Cine Club shooting a scene from *Unlucky for Some*, voted one of the Ten Best Amateur Films of 1975. Note the new attention to sound, with a specialist sound recordist, and the home-made 'blimp' surrounding the camera.

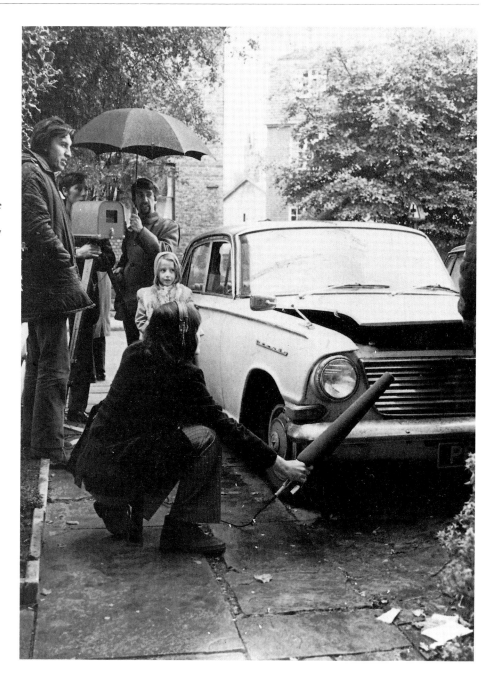

gauges—almost a re-run of the confusion over gauges at the turn of the century. Although Standard 8 was well established as a home movie gauge in the 1960s, and 9.5mm maintained a respected presence, the higher quality of 16mm had attracted a following from more serious amateurs. Super 8 restored some of the balance, was cheaper to run and used smaller equipment suited to less committed users.

The larger 16mm gauge, which had become a standard for film screenings in education, business and film societies, was now being adopted by professional film-makers. One important consequence of this was the introduction of sophisticated 16mm equipment of the kind which hitherto had been made only for the 35mm professional market. The artefacts and all the technology of Hollywood and Wardour Street were now becoming available for what was originally an amateur film gauge. Specialist magnetic sound equipment for 16mm editing—

hitherto not manufactured—was now made for the professional user. New colour film stocks, notably negative colour rather than only reversal, were introduced in 16mm because professionals needed prints (copies) of similar quality to those in the commercial cinema. And high quality cameras in 16mm started to appear; until then, the serious 16mm film-maker used the ubiquitous Bell & Howell, Paillard Bolex or Cine-Kodak Special—all excellent cameras, but no match for the Arriflex and others which were to follow.

These developments, although inspired by professional needs, were to have a profound effect on the serious amateur. At last, cine clubs could have access to equipment, materials and facilities to match (almost) those used in feature film production. Despite the excellent quality that the new Super 8 gauge could yield, it found itself in a battle, often of words in the cine press, with 16mm. But the higher running cost of 16mm ensured that its widespread adoption by home movie users would never happen; to that extent, Super 8 won the battle of the gauges.

For the casual family user, Super 8 had in any case brought really acceptable quality to home movies. With the wider exposure latitude of the newer film stocks, and the ease with which synchronized sound could be recorded on the camera film, by anyone, it was possible (technically and economically) to put the family on the screen, talking; or, in the words of that viewer in 1896, 'so faithful that one longed to be there'.

It began to seem that home movies, as an extension of the cinema, were now going to be as commonplace as refrigerators, washing machines and television sets. The sprocketed film was going to join the $33\frac{1}{3}$ audio and audio-cassette recorder as part of every household aspiring to middle-class status. But the electronics industry had other ideas . . .

When videotape recording was introduced in the late 1950s, it was regarded as a development for use in broadcast television. In November 1951, the electronic division of Bing Crosby Enterprises demonstrated a practical monochrome

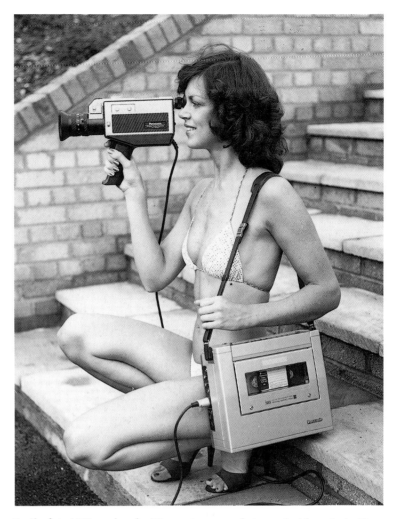

By the late 1960s and early '70s, various manufacturers had launched video cameras and recorders aimed at the amateur user, such as the Panasonic system shown above. These all had a separate camera and portable videotape recorder connected by a cable. Such systems were too complex to interest the casual user but, in the mid-1970s, came easy-to-load Video Cassette Recorders (VCRs) designed for home users to record TV programmes.

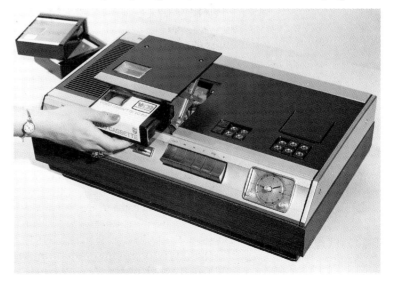

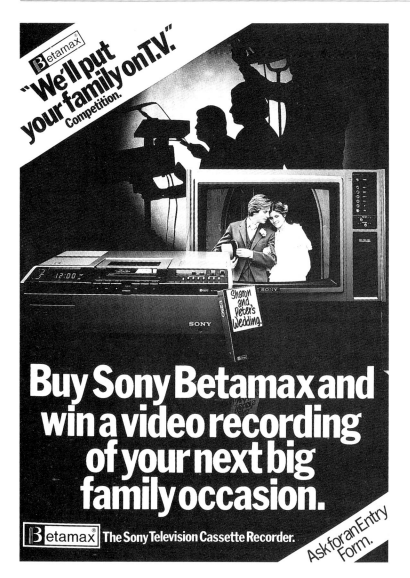

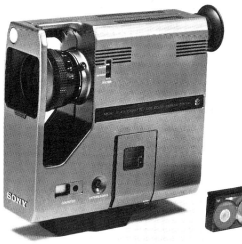

ABOVE By the early 1980s, the big Japanese consumer electronics firms, in particular, were marketing video movie equipment aimed fairly and squarely at the casual family user, as this advertisement for Sony shows.

ABOVE RIGHT Sony's Micro ·Video Cassette Recorder appeared only as a prototype, but differs only in cosmetic detail from most of today's popular camcorders.

system, using inch-wide tape which moved past the recording heads at the alarming speed of 8 feet a second. The equipment was extremely costly, large, complex and yielded poor picture quality. In England, the BBC's experimental machine (VERA, acronym for Vision Electronic Recording Apparatus) ran the tape twice as fast, and few, if any, people in the television industry then imagined that videotape recording would be of relevance to the consumer market.

There were, however, some visionaries. In 1963, a British company (Nottingham Electronic Valve) demonstrated a home videotape recorder that was to be marketed under the name Telcan. But the technology, using fixed recording heads

and tape running at 120 inches per second, made it as impracticable as VERA. More ominously, the Japanese were hard at work developing home machines which relied on the better principle of rotating heads, so that the tape 'writing speed' needed for satisfactory picture quality was increased without the tape itself thundering along at the speed of an express train.

In 1965, Sony introduced the CV-2000 (CV for Consumer Video), the first videotape recorder intended for home users. Thereafter, various manufacturers followed with other machines, and by the late 1960s and early seventies a range of non-compatible systems aimed at the home market were becoming available.

These developments followed a number of routes. Some systems were open-reel machines (that is, with a feed spool and take-up spool) for use with cameras, the market in mind being very much professional and semi-professional owners. Then followed the concept of cassetting the tape so that loading was simple.

Thus was born the videocassette recorder (VCR), aimed at the home user as a method of recording TV programmes off-air (but initially successful in Sony's U-matic version for professional applications). It was a development that took many consumers, used to photography and cine, by surprise; typical of comments

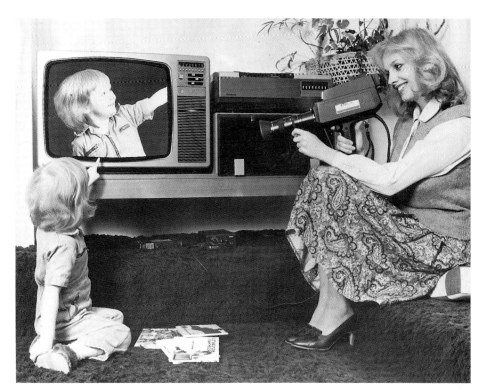

The excitement of video for the home moviemaker lies in its immediacy. There is no waiting around to see the results while the film is sent away for processing. Recordings can be played back instantly on the television. And there is a certain thrill in seeing yourself 'live' on television, moving your hands and watching your screen image move its hands too, as in a mirror—as these publicity shots from around 1980, for Panasonic and Philips, illustrate.

The JVC Video Movie uses small VHSC cassettes that can be played on a regular VHS recorder using a simple adapter.

was 'you mean, you don't have to send it away to be developed?'

As a consumer product in the very early '80s, the VCR was slow to take off. Indeed, some cynics doubted that it would ever be a significant product. But from a UK penetration of about half-a-million in 1980, the number of machines in use quickly rose, to over 5.5 million by 1983 and nearly 10 million by the end of 1986. A battle of formats followed, not unlike the 16mm, 9.5mm, and 8mm war of the gauges, with Philips eventually losing in two attempts to establish a *de facto* standard (the N1500/N1700, then the V2000). The VCR conflict finally resolved itself in the early 1980s to a straight slugging match between Sony's Beta system and JVC's VHS format; the latter is now effectively a world standard and Beta certain to vanish.

Before the introduction of video-cassette recorders for use in the home, the somewhat cumbersome open-reel machines were being sold to educational and business concerns for use in producing video programmes, to be followed in 1965 by portable battery-operated versions for location shooting. The name portapak was

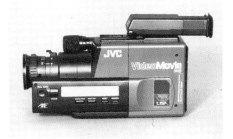

BELOW Sony's 'Handycam', shown here, was the first genuine 'snapshot' video, able only to record, not play back—as most camcorders could—but making the most of the tiny 8mm format to give full length recordings on a cassette no bigger than an audio tape cassette.

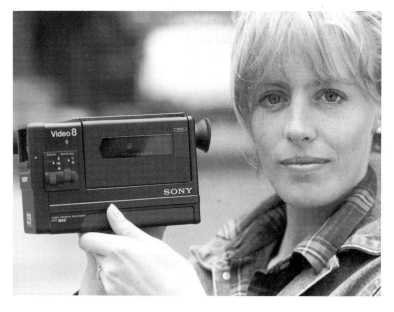

then coined to describe any unit linking video cameras to portable recorders. But videocassette recorders soon rendered the open-reel machine obsolete, and it was not long before battery-operated portapaks for location shooting were based on videocassette technology.

By the early 1980s, amateur movie-making on video had become a relatively easy (if capitally expensive) pastime. Small, lightweight video cameras designed for consumers could now be plugged in to compact, battery-operated VCRs slung from the shoulder. It was a more practical development of the open-reel portapak. But even if the running cost was dramatically cheaper than Super 8mm film (and the tape reusable), like 16mm it was a rich man's indulgence. It seemed an élitist development of little consequence to the average family man, who anyway had his home VCR to record TV programmes off-air (or he could rent them from the local video shop).

Viewing films at home on the VCR, recorded or 'time-shifted' off TV or sometimes rented locally for less than £1 per night, meant that a family of four who might spend over £8 in going to the cinema could now view feature films in the comfort of their own home, and save money. It was an experience as exciting as talkies on 16mm before the war, but considerably cheaper and much easier to organize.

This revolution in home viewing had such an impact on cinema-going that by the mid-1980s more people were watching feature films on video in one week than attended the cinema in one year.

The home video revolution had not yet finished, however. The impressive statistics (by 1987, 50 per cent of all TV homes in the UK owned a VCR) all related to equipment used for viewing programmes recorded off-air or rented and purchased. But now the manufacturers, notably in Japan, had another idea: to put the VCR and the lightweight video camera into a single battery-operated unit.

What emerged was the camera cassette recorder (CCR) or, as it is more popularly called, the camcorder. By the mid-1980s, units no larger than a Super 8 film camera

The big drawback of video for the serious home moviemaker is the fact that only a few people can sit around the television at a time to watch the movie. One possible solution seemed to be the video-cassette mini-theatres which project the video image onto a screen. The Advent VideoBeam illustrated here uses a special aluminium foil screen positioned exactly 100 in front of the projector, with its beam for each of the three colour images, to give an image large and bright enough to show in a room holding up to 70 people. Such systems inevitably suffer in both brightness and quality when compared to a television screen.

became available—no cables, no outward evidence that the tiny camera in fact also concealed a video recorder and small cassette or videotape.

Camera cassette recorders at first seemed priced for an exclusive market again—£1,200 or more in 1986–7. But larger production lines and fiercer competition started to bring some models down below the £1,000/$1,700 barrier and in exceptional cases to near £500/$850.

At the time of publication, the decline in prices had not reached the bottom, and CCRs of the future will probably cost little more than mid-range still cameras. In the meantime, the consumer is faced with yet another battle of the gauges with camera cassette recorders. Sony are fighting it out with JVC, the former with their so-called 8mm video system (the tape is in fact not quite eight millimetres wide, but it was a good name to borrow from film) and JVC with their VHS movie system (using videocassettes compatible with home VCRs, unlike the Sony 8mm format which is a totally new standard).

For the consumer, it may well be irrelevant who wins this latest battle. What is important for home movie users is that anyone almost anywhere can now shoot movies, and lip-synchronized sound, with infinite ease. The high cost of film stock no longer imposes a limitation on the amount of material shot (the limitation now is the patience of the audience); video can be exposed at lower light levels than film, even by the candlelight of the children's birthday cake; and it can be viewed instantly, albeit on a television set and not on a large screen in a darkened living room.

In time, though, this will change too. A new generation of television equipment will hit the home market some time in the 1990s—low-cost video projectors—the electronic equivalent of the home movie projector—or (more likely) TV sets with large flat screens. Such developments are the last link in the chain which make movies as accessible to everyone as pen and paper.

When this happens, with the penetration of camera cassette recorders reaching a proportion comparable to still cameras—as some believe it will—a new age of communication could be heralded; it will be an age in which anyone can communicate with anyone else, anywhere, without needing to read or write.

The Victorians, charmed by the magic lantern, intrigued by photography, amazed by the cinematograph, would be astounded—and in all probability shocked and disapproving at the social implications. But it was D. W. Griffiths, a great film-maker of the early 1900s, who predicted that movies would become the universal language depicted by the Bible. Maybe he was right.

Further Reading

ACKERMAN, Carl W. *George Eastman* (London, 1930)

ARNOLD, H.J.P. *William Henry Fox Talbot: The Pioneer of Photography and Man of Science* (London, 1979)

BEATON, Cecil and BUCKLAND, Gail. *The Magic Image: The Genius of Photography from 1839 to the Present Day* (Boston and London, 1975)

BUNNELL, Peter. *A Photographic Vision: Pictorial Photography, 1889–1923* (Utah, 1980)

COE, Brian. *Cameras: From Daguerreotypes to Instant Pictures* (London and New York, 1978)

COE, Brian. *Kodak Cameras: The First Hundred Years* (Cincinnati and Hove, 1988)

COE, Brian. *The Birth of Photography* (London, 1976)

CRAWFORD, William. *The Keepers of Light: A History and Working Guide to Early Photographic Processes* (New York, 1979)

HAWORTH-BOOTH, Mark. *The Golden Age of British Photography* (London and New York, 1984)

DOTY, Robert. *Photography in America* (London and New York, 1974)

EDER, Josef Maria. *History of Photography* (New York, 1978)

GREEN, Johnathon. *American Photography: A Critical History 1945 to the Present* (New York, 1984)

HARKER, Margaret. *The Linked Ring: The Secession Movement in Photography in Britain 1892–1910* (London, 1979)

FREUND, Gisèle. *Photography and Society* (London, 1980)

GREENHILL, Ralph. *Early Photography in Canada* (London and Toronto, 1965)

GERNSHEIM, Helmut. *The Origins of Photography* (London and New York, 1982)

GERNSHEIM, Helmut and Alison. *The History of Photography* (London and New York, 1969)

HILEY, Mike. *Seeing Through Photography* (London, 1983)

GOLDBERG, Vicki (Ed). *Photography in Print, Writings from 1816 to the Present* (New York, 1981)

HILL, Paul and COOPER, Thomas. *Dialogue with Photography* (New York, 1979)

HOMER, William Innes. *Alfred Stieglitz and the Photo-Secession* (Boston, 1983)

KOLTUN, Lily (Ed). *Private Realms of Light, Amateur Photography in Canada 1839–1940* (Ottawa, 1984)

JEFFREY, Ian. *Photography: A Concise History* (London and New York, 1981)

LEMANGNY, Jean Claude and ROUILLE, Andre. *A History of Photography* (Cambridge and New York, 1987)

LOTHROP, Easton S. Jnr. *A Century of Cameras from the Collection of the International Museum of Photography at George Eastman House* (New York, 1973)

MOHOLY, Lucia. *A Hundred Years of Photography* (London, 1939)

NEWHALL, Beaumont (Ed). *Photography: Essays and Images* (London and New York, 1980)

NEWHALL, Beaumont. *The Daguerreotype in America* (London and New York, 1976)

NEWHALL, Beaumont. *The History of Photography* (London and New York, 1982)

PHOTOKINA. *50 Years, Modern Colour Photography* (Cologne, 1986)

POLLACK, Peter. *The Picture History of Photography* (New York, 1958 and 1969)

ROSENBLUM, Naomi. *A World History of Photography* (New York, 1984)

RINHART, Floyd and Marion. *The American Daguerreotype* (Georgia, 1981)

LEE, Emanoel. *To the Better End. A Photographic History of the Boer War 1899–1902* (London and New York, 1985)

RUDISILL, Richard. *Mirror Image: The Influence of the Daguerrotype on American Society* (New Mexico, 1971)

SCHARF, Aaron. *Art and Photography* (Baltimore and London, 1968)

VARIOUS. *Contemporary Photographers* (London, 1982, and New York, 1985)

SIEBERLING, Grace. *Amateurs, Photography and the Mid-Victorian Imagination* (Chicago, 1986)

SOBIESZEK, Robert. *Masterpieces of Photography from the George Eastman House Collections* (New York, 1985)

SZARKOWSKI, John. *The Photographer's Eye* (New York, 1980)

SZARKOWSKI, John. *Looking at Photographs* (New York, 1973)

TAFT, Robert. *Photography and the American Scene* (New York, 1938, reprinted 1964)

TAUSK, Petr. *Photography in the 20th Century* (London, 1980)

COKE, Van Deren (Ed). *One Hundred Years of Photographic History* (New Mexico, 1975)

TURNER, Peter. *History of Photography* (London, 1987)

Glossary

additive primary colours The colours red, green and blue that, when added together, can generate any colour of the spectrum.

Agfacolor Originally a NON-SUBSTANTIVE colour REVERSAL film introduced in 1936, though subsequent films bear the same name.

albumen Egg white, used on albumen printing paper to fix light sensitive silver salts onto the paper's surface.

ambrotype Form of COLLODION POSITIVE image on glass.

anastigmat Lens that does not suffer from astigmatism—the tendency to record a point in the subject as two short lines at right angles, one in front of and one behind the plane of sharpest focus.

aperture The circular hole formed by the IRIS DIAPHRAGM between the elements of a camera lens. The largest possible aperture is a measure of the light-gathering power of the lens.

aspheric lens Lens with surfaces that do not conform to the shape of a sphere. Aspheric lenses are difficult to manufacture, but permit advanced optical designs in a small, light lens.

Autochrome Additive colour REVERSAL process that used dyed grains of starch to separate the spectrum into red, green and blue components, each recorded on the same PANCHROMATIC EMULSION.

Autographic camera/film Process that allowed photographers to write a short message on the negative at the time of exposure, using a small slot on the camera back.

beam-splitter Prism or mirror that divides image of the subject into two or three parts, either to make a STEREOGRAM, or to separate the image into three parts, each recording a different section of the spectrum.

blimp Sound-deadening cover used to muffle camera noise.

bromaloid Variant of the BROMOIL process.

bromide paper Though now used just to mean printing paper, 'bromide' originally meant paper containing silver bromide, that was sufficiently sensitive to light to use for enlargement.

bromoil Printing process in which the surface of a BROMIDE print was bleached and hardened. The gelatin surface then absorbed pigment in proportion to its thickness, so that dabbing with ink revealed the image —but made it look more like a painting.

cabinet card Print measuring about $4 \times 5\frac{1}{2}$ in, mounted on card and decorated much like a CARTE-DE-VISITE picture.

calotype Early photographic process that produced a paper negative only after development of the LATENT IMAGE. The calotype was Talbot's improvement on his earlier PHOTOGENIC DRAWING process.

camera lucida Sketching aid that superimposed an image on the subject over that of the sketch pad, so that the artist could simply trace off the subject's outlines.

camera obscura Optical device (and direct forerunner of the camera) that used a converging lens in a light-tight box to project an image of the subject onto a screen, where it could be observed or traced.

Canada balsam Transparent resin used to glue lens elements together.

carbon printing Printing process that used a tissue coated with gelatin and pigment. After sensitization, exposure to light in contact with the negative hardened the most heavily exposed areas of the tissue. Soaking and pressing into contact with paper transferred a positive image in any one of up to 50 colours.

carte de visite Small print, usually a portrait, measuring about $4 \times 2\frac{1}{2}$ in, mounted on card. Cartes were especially popular in the 1860s, and were the first mass-produced photographs of famous people of the day.

cellulose film Non-flammable film base that replaced the highly flammable NITRATE film. Often called safety film.

chloride paper Printing paper using silver chloride as its light sensitive component. Relatively insensitive to light, it could be used only for CONTACT PRINTING.

chlorobromide paper Printing paper containing both chloride and bromides of silver, and combining the properties of CHLORIDE and BROMIDE PAPERS.

collodion process A sticky solution made by dissolving gun-cotton in ether and alcohol, collodion was used to fix light-sensitive silver salts to a glass plate before exposing the plate in the camera. This had to be done before the plate dried, so the process was often called the wet plate or wet collodion process.

collodion positive A direct positive image made by adding mercury salts to the developer, thus turning the collodion image white. Viewed against a black background, the image appeared positive. *See also* TINTYPE AND AMBROTYPE.

colour coupler Colourless organic compound that combines with the bi-products of film development to form a coloured image on the film.

colour separation The division of the spectrum into three components—either the ADDITIVE or SUBTRACTIVE PRIMARY COLOURS—so that each can be separately recorded on film.

contact print Print made by using a glass sheet to press a negative in contact with printing paper, before exposing the sandwich to light.

coupler *See* COLOUR COUPLER.

daguerreotype Process invented by Louis Daguerre in 1839 using a sensitized silver plate to form a dulled image on the highly-polished surface. Reflection of a black object in the plate revealed the positive image.

darkslide Shallow light-tight box holding plate or film, so that the camera could be loaded in daylight.

detective camera Early name for any compact camera.

dry plate Forerunner of today's film, a dry plate suspended the light-sensitive silver salts in a coating of gelatin. The dry-plate process followed and eventually replaced the wet COLLODION process.

Dufay process Colour process that separated the hues using a grid of fine coloured lines.

dye coupler *See* COLOUR COUPLER.

dye imbibition Printing process that works by the absorption of dye by an image formed from a gelatin layer of varying thickness. Pressing the dyed image in contact with paper transfers the picture.

emulsion The light sensitive layer of a film, plate or photographic printing paper.

exposure latitude The ability of film or paper to cope with incorrect exposure.

exposure value Single numeric value for exposure, used to represent a range of shutter speed and aperture values.

ferrotype *See* TINTYPE.

fixation Process of making permanent a photographic image by removing its sensitivity to light.

flash synchronization Arrangement in a camera shutter that closes an electrical circuit to fire a flash at the exact instant when the shutter is fully open.

gum bichromate process Process that uses pigment suspended in sensitized gum arabic, and coated on paper. Exposure to light in contact with a negative hardens areas of the gum layer, and washing with water reveals the picture.

integral tripack Colour film made by coating three EMULSION layers, each recording a different portion of the spectrum, onto a single film base.

iris diaphragm Circle of sliding blades in a camera lens, arrangement to form an aperture of adjustable size.

Kodachrome The first colour film in the sense that we use the term today. Kodachrome is a NON-SUBSTANTIVE INTEGRAL TRIPACK.

Kromskop Viewing device used to create a coloured image from three separate black and white positive images on glass.

lantern slide Positive image (not always a photograph) on glass, viewed by projection.

latent image Invisible image on film or paper, made visible by development.

lenticular stereoscope Viewer for STEREOGRAMS that uses lenses to direct the left and right images to the appropriate eye.

lip-synchronization The recording and playback of sound exactly synchronized with a moving picture, so that a speaker's lips move in perfect time with the words on the soundtrack.

magnetic striping The recording of a film soundtrack on

strip of magnetic tape attached to the film.

nitrate film Early form of film base that was highly inflammable.

non-substantive colour process Colour process in which the COUPLERS are incorporated not in the film, but in the processing solutions.

orthochromatic Film or paper that is sensitive to blue and green light.

panchromatic Film that is sensitive to all colours of the spectrum, so that subject tones are recorded in their correct relationship, regardless of hue.

photo-engraving Process of making printing plates from a photographic image, so that the pictures can be printed concurrently with raised type.

Photochromoscope Synonym for KROMSKOP.

photogenic drawing Talbot's 1839 photographic process that created a negative on sensitized paper without development. CONTACT PRINTING in a similar manner formed a positive image. *See also* CALOTYPE.

photogram Today, used to mean a picture made without a lens by casting shadows of solid objects on photographic paper. Used in the past synonymously with photograph.

Photomicrograph Photography of small object using a microscope.

pictorialism Style of photography that values a pleasing image of the subject more highly than strict accuracy and truthfulness.

pigment paper *See* CARBON PROCESS.

primary colours Colours of the spectrum that in combination can be used to make any other colour. *See also* ADDITIVE and SUBTRACTIVE PRIMARY COLOURS.

printing frame Shallow frame resembling a picture frame, used to press a negative in contact with light-sensitive paper for the purposes of CONTACT PRINTING.

printing out Contact printing process in which light alone creates an image, without the need for development.

reflex camera Camera using mirrors or prisms to create a right-side up image in the viewfinder.

retouching Manual correction or improvement of a negative or print, using pigments or dyes.

reversal process Any process that produces a positive image of the subject directly, without the need for an intermediate printing stage.

roll-holder Device that permits roll-film to be used in a camera designed to expose plates.

slide Reversal image produced primarily for projection.

sliding-box camera Camera made from a pair of nested boxes, which slide apart and together to focus the image.

stereo card Pair of STEREOGRAMS mounted together on a card a standard distance apart, for convenient viewing in a STEREOSCOPE.

stereogram Pair of images taken from camera positions separated horizontally by a few inches, and representing views of the subject as seen by the photographer's left and right eyes. Viewing in a STEROSCOPE combines the two pictures to give an illusion of the third dimension.

stereoscope Viewer for STEROGRAMS.

striping *See* MAGNETIC STRIPING.

stripping film Type of film, usually coated on paper, and designed so that the emulsion carrying the image could be stripped off and coated on glass for printing.

substantive colour process Colour process in which the COUPLERS are incorporated in the film itself, not in the processing solutions.

substractive primary colours The colours yellow, cyan and magenta which when laid one on top of another, absorb parts of the spectrum to create all other hues.

talbotype Synonym for CALOTYPE.

tintype COLLODION POSITIVE image on black lacquered iron plate.

transparency Positive image on transparent base, frequently made using a REVERSAL PROCESS.

tri-chrome carbon print CARBON PRINT made using tissues in the three SUBTRACTIVE PRIMARY COLOURS, to produce a picture with lifelike hues.

ultra-violet Invisible radiation forming an extension of the spectrum just beyond human vision.

Union case Case for AMBROTYPE picture, made from shellac and sawdust pressed into a relief mould.

Vest Pocket Kodak Popular type of folding roll film camera in which the lens was supported on a lazy-tongs arrangement.

Vivex colour print Process for making colour prints from separation negatives using three sheets of carbon tissue in the primary colours. With careful control, the process was capable of high quality.

VPK *See* VEST POCKET KODAK.

wet collodion *See* COLLODION.

Woodburytype Printing process in which a relief mould was made from the original print, and the mould filled with coloured gelatin. Pressing the mould in contact with paper transferred a high-quality copy of the picture.

Index